759.36 K65c 2017 Comini, Alessandra, author. Gustav Klimt

Gustav Klimt

Other Books by Alessandra Comini:

The Changing Image of Beethoven
Egon Schiele's Portraits
The Fantastic Art of Vienna
Egon Schiele
In Passionate Pursuit: A Memoir
Schiele in Prison

The Megan Crespi Mystery Series:

Killing for Klimt
The Schiele Slaughters
The Kokoschka Capers
The Munch Murders
The Kollwitz Calamities
The Kandinsky Conundrum

GUSTAI/ KLIMT

ALESSANDRA COMINI

SANTA FE

© 2017 by Alessandra Comini All Rights Reserved.

No part of this book may be reproduced in any form or by any electronic or mechanical means including information storage and retrieval systems without permission in writing from the publisher, except by a reviewer who may quote brief passages in a review.

Sunstone books may be purchased for educational, business, or sales promotional use. For information please write: Special Markets Department, Sunstone Press, P.O. Box 2321, Santa Fe, New Mexico 87504-2321.

Printed on acid-free paper

000

Library of Congress Cataloging-in-Publication Data

Names: Comini, Alessandra, author. | Klimt, Gustav, 1862-1918. Title: Gustav Klimt / by Alessandra Comini. Description: Santa Fe: Sunstone Press, 2017. | Includes bibliographical references and index. Identifiers: LCCN 2016057587 | ISBN 9781632931689 (softcover : alk. paper)

Subjects: LCSH: Klimt, Gustav, 1862-1918--Themes, motives. Classification: LCC ND511.5.K55 C65 2017 | DDC 759.36--dc23 LC record available at https://lccn.loc.gov/2016057587

SUNSTONE PRESS IS COMMITTED TO MINIMIZING OUR ENVIRONMENTAL IMPACT ON THE PLANET. THE PAPER USED IN THIS BOOK IS FROM RESPONSIBLY MANAGED FORESTS. OUR PRINTER HAS RECEIVED CHAIN OF CUSTODY (GOC) CERTIFICATION FROM: THE FOREST STEWARDSHIP COUNCIL® (FSC®), PROGRAMME FOR THE ENDORSEMENT OF FOREST CERTIFICATION® (PEFC®), AND THE SUSTAINABLE FORESTRY INITIATIVE® (SFI®). THE FSC® COUNCIL IS A NON-PROFIT ORGANIZATION, PROMOTION THE ENVIRONMENTALLY SOPROPRIATE, SOCIALLY BENEFICIAL AND ECONOMICALLY VIABLE MANAGEMENT OF THE WORLD'S FORESTS. FSC® CERTIFICATION IS RECOGNIZED INTERNATIONALLY AS A RIGOROUS ENVIRONMENTAL AND SOCIAL STANDARD FOR RESPONSIBLE FOREST MANAGEMENT.

WWW.SUNSTONEPRESS.COM

SUNSTONE PRESS / POST OFFICE BOX 2321 / SANTA FE, NM 87504-2321 /USA (505) 988-4418 / ORDERS ONLY (800) 243-5644 / FAX (505) 988-1025

For Felizitas Schreier,
Formidable fighter for Klimt and dear friend.

Praise for Gustav Klimt:

"When I first read Alessandra Comini's *Gustav Klimt* years ago I was astounded by the American author's keen knowledge and deep insights. Everything in her book still holds true today and she laid the foundation for many subsequent Klimt publications and exhibitions. The name Gustav Klimt is now known throughout the world. It is appropriate therefore that the author has chosen to publish this thirteenth edition. The book, with its far-ranging new Preface, will be valuable for scholars and Klimt lovers alike and an essential item for museums and libraries."

—Dr. Felizitas Schreier, President, Verein Gedenkstätte Gustav Klimt, Vienna

"Highly readable, impeccable in its scholarship, and pioneering in its interpretations, Alessandra Comini's *Gustav Klimt* has been an invaluable introduction to the Austrian artist for over thirty years. More than any other author, Comini has shaped our perception of Klimt and his place in Vienna's cultural life around 1900. This new edition comes to us with an intriguing Preface. It considers the remarkable popularity and record-breaking prices the artist's works now command, as well as what the pervasive presence of Klimt reproductions may tell us about ourselves. Comini's informative study continues to guide us today as we savor the rich, sumptuous world that Gustav Klimt's gold-laced portraits, his contemplative landscapes, his uninhibited nudes and his philosophical allegories offer us."

—Reinhold Heller, Professor of Art History and of Germanic Studies emeritus, The University of Chicago

"Art historian Alessandra Comini brings great scholarly passion and imaginative sympathy to her work on Gustav Klimt and the Viennese culture that formed him. Her groundbreaking research has illuminated the life and work of some of the twentieth century's most compelling artists as well as composers. She is a superb and engaging teacher, and we are all her students."

—Renée Price, Director, Neue Galerie New York, Museum for German and Austrian Art

Contents

Preface to this Edition / i
Introduction / 5
Notes / 29
List of Plates / 30
The Plates / 32

Preface to this Edition

he legendary New York publisher George Braziller asked me in 1974—after hearing a lecture of mine on things Viennese at the Guggenheim Museum—if I would care to write a book about Gustav Klimt. Up to then, as an assistant professor of art history at Columbia University, I had published only two books, both on Egon Schiele, the same rebellious Viennese artist who was mentored by Klimt. One slim volume concerned the painter's tortured time and his drawings made in prison, Schiele in Prison (1973, 2016). The other, Egon Schiele's Portraits (1974, 2014), was a heavy tome with 340 illustrations, 517 chatty footnotes, and a dedication page honoring the editing and photographic contributions of my American mother and Italian father. And I am happy to say it was nominated for a National Book Award. One of the results of my early research on Schiele, beginning in 1963, is that it brought me to people who still had fascinating memories not only of Schiele but also of Klimt.

I still vividly recall the dramatic relish with which, over half a century ago, Schiele's older sister Melanie told me the story of her seventeen-year-old brother's first encounter with Vienna's most famous Gustav Klimt. Irritated by the old-fashioned teaching methods of his Vienna Academy professors, Schiele impetuously assembled a portfolio of his own drawings and presented himself at Klimt's Josefstädter Strasse 21 studio. There he thrust the folio into Klimt's hands and tersely asked: "Hab ich Talent?" ("Do I have talent?"). Klimt—twenty-eight years his senior—looked through the drawings without saying a word, then answered emphatically: "VIEL zu viel." ("MUCH too much!")

And so it was early in my research when I realized that to know about Schiele and his Expressionist generation I must also find out about Klimt and his generation's Art Nouveau emphasis on beauty and the façade. It was Klimt's alluringly voluptuous subjects with their suggestive, symbolic ornamentation and shimmering veneers that younger Austrian artists such as Richard Gerstl, Oskar Kokoschka, and Schiele would reject. For the young Expressionists it became imperative to penetrate the beauteous façade in order to expose the psyche, even if the underlying "truth" was ugly.

But at the very same time, in the Vienna of Sigmund Freud, Klimt was methodically *masking* explicit sexual detail in symbolic and cumulative ornament. Decoration became content. The painter was reversing the physician's revelations of the repressed libidinous content of dream imagery. Instead, with his ubiquitous awareness of gender and biology, Klimt offered up sensuous pulsations of subliminal forms that signaled to him the manifest content of a latent world force—Eros. Mesmerizing sensualism versus shocking, in-your-face sexuality. Perhaps it is just this difference that accounts for the greater popularity of Klimt over Schiele with the general public in both Europe and America.

The ever-rising barometer of Internet references on Klimt-2,470,000 as of this writing-confirms that more exhibitions, auctions (Klimt produced possibly 6,000 drawings, initially on heavy buff wrapping paper, and from 1903 on, simile Japan paper), catalogue kitsch, calendars, postcards, fashion responses, films, documentaries, books, essays, and newsprint articles have been devoted to Klimt than to Schiele. For instance, this book on Klimt, first published in 1975 with simultaneous editions in French, German, and Dutch, went through twelve printings by 2002, whereas my companion volume on Schiele published by Braziller a year later, in 1976, with translations into Italian, French, German, and Dutch, saw only three later editions, until 2016. Klimt's international reputation and far longer life span (1862-1918), as compared to that of Schiele (1890-1918), have also figured as factors.

Nevertheless, both artists assumed central stage for me when I began archival research in Vienna during the summer of 1963. (As a student at the University I had lived in the city before, right after graduation from Barnard College, but it was the real-life, day-to-day drama of the Hungarian Revolution of 1956 that filled my thoughts then, not deceased artists.) My very first discovery concerned Klimt. While paging through old permission-to-copy records at the Kunsthistorisches Museum to see whether Schiele might have copied a famous work of art, I suddenly came across a familiar name and a flowing signature. I learned that on 3 June 1885, a young Gustav Klimt, living at Sandwirtgasse 8, had applied

for permission to copy Titian's glamorous 1536 oil portrait of Isabella d'Este. This was a precious piece of information I was able to pass on right away to my knowledgeable friend, Christian Nebehay, the rare book and art dealer whose renowned Antiquariat shop on Vienna's narrow Annagasse was just a few blocks distant. Christian's father had been the dealer for Klimt's art, and now Christian had begun work on what would become the copiously illustrated Klimt Dokumentation of 1969—still today, many decades later, the absolute Bible of Klimt data. I was privileged to read each chapter in the making and thus absorbed a great deal about Klimt's forerunners and contemporaries in the art world.

One of Klimt's sitters, who since 1934 had lived in New York, but was visiting in Vienna during the early fall of 1963, was Friedericke Maria Beer-Monti. Her life-size portraits had been painted by both Schiele and Klimt (Figure 19 in the Introduction, Plate 13). And the portraits were executed "in that order," as she emphasized to me when I first visited her, according to my diary, on 23 August 1963 in the large downtown apartment at Krugerstrasse 3/8, which her family had owned since 1904. Daughter of a wealthy proprietor of two fashionable nightclubs, educated in Belgium and England, and recently returned from a trip around the world, she belonged to Vienna's young Jewish intelligentsia. As an enthusiastic collector of Wiener Werkstätte (Vienna Workshop) products, she loved to dress in the hand-printed fabrics designed by its fashion department. Proudly she told me: "In those days I was so wild about the Wiener Werkstätte that every single stitch of clothing I owned was designed by them. I was really a walking advertisement for the Wiener Werkstätte!" When I asked this spunky septuagenarian what she was doing at the time of her portrayals by Schiele and Klimt, she answered spiritedly: "What was I doing? Nothing! Just living—going to the theater, to art exhibitions, to the opera." Concerning her pilgrimage out to Klimt's studio on the Feldmühlgasse near Schönbrunn Palace in order to ask him to portray her, Fritzi (as she asked me to call her) reminisced:

When I went out to Klimt's garden house in Hietzing I was really prepared for anything, because I knew how eccentric he was with that beard and always going about in a sort of monk's robe and sandals. But when he opened the door to me I wasn't prepared for one thing! He wore a big monocle in one eye and looked at me sedately up and down without saying anything! That was rather unsettling. Finally he said to me: "What do you

want to come to me for? You have just had your portrait done by a very good painter." I was afraid he was going to turn me down and so I answered quickly that yes, this was certainly true, but that through Klimt I wanted to be made immortal, and he accepted that.

Little could Fritzi or the artist have known that the "immortal" portrayal would, many decades later, almost perish in a winter storm. She had lent her Klimt portrait to a London gallery exhibition, and upon its return by air to New York, a TWA strike at Kennedy International marooned the painting in its large crate outdoors on an airport tarmac during two weeks of rain and snow. "The oil slid right off the canvas," Fritzi exclaimed after she saw the damaged work. Then she moaned: "I thought I would be immortalized by Klimt; now his portrait of me is in ruins!" Fortunately, an excellent restoration job returned the picture to its former glory and it is now in the Tel Aviv Museum of Art. Klimt's price for the finished portrait in 1916 had been the equivalent of \$7,000, an enormous sum for the time.

Frau Fritzi passed away in Honolulu in 1980, but she would have been pleased to know that during the two-hundred-and-fiftieth anniversary of Mozart's birth celebrated in Vienna in 2006, Gustav won out over Amadeus. Despite the citywide festooning of Mozart imagery from candy to cars, Klimt icons maintained their ubiquitous hold on the metropolis. (Although even in his native city, Klimt's name could occasionally be seen misspelled as "Klimpt.") Actually, during the artist's lifetime, the titles of some of his paintings got mangled or peremptorily changed. This was the case with a 1912 issue of the noted German periodical Die Kunst in which the artist's presentation of Judith as blissful beheader of Holofernes (Plate 23) was identified as Salome. But at least the artist did not live to see reproductions of his works reversed, as is not infrequently the case in today's world of irresponsible Klimt Kitsch.

So universal is admiration for Klimt's gold-studded painting *The Kiss* (Plate 30, 1907–08) that it has been turned into little seven-pound porcelain replicas (inadvertently recalling its indebtedness to Rodin's earlier sculpture *The Kiss*). It has been advertised by Ancient Treasures in *Home & Garden* as "The Kiss Grande" with the scolding notation: "These are not some cheap department store item." No, certainly not (the original price is \$187.20), especially if one reads the accompanying description of Klimt's work: "His Jugendstil style [a little repetition here, since "stil" means "style"] evokes an irresistible feeling which is

inspired by the 'fin-de-siècle' of nineteenth-century Vienna: elitist, liberal-middle-class, decadent, pleasantly-decorative." Klimt's iconic canvas *The Kiss* has become so representative of Austria that a detail from it was selected as the main motif for numismatic acquisition. This was the 100 euro gold coin issued on 5 November 2003.

Every year the cyber world has a field day a few weeks before Valentine's Day with exhortations to send a reproduction of "Klimt's timeless vision of romance to show your loved one just how very much they mean to you." Another impressive Klimt painting, the frank but tender 1905 allegory Three Ages of Woman (Three Ages of Life), Plate 26, has spawned yet a further statuette. It is advertised on the Internet as Three Ages of Woman in spite of the fact that only two of the three nude figures in the painting are shown (and shown in reverse!)—the nude mother and child. The despairing naked old woman of the original is not admitted to this dreamy ensemble of two. In the year 2000, for the luxurious exhibition catalogue accompanying the Belvedere Museum exhibition, Klimt und die Frauen (published in English as Klimt and Women in 2001), I had the iconographical pleasure of putting into cultural context the three figures of Klimt's poignant allegory. Perhaps this is why I have placed the double-figured statuette on my "Crimes Against Klimt" list.

Dating from 2007, a photographer named Merisi has gallantly offered an undulating "Klimt Rose" to the Klimtloving cyber public. The photograph was taken at a "garden gate near Gustav Klimt's last atelier." This location citation brings up the attempts to preserve as a museum the secluded studio and garden at Feldmühlgasse 11 in Hietzing that Klimt rented and worked in from 1912 until his death in 1918. After rediscovery of this previously forgotten atelier—over which a second story in pseudo Baroque style had been built in 1923—the Verein Gedenkstätte Gustav Klimt (Gustav Klimt Memorial Society), headed by an indefatigable Dr. Felizitas Schreier, was founded in 1999 with the specific goal of turning the original ground floor rooms and wild garden outside into a historical monument. The house's floor plan had scarcely changed since Klimt's time. Two photographs by Moritz Nähr taken in 1918 of the studio layout have been preserved. Using them as a guides, the Society installed an exhibition with color reproductions of the two major works abandoned on Klimt's easels (Figure 1 in the Introduction) when the artist suffered the stroke that hospitalized him a few weeks before his death from pneumonia on 6 February 1918. Recently, the Austrian government ministry responsible for this only

authentic site left of all of Klimt's studio addresses, spent two million euros to renovate the owner's villa which had been built around and over the artist's little garden cottage. Klimt's studio interior on the ground floor is partly reconstructed according to the two Nähr photographs, with Josef Hoffmann-designed furniture and Japanese woodcuts on the wall. The other studio rooms show objects reminiscent of Klimt and his time and a documentation is presented of the artist's correspondence from 1911–1918. The upstairs room of the 1923 villa is used for concerts, lectures, and such social events as wedding receptions. As for the studio, we can watch online Klimt's two paintings magically change from black and white to glowing color at the Klimt Society's attractive *Klimt Atelier* website.

Sometimes, however, there can be too much cyber Klimt. Here is the rationale of an English-language Klimt website that recently announced its termination on line: "The End: No More Mr. Klimt Guy. The Klimt page is down for good. I don't have the time to update the pages anymore [and] 90% of those who ask about the posters and 30% overall, spell Gustav 'Gustave' and Klimt 'Klimpt' even if the correct spelling is plastered all over the site."

We have run into this spelling problem before, and perhaps this is the place to mention an amusing fact that surfaced with the 1997 publication of the early diaries (1898–1902) of Alma Maria Schindler (soon to become Alma Mahler, then Alma Mahler-Gropius, then Alma Mahler-Gropius-Werfel). During the first three months of her escalating flirtatious "affair" (her word) with Klimt, who eagerly followed her and her family to Italy, she too spelled his name "Klimpt" in her diary entries. (She later deleted the plosive "p.") Figure 20 in the Introduction of this book is the photograph "with the bear" Klimt asked for, received, then had to return at Alma's guilt-ridden request, then finally retrieved again.

In 2005, the same year as the Neue Galerie Museum's definitive exhibition of Klimt, Vienna's Klimt Society published a little gem of a book that highlighted the May 1913 visit of a young Japanese artist, Kijiro Ohta (1883–1951) to Klimt at the artist's Hietzing studio—the same studio in which Fräulein Fritzi Beer-Monti would pose for her portrait three years later. We get an idea of Alma's "sensuous" Klimt from Ohta's comment that the artist seemed so dignified he could in no way believe the story of "love bites" from Klimt that one of the artist's models reputedly showed off to fellow models. Despite this disconnect, the discerning Japanese visitor noticed that his host was wearing a kimono-like gown (Klimt's famous blue

linen smock) and that he wore "neither a belt nor socks and apparently no underwear." (See photograph opposite title page of this book and Figure 3 in the Introduction.) This sartorial observation is the same as that of Fritzi Beer-Monti, who declared: "what Klimt had on underneath that blue robe, I did not know." She also remarked vehemently: "He was actually 'animalisch'; he even smelled like an animal! One could really be afraid of him, and I felt that he did not study me at all with the shy aloofness that Schiele had." Fritzi's remarks to me over the years in Vienna, New York, and Honolulu, where I last visited her on 3 August 1970, are all given in the text and footnotes of my Egon Schiele's Portraits. (Quotations of Fritzi's observations have accelerated in a spate of recent publications on Klimt and Schiele, but few brake long enough to acknowledge the source.)

Kijiro Ohta also reported that Klimt graciously showed him not only the work-in-progress in his atelier but also, in the room next to it, his prized trove of Japanese and Chinese gowns (see Figure 4 in the Introduction for a photograph of Klimt's collection of Japanese color woodcuts and Chinese scrolls). Ohta commented (dryly or proudly?) that Klimt apparently derived the strange patterns in his pictures from these gowns. This is a not unexpected confirmation of the hold Japonisme had on many artists of the time, and especially on Klimt. Significantly, a reproduction of his *The Kiss* shares with a colorful Japanese print the cover of a massive study (over 1,000 illustrations) by Siegfried Wichmann published in 1980 titled *Japonismus: Ostasien und Europa* and issued in English the following year (Figure 3 in the Introduction).

Ohta ended his description of Klimt's studio with the cautious conclusion that he did not think Klimt was married ("Ich glaube, der Professor ist nicht verheiratet"). It is quite true that Klimt remained unmarried, but he managed to father several children by different women—a situation that led to interesting legal complications after his death (and which figured in my first art history murder mystery, *Killing for Klimt*, of 2014).

Woman to Klimt represented universal regeneration as well as the sexual imperative. So central to the artist's vision was the subject of woman, whether in portraiture or allegory, that in 1989 the author Gottfried Fliedl devoted an extensive study to the theme in *Die Welt in weiblicher Gestalt (The World in Female Form*, translated into English 1998). And Klimt popularizer Susanna Partsch's book, *Gustav Klimt: Maler der Frauen (Gustav Klimt: Painter of Women)* of 1994, has seen several later editions in

both German and English. Wolfgang Fischer, formerly connected with two fine art galleries in London, took upon himself the task of elucidating the relationship between Klimt and the (platonic?) anchor of his life, the fashion designer Emilie Flöge (Figure 3 in the Introduction, Plate 5). Fischer's 1987 conscientious exploration *Gustav Klimt und Emilie Flöge* saw its English translation in 1992 under the title *Gustav Klimt and Emilie Flöge: An Artist and His Muse.* In his 1987 publication, *Gustav Klimt Egon Schiele und die Familie Lederer*, Christian Nebehay focused documentary attention on Klimt's portraits of the Lederer women, Serena Lederer (1899, Plate 4), her daughter Elisabeth (1914, Plate 12), and Serena's mother, Charlotte Pulitzer (1915)—of the Pulitzer Prize family.

More recently, attention has focused upon single individuals portrayed by Klimt, as with the young girl Mäda Primavesi (Plates 11 and 69). A copiously documented account of her family's relationship with the Wiener Werkstätte, Josef Hoffmann, and Gustav Klimt was published eponymously by Claudia Klein-Primavesi in 2006. And modern scholarship has not neglected the prominent art critic, loyal supporter, and good friend to Klimt, Berta Szeps-Zuckerkandl. Her rich life has been treated by Michael Schulte in his interesting 2006 volume, Berta Zuckerkandl: Salonière, Journalistin, Geheimdiplomatin (Berta Zuckerkandl: Salonist, Journalist, Secret Diplomat). Berta's husband, Emil Zuckerkandl, famed professor of anatomy at the Vienna Medical School, was also an avid champion of Klimt. His lectures on "art forms and nature," which the artist attended with sketchbook in hand, revealed the world of cytogenetics to Klimt, inspiring rich morphological results in his decorative fills not only in allegories and portraits, but also in his landscapes (Plates 39 and 43).

Part of the challenge of investigating Klimt in the early 1960s was locating the various sites around Austria captured in the artist's pulsating, mosaic-like landscapes. Emulating Klimt (Figure 48 in the Introduction), it was only by rowboat that I managed to photograph from just the right distance (Figure 54 in the Introduction) the island in the Attersee that dominates the top of Klimt's waterlogged portrayal of the same (Plate 37). And the same holds true for the village church with bulging bell tower (Figure 55 in the Introduction) dominating Klimt's *Church at Unterach on the Attersee* (Plate 48). The art historian Johannes Dobai (who left Hungary for Austria during the revolution of 1956), devotedly assembled a detailed oeuvre catalogue of all Klimt works (published in German, 1967, in English, 1968), and later (1981) produced a lavishly

illustrated volume devoted solely to Klimt's landscapes. Jane Kallir, co-director of New York's renowned Galerie St. Etienne, where works by Klimt have been shown over seven decades, has cogently analyzed all three subject categories—allegories, portraits, landscapes—in her 1989 book *Gustav Klimt: 25 Masterworks*.

Klimt's mesmerizing *Beethoven Frieze* allegory (Figures 35, 37, and 40 in the Introduction; and Plate 57) for the 1902 Secession exhibition of Max Klinger's life-size polychromatic statue of Beethoven enthroned was the stimulus that inspired me to embark on an iconographical pursuit of the composer's mythopoesis from bungling recluse to cultural tone hero. The result, ten years in the writing, is an abundantly illustrated monograph *The Changing Image of Beethoven, A Study in Mythmaking* (1987, 2008.)

In August of 1974 I first encountered (under cellophane wrap) and photographed Klimt's seven-part Beethoven Frieze (casein colors on stucco with gold and semiprecious stone inlay) in a storeroom of the Österreichische Galerie, Belvedere, where it was undergoing a lengthy restoration. At least it was valued for what it had been and would be again. Klinger's Beethoven monument had not enjoyed the same respect. I first saw it by flashlight in an unlit basement room of Leipzig's old art museum, where the prevailing Communist regime had banished it as useless colossal kitsch. Thanks to conductor Kurt Masur's efforts, Klinger's Beethoven was installed in the small foyer of the Leipzig Gewandhaus in 1981 and, at the end of 2004, it was transferred to Leipzig's brand new Museum of Fine Arts. The concluding chapter of my Beethoven book is devoted to the Klimt/Klinger collaboration: "Vienna's Beethoven of 1902: Apotheosis and Redemption." In the meantime, Marian Bisanz-Prakken's important and extensively illustrated study of the frieze, with all the preparatory drawings, was released in 1977. And in Vienna's 1985 spectacular exhibition Traum und Wirklichkeit (Dream and Reality) Klimt lovers could at last admire the newly restored frieze in temporary installation at the Künstlerhaus before reaching its triumphant final destination the following year. This was in a large, long, specially designed basement room of the Secession museum—the very building in which Klimt had originally exhibited his Beethoven Frieze in 1902. At the lavish private opening of this multimedia show Gustav Mahler conducted the closing chorus from the final movement of the Ninth Symphony, rescored by him for wind and brass only. It was an apotheosis of the sculptor as well as of the composer, and Alma Mahler reported that

tears ran down Klinger's cheeks as the music of Beethoven sounded over his head.

Most interpretations of the Beethoven Frieze (including my own) stress the connection between Schiller's words and the Gesamtkunstwerk (total work of art) aspect of Beethoven's Ninth Symphony, with its choral intoning of the Ode, To Joy in the fourth movement. But a well-argued case—if not completely convincing—has been made by Clare A. P. Willsdon for a grounding in Goethe in her 1996 article "Klimt's Beethoven Frieze: Goethe, Tempelkunst and the Fulfillment of Wishes" in Art History. For those who cannot travel to Vienna to worship in the temple of Beethoven/Klimt, an attractive small volume, edited by Susanne Koppensteiner, and rich with illustrations and pithy essays was published in 2002. British fans of Klimt had a unique chance to admire an exact, full-size replica of the Beethoven Frieze at the Tate Liverpool exhibition of 30 May to 31 August 2008. The show was titled "Gustav Klimt: Painting, Design and Modern Life in Vienna 1900." The Kiss and several key allegories did not travel to this very popular exhibition, although the 111-foot-long, gleaming Beethoven mural with its studded gems and embossed gold foil more than made up for any omissions.

I have mentioned that Klinger's Beethoven Monument was removed from public view during the Communist regime in East Germany. A more recent indictment, reported in the 3 February 1994 edition of the The New York Times, occurred in Egypt with the denunciation of the Minister of Culture by a fundamentalist member of Parliament for having published a reproduction of Klimt's "nude, pornographic" Adam and Eve (Plate 34). Although the artist's unfinished canvas of 1917-18 shows frontal female nudity, far more provocative images of female nudes by Klimt exist for public consumption. A recent example is Prestel Publishing's 2005 edition of Erotic Sketches by Gustav Klimt—part of a continuing series of "erotic sketchbooks" that includes Rembrandt, Picasso, and Schiele. Klimt himself supervised the photogravure facsimile reproduction of some of his female nude studies, and he contributed fifteen (increasingly erotic) collotype illustrations to Franz Blei's 1907 translation of Lucian, Die Hetärensprächen des Lukian (The Courtesans' Dialogues of Lucian).

The history of Klimt exhibitions and Klimt museum acquisitions, both during the artist's life and posthumously, is long and impressive. Mention of a few is merited. Two examples testify to the artist's standing during his lifetime: for instance, during the 1908 Kunstschau in Vienna, before

the exhibition even closed, Klimt's The Kiss was acquired for the collection now displayed in the Belvedere Museum. And Klimt's second version of the seductive slayer of Holofernes, Judith II of the following year, was already in the collection of the venerable Galleria Internazionale d'Arte Moderna (the Ca' Pesaro) in Venice by 1910. In New York, the first one-man show for Klimt in America was mounted in 1959 by the redoubtable Galerie St. Etienne, thanks to the keen eye, passion, and ability of its Austrian founder, Otto Kallir. A modest exhibition entitled Viennese Expressionism: 1910-1924, organized by Herschel Chipp in 1963 for the University of California at Berkeley, not only demonstrated California collectors' lead in appreciating Klimt, but also provided a turning point in the life of one beginning graduate student—me. It was at this small campus exhibition in northern California that I became an instant convert to early twentieth-century Austrian art. I knew straight away that from now on my life would center on Klimt and Schiele. Now it made sense that I had already lived in their city! Now I could associate the metropolis not with the wrenching displacement of Hungarians fleeing their Communist homeland, but with the music of Vienna that I already knew and cherished. In the "memoir of your art history adventures" that the ever-persuasive George Braziller urged me to write shortly before 9/11/2001, I have recounted the making of an art historian which followed that Berkeley epiphany—a joyous career with lifelong links to Klimt and Schiele (In Passionate Pursuit: A Memoir, 2004, New Edition, 2016; Killing for Klimt, 2014; The Schiele Slaughters, 2015).

In 1965, Thomas Messer, soft-spoken director of the Solomon R. Guggenheim Museum, assembled a full-fledged showing of major works by both Klimt and Schiele—works which glowed like jewels as they lined the curving walls of Frank Lloyd Wright's "snail" building. I had been asked to help in securing some of the European loans and to contribute an essay for the catalogue. A stone's throw away on Fifth Avenue, the Serge Sabarsky Gallery began, from 1969 onward, to feature Klimt. And in 1981 Sabarsky curated at the Isete Museum of Art in Tokyo the first showing of Klimt works to be seen in Japan. (Kijiro Ohta, who died in 1951, would have been justly proud.)

New York's Museum of Modern Art gave its prestigious imprimatur to Klimt and Viennese art in 1986 with a large and ambitious overview titled *Vienna 1900—Art*, *Architecture and Design*, curated by Kirk Varnedoe. That same year, 1986, a second milestone in the increasing

recognition of Klimt took place at Paris's Centre Pompidou under the direction of Jean Clair: Vienne 1880–1938: L'Apocalypse Joyeuse. The 1990s saw the Belvedere lending Klimt canvases to important exhibitions in Zurich (1992), Tokyo (1996), and Milan (1999). With the coming of the new century the Belvedere gathered its magnificent stable of Klimts, borrowed others, and under the guidance of Tobias G. Natter and Gerbert Frodl staged a blockbuster exhibition to celebrate the millennium. This was the already alluded to Klimt und die Frauen, which ran from September 2000 to January 2001.

One year into the 21st century, Dr. Rudolf Leopold, an avid collector of Austrian art since the 1950s, and of Klimt and Schiele in particular, saw his life ambition realized when the city of Vienna constructed a permanent, four-story home for his vast art collection of some 5000 items—the Leopold Museum. A strikingly austere building, sheathed in white limestone and built in the heart of the Museum Quarter, it has become Vienna's most heavily visited museum. One entire room is devoted to Klimt while three rooms display Leopold's favorite, Schiele. During the 1960s I twice visited this art-loving ophthalmologist with an acquiring eye, and was given a personal tour of the artworks crowding the walls of his spacious house out in Grinzing at Cobenzlgasse 16. After the second visit, I was invited to stay for a dinner of gefüllte Paprikaschoten (stuffed peppers—the same menu offered to Gustav Mahler when he began his courtship of Alma) and was sent home at ten o'clock with fresh peaches from Leopold's garden (so reads my diary entry for that day).

Ironically, some would say, one year after the opening of the Leopold Museum, a very different collection of works was presented to the art-loving public. This was a thick, exquisitely researched and detailed "handbook"— Sophie Lillie's Was einmal war: Handbuch der enteigneten Kunstsammlungen Wiens (What Once Was: Handbook of Vienna's Plundered Art Collections). The author had spent seven years handling Jewish restitution claims in Vienna, examining Nazi seizure inventories and complicitous auction house listings where the names of the original Jewish owners were omitted, and the items seized from "Aryanized" dwellings were listed as "voluntary." Lillie's discussion and her listing of 148 confiscated collections (including that of Alma Mahler-Werfel) bring attention to the many expropriated art works that are still missing or have not yet been returned to the original owners or their heirs. Some of these, including works by Klimt and Schiele, are today in "famous Austrian art institutions [including]

the Belvedere ... and the Leopold Museum" (press release of November 21, 2003).

Almost as though on cue after the appearance of Lillie's recriminating book, and after a drawn-out and sometimes dramatic international legal dispute, in January of 2006, the Austrian government ordered the return of five major Klimt paintings stolen by the Nazi regime, then hanging in the Österreichische Galerie Belvedere, to the family of Maria Altmann of Los Angeles. The five works comprised two portraits of Maria Altmann's aunt, Adele Bloch-Bauer (Plates 8 and 10) and three large landscapes. The victorious American lawyer for the case, who worked on a "no-win, no-fee" basis, was none other than the grandson of the Viennese composer Arnold Schoenberg, E. Randol Schoenberg. A special exhibition of the paintings was quickly arranged by the Los Angeles County Museum of Art under the title Five Paintings from the Collection of Ferdinand and Adele Bloch-Bauer and ran from April to June of 2006. I had the honor of lecturing for the museum during the exhibition, and at a book signing event afterwards, was pleasantly surprised to meet the very modest Randol Schoenberg.

And then, on 19 June of that same year, 2006, the BBC broadcasted and the New York Times printed the startling news that Ronald Lauder had acquired the earlier, gold-flecked portrait of Adele Bloch-Bauer for the Neue Galerie for German and Austrian Art in Manhattan, doling out "the highest sum ever paid for a painting"-\$135 million. I was on a flight from Warsaw to Copenhagen that day and happened to spot a reproduction of the Adele Bloch-Bauer portrait (Plate 8) on the front page of a newspaper being read by someone sitting three aisles ahead of me. Ripping off my seat belt, I dashed up the aisle and implored the astonished reader to lend me the paper. It was true! The golden "Byzantine" (Alma Mahler's designation) Adele was coming to America. Soon eye-catching color posters in Vienna blazoned forth her image with the message "CIAO ADELE."

But Adele, rather both Adeles, had found a new home in the New World and they, along with the three restituted landscapes, became the centerpiece of an extraordinary exhibition on view at the Neue Galerie from 13 July to 9 October, 2006. That showing was put together by Renée Price, adroit director of the stylish new museum. (Later the four other Klimt paintings were auctioned at Christie's for extremely lucrative prices.)

Riding the crest of the new public interest in Klimt, the Neue Galerie soon organized an exhibition

of its complete Klimt holdings—8 paintings and 120 drawings— that ran from October 2007 to June 2008. The show filled all its gallery space and, in addition, one large gallery room was devoted to a full color reproduction of scenes from Klimt's extraordinary *Beethoven Frieze*. Yet another room was fitted out as a convincing replica of the large anteroom to Klimt's Josefstädter Strasse 21 studio. The exhibition's accompanying seven-pound, sumptuously illustrated catalogue, printed in the elegant style that has become synonymous with the museum, is entitled: *Gustav Klimt: The Ronald S. Lauder and Serge Sabarsky Collections*. My contribution was an essay on "The Two Gustavs: Klimt, Mahler, and Vienna's Golden Decade, 1897–1907."

In addition, the Neue Galerie took me up on the suggestion that it produce a CD of music pertaining to Klimt, who, we know, had been a great lover of Schubert. Renée Price bounced the prickly ball of pertinence right back into my court when she said she would find the CD production company, but that I should pick the music and write the liner notes. What a stimulating challenge! As soon as I began seriously considering what would be appropriate, the track sequence and selections seemed to suggest themselves to me. The starting point would have to be Schubert. Klimt's 1899 intimate, candlelit depiction of the composer seated at the piano in the company of three young women (Plate 52) had become an Austrian cult icon almost overnight. A pictorial hymn to the art of music, the artist's image parallels Schubert's own inspired setting (1827) of Franz von Schober's poem, An die Musik (Ode To Music). Klimt's portrayal was lauded as having created a uniquely Austrian genius—seen to be gentle and "feminine," as opposed to aggressive, "masculine" German genius. Alma Schindler (not yet Mahler) wrote in her diary, after seeing Klimt's painting at the Secession, that it was "indisputably" the best picture at the exhibition. The painting seemed to send forth the hymn of gratitude expressed in the poem:

> You sublime art, how often in dark hours, When the savage ring of life tightens 'round me, Have you kindled warm love in my heart, Have transported me to a better world!

Often a sigh has escaped from your harp, A sweet, sacred harmony of yours Has opened up the heavens to better times for me. You sublime art, I thank you for that! Du holde Kunst, in wieviel grauen Stunden Wo mich des Lebens wilder Kreis umstrickt, Hast du mein Herz zu warmer Lieb' entzunden. Hast mich in eine bess're Welt entrückt!

Oft hat ein Seufzer, deiner Harf' entflossen, Ein süßer, heiliger Akkord von dir Den Himmel bess'rer Zeiten mir erschlossen. Du holde Kunst, ich danke dir dafür!

The order of composers selected for the CD (produced by Museum Music of New York) proceeded from Schubert to Brahms, Gustav Mahler, Alma Mahler (yes, as a stalwart feminist formed in New York of the 1960s, I was determined to include a woman composer), Johann Strauss II, Franz Lehar, Robert Stolz, Richard Strauss, and, of course, Beethoven. In order to amplify Klimt's identification with Schubert, two tracks of the same Ode to Musik song were chosen, one for male voice, the second for female voice, thereby signifying both Klimt and the women in his life, three of whom stand around Schubert in the painting. A color transparency of Klimt's Schubert at the Piano—which had been destroyed by fire in the final days of World War II—was located and graced the back cover of the CD, while a color reproduction of Klimt's pensive female portrait The Black Feather Hat of 1910 (Plate 9) commandingly adorned the front cover. This choice was especially meaningful to me for I had first encountered and photographed the painting (now in a New York private collection) in the Graz living room of the discerning Austrian collector of Klimt and Schiele, Viktor Fogarassy and his wife Dollie.

During many summers of research in Austria, the Fogarassys and their four young daughters treated me as a member of the family and aided me in countless ways. The parents are gone now, but two of their daughters showed up at a lecture I gave for the Klimt Society in Vienna in the fall of 2006, and again when I spoke at a symposium in honor of my Schiele prison discovery at Neulengbach in 2012. As for the *Klimt Musik* CD, it played softly on endless loop throughout the Neue Galerie rooms during the exhibition, and more than once I heard a guard unconsciously humming along with the music.

It makes perfect sense that a movie should have appeared in 2006—the year of the stunning Bloch-Bauer settlement—concerning not only Klimt but other art works stolen during twelve years of Nazi looting. Poignantly titled *The Rape of Europa* and narrated by the actress Joan

Allen, the film commences and concludes with the saga of the golden Adele Bloch-Bauer portrait. In between this affecting frame of crime and final retribution, the movie visits six other countries, concentrating on the plunder and destruction visited upon each nation. Based on Lynn H. Nicholas's manuscript of the same title (published in 2006), the film was coproduced with Robert M. Edsel, author of the absorbing book on war crimes during World War II, Rescuing Da Vinci (also published in 2006). In November of the very next year a riveting British-made hour-and-a-half long documentary called Stealing Klimt premiered. It chronicled Maria Altmann's early life, escape from Austria, and her determined attempts to recover her family's five Klimts. We are treated to interviews with her (a sprightly ninety-year old) and other principals, including Randol Schoenberg.

Klimt's golden portrait of Maria Altmann's aunt had already made its own film debut in an earlier British movie, *Bad Timing: A Sensual Obsession*, produced in 1980. The Adele Bloch-Bauer portrait, hanging in situ at the Belvedere, serves as erotically embedded backdrop for Art Garfunkel, an American psychology professor who is sexually involved with a suicidal young American woman, played by Theresa Russell.

We are yanked from the sober to the oversexed with yet another 2006 film debut, this one starring John Malkovich in the title role of *Klimt*. One of the opening scenes shows the artist in his favorite smock at work on a large canvas in his studio. For his inspiration, three naked women swing and spin lazily on drapes suspended from the ceiling—thus rivaling and perhaps surpassing the swinging nudes floating over the crowded bordello boat scene in the 1979 Italian (*Penthouse Magazine* financed) *Caligula*. That film was originally scripted by Gore Vidal, but he later sued to disassociate himself from the movie credits. Malkovich should have done the same with the celluloid *Klimt*, but now it is too late.

What else could fans of Klimt do to propagate (or cash in on) his fame? The answer, of course, is a musical. One opened in Vienna's revered Künstlerhaus in 2011: Gustav Klimt—Das Musical and was wildly successful, even if "melodies" from it have not joined the collective consciousness.

The film world redeemed itself, however, in the gripping 2015 movie *Woman in Gold*, starring Helen Mirren as Maria Altmann and Ryan Reynolds as "Randy" Schoenberg.

If all this takes us from the sexual sublime to the

profligate profane, there may be some comfort in the Klimt kitsch inundating magazines and proliferating in cyber space. Offered up for sale are Klimt "paintings" (texturized to look like the real thing on canvas), Klimt posters and prints of all sizes and prices (see bargain department store Target's seductive Klimt webpage), Klimt beer mugs, Klimt coffee cups, Klimt coasters, Klimt candies, Klimt compact mirrors, Klimt key chains, Klimt calendars, Klimt carpets, Klimt refrigerator magnets, Klimt-inspired shoes, and even Klimt bed sheets. At the time of publication of this new preface there are about 2,470,000 web results and links (including YouTube videos) for Gustav Klimt as compared to a mere 786,000 entries for Egon Schiele.

Commercializing Klimt is a continuing and collectable phenomenon. My favorite candidate, culled for my students from a 1973 Midol advertisement for a "feminine hygiene deodorant spray," juxtaposes the ecstatic face of Klimt's Judith I (Plate 23) with that of a cool and in control modern woman, complete with Judith-like neck choker. The self-congratulatory blurb below runs: "If women knew then ... what they know now." Oh, how my classes would shiver and giggle as I read out the whole Midol blurb with increasing suggestiveness. This example and one other gem (a tiny tin of Klimt peppermints) from my Klimt Kleptomania Kollection were reproduced in the Neue Galerie's Gustav Klimt catalogue's intriguing section on "Klimt in the Popular Sphere." As I write this preface it would seem that Klimt has captured Italy: an excited email from a former student included a photograph of expensive porcelain figurines from his Beethoven Frieze.

Klimt kleptomania is not bad when redounding to the artist himself. Responding to my suggestion, a treasured colleague at Southern Methodist University, Karl Kilinski, became the first to trace in detail the many reflections of archaic Greek vase subjects in Klimt's work. These handsome steals were published under the fetching title "Classical Klimtomania" in *Arts Magazine* in 1979 and updated in another issue of 1982. (See also Figures 7 and 8 in the Introduction.)

Klimt and fashion is a very popular category on the Internet (some 4,830,000 results) with multiple links to Byzantine art (Figure 15 in the Introduction) and oriental art—including Japanese stencil techniques. This intriguing subject was richly explored in the Neue Galerie *Klimt* catalogue's "Klimt and Fashion" section and follows Klimt's lead, since he designed clothing for the Wiener Werkstätte as well as for Emilie Flöge (see Figure 11 in the Introduction).

The topic "Klimt and Fashion" is the title of a quixotic offering by Christian Brandstätter in a small illustrated book of 1998. Quixotic because there seems to be absolutely no rationale concerning the cover choice of Schiele's plummeting portrait of Fräulein Fritzi Beer rather than Klimt's portrayal of Fritzi with, as she told me, her "fur jacket turned inside out to show its beautiful Wiener Werkstätte lining" (Figures 18 and 19 in the Introduction, Plate 13). An interesting modern view of Klimt and fashion is proposed in the 2005 book by Radu Stern, *Against Fashion: Clothing as Art*, 1850–1930. Along with Henry van de Velde and Sonia Delaunay, Klimt figures in the author's examination of the desire to reject mercantile fashion by successive avant-garde movements and replace it with a utopian "anti-fashion."

Coffee table books on Klimt are becoming increasingly fashionable (and heavy). Some are so large they are almost coffee tables themselves. Two weighty examples are Alfred Weidinger's slipcased *Gustav Klimt* (Munich, 2007) with a detail from *The Kiss* gracing the cover, and Rachel Barnes' *Gustav Klimt* (London, 2008), a luxury volume with, surprise, surprise, a detail of *Adele Bloch-Bauer I* on its cover. The illustrations are handsome, however, even though the seventeen-and-a-half-inches-tall volumes are most difficult to manage.

A decidedly easier book to handle, instructive and charming to boot, is the 2005 Flotainmet paperback children's book with text by Florian Deutsch and enchanting illustrations by Arantzazu Moral Lasala. One short but informative chapter addresses the fashionable dress designing Flöge sisters (Emilie was not only Klimt's life companion but also his sister-in-law). Another brief chapter is about Klimt's trips, accompanied by a drawing of the artist in his blue smock and carrying a briefcase, walking past the train that has brought him to yet another destination. To my mind this little book, based on actual Klimt images and photographs, is more worthwhile than any historical novel. Following upon this success, a *Gustav Klimt Coloring Book* was offered to children by Pomergranate in 2010.

There is one cinemagraphic scene in John Malkovich's *Klimt* that redeems the film. This takes place in the laboratory of Klimt's scientific friend Emil Zuckerkandl, and shows the artist peering through the professor's microscope, marveling at the world of forms and shapes histology reveals. It was this ability to see, where others only looked, that gave Klimt inspiration for the multitude of "other appearances" that inhabit his work. And it is this quality of *Schein* and *Sein* (appearance and being)

that continues to fascinate art lovers of the twenty-first century, because each time we look at a Klimt painting there is more to see.

One recent fine morning in October, I had received permission from the Museum of Modern Art in New York to photograph and be photographed with the institution's two major Klimt canvases: the riveting allegory *Hope II* and the luxuriantly dappled *Park*, with its tesserae-like articulation. As I stood reverently between the two paintings waiting for my companion to take (without flash, of course) a quick shot of the ensemble, a museum visitor began to bawl us out for photographing inside MoMA. A guard intervened, saying we had permission. The complainant—his righteous indignation now fanned—then turned to me and pronounced loudly with palpable scorn: "Oh! You must be a TEACH-er!"

I gladly accepted the charge, taking comfort in the fact that I have, in printed word and spoken deed, had the honor of passing on Gustav Klimt's legacy to a host of readers and to two generations of students in New York and Texas.

—Alessandra Comini Dallas, 2017

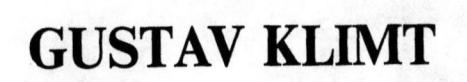

Alessandra Comini

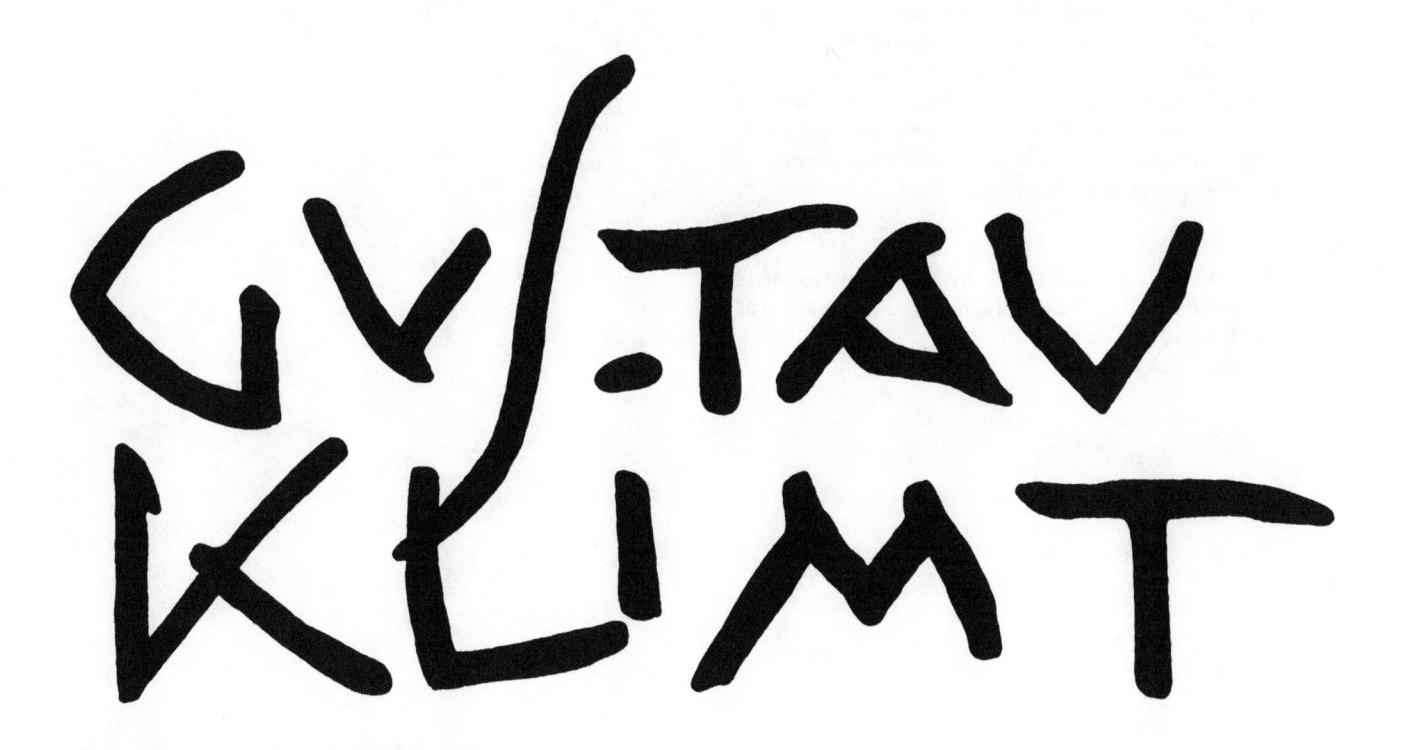

Acknowledgments

Innumerable thanks are due to Galerie Welz, Salzburg. In addition I am grateful to the following private collectors for their aid—immediate and generous—in providing reproductions of their works: Dr. Otto Kallir, New York; Viktor Fogarassy, Graz; and Erich Lederer, Geneva.

No scholar can deal with Klimt without incurring a tremendous debt to two vast and authoritative works on the artist: Johannes Dobai's oeuvre catalogue *Gustav Klimt* of 1967 (with an introduction by Fritz Novotny) and Christian M. Nebehay's comprehensive *Klimt Dokumentation* of 1969. The "D." numbers appearing in the text and notes refer to the Dobai catalogue raisonné numbering.

The readability of the text is due to the combined alertness of Julianne J. deVere in New York and the relentless editing of Megan Laird Comini in Dallas.

Frontispiece: Gustav Klimt in the garden of his Josefstädterstrasse studio, c. 1910 (photograph by M. Nähr, Vienna)

INTRODUCTION

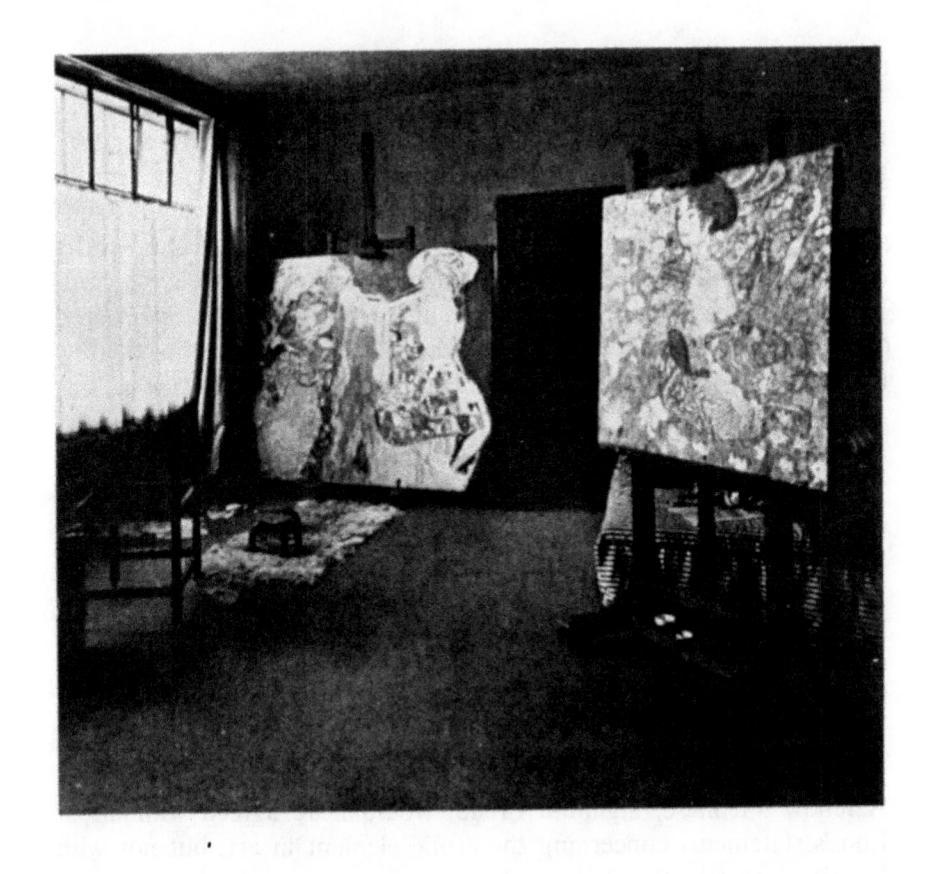

 Photograph of Klimt's Hietzing studio at the time of his death, February 1918. (From E. Pirchan, Gustav Klimt, Vienna, 1956)

On a chilly thirteenth of January in the year 1918, in Vienna, burglars broke into a painter's studio while its owner was away and helped themselves to its contents. One thing they did not take, but at sight of which they must have paused in amazement, was a large, unfinished canvas on an easel next to the studio windows (Fig. 1). For here, even to the uninitiated, was an extraordinary revelation of what might be called a "dirty old-master" technique. In opposition to the floating knot of figures covering the left side of the canvas, the splayed-out nude body of young girl dominated the other half. Her face was averted in a profile turn to the right, and a mufflerlike wrap at the throat seemed to separate the head from its glimmering white torso, creating a startling effect of mutilation (Fig. 2 and Pl. 35). The knees were bent and the legs spread apart to expose a carefully detailed pubic area upon which the artist had leisurely begun to paint an overlay

"dress" of suggestive and symbolic ornamental shapes.

The painting was called *The Bride*, and the absent owner of the studio was Gustav Klimt, who two days before had been felled by a stroke as he was dressing for his morning stroll to the Tivoli gardens for breakfast. Paralyzed on his right side, he was hospitalized and kept alive for a few weeks, but pneumonia set in and he died on the sixth day of February at the age of fifty-five. The unfinished painting, by the mere fact that it was unfinished, contained the clue to the erotic premise of Klimt's great allegories involving female figures. The unknown ransackers of the studio had, sheerly by accident, caught

2. Klimt, detail from unfinished painting, *The Bride*, 1917–18.

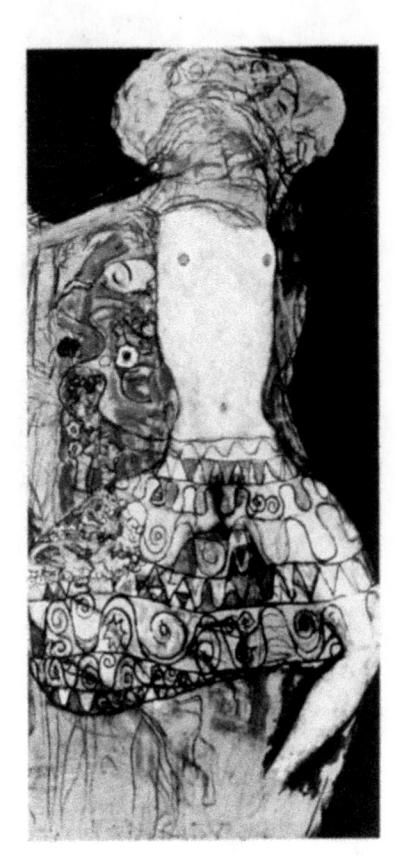

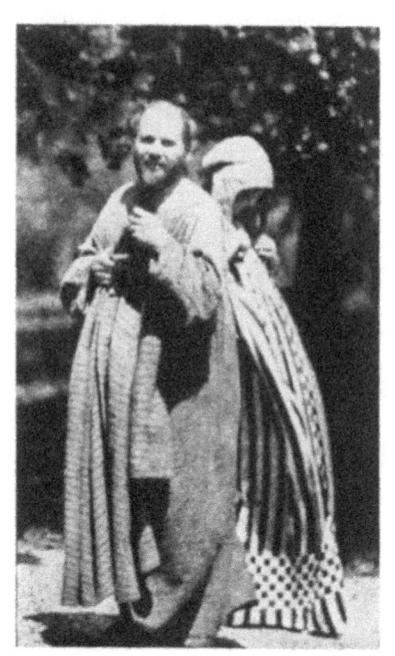

 Klimt and Emilie Flöge in the garden of the Josefstädterstrasse studio, c. 1905–10. (Photograph, M. Nähr, Vienna)

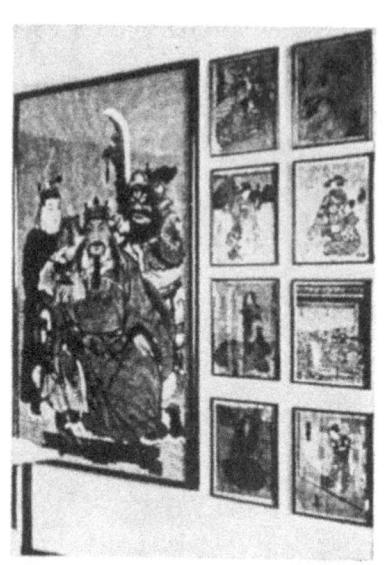

 Klimt's collection of Japanese color woodcuts and Chinese scrolls as installed in the foyer of his last studio in Hietzing, 1914–18. (Photograph, M. Nähr, Vienna)

the artist in the secret and revelatory act of flagrant voyeurism.

Such confirmation of the sexual implications of Klimt's decorative overlay surprised few of his contemporaries. As early as 1908 the outspoken Viennese architect and defender of a new, proto-Expressionist severity in art, Adolf Loos, had publicly accused Klimt and the artists of the Wiener Werkstätte—Vienna's arts-and-crafts center—of erotic pollution. In a speech intending to shock the complacent bourgeoisie, and published under the title *Ornament and Crime*, Loos discussed what he considered the erotic origin as well as the outdated "plague of ornament" besetting Austrian art:

All art is erotic.

The first ornament that was born, the cross, was of erotic origin. The first work of art, the first artistic act which the first artist scrawled on the wall to vent his exuberance was erotic. A horizontal line: the recumbent woman. A vertical line: the man penetrating her. . , .

But the man of our own times who from an inner compulsion smears walls with erotic symbols is a criminal or a degenerate. . . .

Just as ornament is no longer organically linked with our culture, so it is also no longer an expression of our culture.¹

A fellow Viennese, Sigmund Freud, would have agreed with all of Loos's statements concerning the erotic element in art, but not with Loos's contention that ornament was no longer organically connected with or expressive of the present culture. Here Freud and Klimt both opposed Loos; for them the interpolation of a symbolic dream, or of a decorative overlay, was the *link* between the conscious and the unconscious life—an interpretable link in which manifest images pointed to the latent content of the psyche or world cycle.

It is not strange, in a neurotic, self-indulgent metropolis like Vienna—already titillated to the point of spontaneous combustion by the "erotic pollution" of Arthur Schnitzler's plays and Richard Strauss's operas—that both Klimt and Freud should have focused upon sex as the primary spectacle and motivating factor of life. What is surprising is that time and the sheer beauty of Klimt's sensuous facades have obscured the blunt urgency of that artist's close and unremitting fixation upon sexuality. History seems to have ascribed the full revelation as well as exploitation of sex in art to the Expressionist and Surrealist movements, interpreting the *Jugendstil* generation of Klimt and indeed the whole international Art nouveau movement as merely an erotic prelude. Nevertheless this prelude, orchestrated in a period of hypocritical Victorian repression, was of Wagnerian proportions—sensuous and insistent—a leitmotif that predicated what was to come.

What kind of person was Klimt? To look at, he could have been mistaken for a farmer, a carpenter, or a butcher (Figs. 3 and 56). He was heavyset with powerful shoulders and had strong dark features with an open gaze. His appearance gave no inkling of the exquisite delicacy of his work. Taciturn and uncommunicative by nature—in

fact bored by words—he let his paintings speak for him. As for his artistic sources and styles, how did the artist's personal predilections and convictions affect the content of his art and the reactions of his public? As late as 1899 when, to the enchantment of all Vienna, Klimt's Schubert at the Piáno (Pl. 52) was installed in the music room of Nikolaus Dumba's villa on the Parkring, the painter and his work were considered quintessentially Austrian. Speaking for everybody, Hermann Bahr hailed the charming evocation of Schubert as the most beautiful picture ever painted by an Austrian, full of an inexpressible melancholy that was "wholly Austrian" in feeling.²

And yet, one year later, in May of 1900, after public exhibition of the painting Philosophy (Pl. 58)—the first of three pictures commissioned from Klimt by the Ministry of Education for the ceiling of the main hall of the University of Vienna-eighty-seven professors indignantly signed a petition denouncing Klimt's work as unacceptable. The bewildering iconography of nameless, naked humans floating in a cosmic cluster without direction and apparently without hope was contrary to the "School of Athens" hall-of-fame concept and seemed to pose a double threat of psychological spatial tension and ambiguous content. Klimt's search for a personal, rather than "Austrian," style in his three University pictures, Medicine (Pl. 19), Philosophy, and Jurisprudence (Pl. 59) left many of his previous admirers feeling excluded and betrayed. The criticism of Klimt's work which was to follow over the next few years until he withdrew from the public eye was, interestingly, based on ethical rather than artistic criteria. By pressing a private iconography upon a general public Klimt lost, in the opening year of the twentieth century, the universal acclaim which had previously pronounced him the greatest living Austrian painter.

In the same year, in nearby Munich, Klimt's formidable colleague and contemporary Franz Stuck (1863-1928) was being hailed as the city's "painter prince," as he continued to mesmerize public and critics alike with images of demonic universal principles such as "Sin," "Sphinx," "War," and "Lucifer." So close was much of the iconography of Klimt's and Stuck's Weltanschauung-in which the irrational ambiguities of the age were projected into powerful images (Figs. 24-26; Pls. 20, 21, 23, 25, and 31)—that a comparison of the two reigning painters and their respective domains is mandatory. The lifelong popular acceptance of Stuck—a painter now all but forgotten except as the teacher, briefly, of Kandinsky and Klee-no doubt reinforced the self-confidence emanating from his Self-Portrait in His Studio with His Wife Mary (Fig. 5). The hint of aristocratic aloofness -we see Stuck wearing his formal frock coat as he painted-was a genuine part of the Munich artist's aristocratic makeup. Both men received their artistic training at a Kunstgewerbeschule (applied arts school) rather than at an Academy. During the late 1880s both experienced commercial success and official recognition. Stuck won a prize of 60,000 marks and a gold medal at the Munich Glaspalast exhibi-

 Franz Stuck, Self-Portrait in His Studio with His Wife Mary, 1902. Oil. Private collection, Munich.

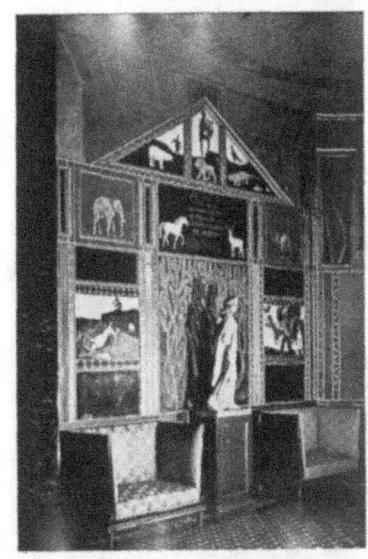

6. The "Pompeian Wall" in the music room of the Stuck Villa, Munich, 1898. (Photograph from Du, July 1969)

 Klimt-designed cover for Ver Sacrum, 1898, Vol. 3, with the Delphic tripod far right. Compare with Fig. 8 and Pls. 1, 2.

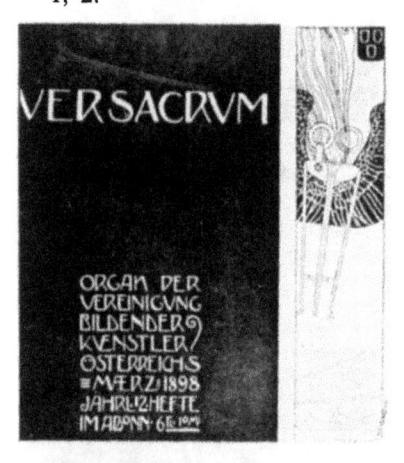

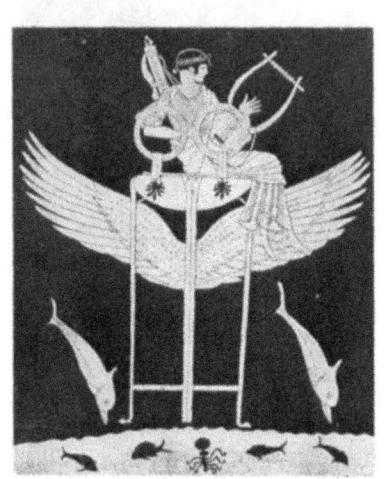

8. Apollo Riding the Sacred Tripod of Delphi, detail from Attic red-figure vase, c. 490-475 B.C. (From H. Lukenbach, Kunst und Geschichte, Munich, 1913) Compare with Fig. 7 and Pls. 1, 2.

tion of 1889 for his astonishing Guardian of Paradise (Fig. 25), and in 1888 Klimt received the golden service cross from Kaiser Franz Josef for his part in the ceiling and pediment decoration of the new Burgtheater. One critic now described Klimt as the "heir" of Hans Makart.

The careers of the two artists continued to parallel each other: in 1892 Stuck became one of the original members of the Munich Sezession; in 1897 Klimt joined in the founding of the Vienna Secession. At this time both painters represented the extreme avant-garde in art, but whereas Stuck was appointed professor of painting at the Munich Academy in 1895, Klimt, during the years 1893 to 1905, was three times blackballed for a similar post at the Vienna Academy, due to the drawn-out scandal (which rocked even the government) concerning the "unacceptability" of his three University paintings. Exasperated, Klimt proclaimed when interviewed by the art critic Bertha Zuckerkandl, whose sister-in-law he was to paint toward the end of his life (Pl. 16):

Enough of censorship. I grasp at self-help. I want to get free. I want to get out of all these unrefreshing absurdities that hinder my work, and get back to freedom. I refuse all state help. I renounce everything.³

Klimt's self-image (Fig. 3) reveals a man who has indeed renounced the establishment in exchange for personal freedom. In contrast to the stiff formality of Stuck, handsomely silhouetted in his evening coat before his blank canvas, Klimt appears to be circling in a free-form dance, as he poses for his photographer friend Max Nähr not in his studio but in the luxurious garden he allowed to grow wild outside his studio door. In both instances a female companion shares the artist's body language. Stuck's wealthy American wife Mary, who financed the construction of her husband's renowned showpiece villa (completed 1898), is a statuesque figure, full of poise—a fittingly regal hostess for the painter prince's lavish home banquets. Emilie Flöge, the swirling partner in Klimt's dance step, is, in her wind-puffed dress and graceful pose, a harmonious counterpart of the freedom expressed by the painter's loose-fitting blue "monk's" tunic. Another kind of liberty also existed in the twenty-seven year relationship between Klimt and Emilie Flöge, the owner of a fashionable dressmaking shop. Although Klimt's younger brother Ernst (1864-1892) had married Emilie's sister Helene in 1891, Gustav and Emilie were never to formalize their union. For Klimt, this freedom to pursue the species female, not only as pictorial content but as the prey of daily encounter, was a natural and necessary way of life. Reluctant to provide a selfportrait in either words or painting, Klimt nonetheless once summed up the female-directed aesthetic of his life and art thus: "There exists no self-portrait by me. I am not interested in a specific personal appearance as a 'subject for a picture,' but rather am I interested in

other individuals, above all women, and even more am I interested in other appearances."4

One of these "appearances" was Alma Schindler (soon to become Alma Mahler—Fig. 20). Perhaps Vienna's most beautiful femme fatale at the turn of the century, Alma vividly recalls Klimt and his pursuit of her when she was eighteen years old:

He was . . . already famous at thirty-five, and strikingly good-looking. . . . He was tied down a hundredfold, to women, children, sisters, who turned into enemies for love of him. And yet he pursued me to Italy. . . . Wherever we stayed Klimt would show up looking for me. . . . In Venice, in the bustle of the Piazza San Marco, we finally saw each other again. The crowd concealed us and his hasty whispers of love, his vows to rid himself of everything and come for me, his commanding request to wait for him. . . . I was deaf to all pleas to visit his studio. ⁵

If Klimt was not always successful in "commanding" women (according to Alma), he had nevertheless an engagingly frank attitude toward his Don Juanian appetites and once drew a swift caricature of himself as genitalia (Fig. 57)—a pithy self-portrait for a man of few words.

Continuing the comparison between Stuck and Klimt, a look at their studio furnishings is especially rewarding in determining the art tastes of these two great masters of eclecticism. Both artists lavished an arts-and-crafts-minded attention upon their ateliers. Stuck designed every feature of his nostalgically "classic" villa and lined the walls with sculpted altars to art and "Pompeian" frescoes (Fig. 6). Upon moving into what was to be his final studio in Hietzing in 1914, Klimt furnished his reception foyer with the elegant Wiener Werkstätte furniture of his friend the architect Josef Hoffmann and hung on the wall his much-prized collection of Japanese color woodcuts and Chinese scrolls (Fig. 4). While Stuck's creative emulation was limited, like that of Arnold Böcklin's, to the world of classical antiquity, the sources of Klimt's stylistic inspiration included, as had those of Makart, a far more catholic and esoteric range, extending from the ancient Orient through practically all periods of Western and non-Western art. In the contemporary area of the dance, just as Isadora Duncan's emphasis on Greece could be equated with Stuck's world, so Ruth St. Denis's employment of Egyptian and Indian motifs had a parallel in the orientalized decorative usage of Klimt (see especially the later portraits, Pls. 10-14). Both these extraordinary representatives of avant-garde dance performed in Vienna during Klimt's formative years: St. Denis's 1906 "Dance of the Sense of Touch" sent the city, and Hugo von Hofmannsthal in particular, into raptures. Sensuality was a Viennese speciality not limited to Klimt. However it was the cloying sexuality of Stuck's nymphs and satyrs that was dubbed "healthy" by writers like Hofmannsthal, who admired Stuck's "mythmaking" ability, while the sense of Eros unabashedly pervading and generating Klimt's great cyclic statements (Pls. 19, 26, 32, 33, 35, 57,

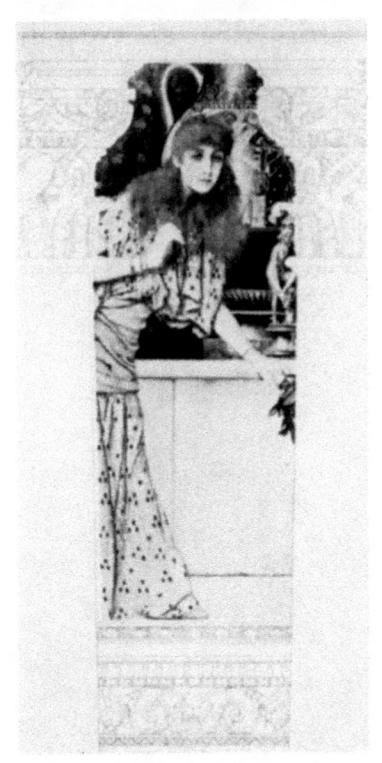

 Klimt, Art of Ancient Greece II (The Girl from Tanagra), 1890-91 (D.56). Oil on stucco ground. Intercolumnar panel in the staircase of the Kunsthistorisches Museum, Vienna. Compare with Pl. 49.

and 59) struck not the acceptable note of titillation but an unwelcome vibration of apprehension and alarm.

Klimt's allegories and their disturbing implications were rejected in his own home city. Throughout his lifetime, his local fame and livelihood were based upon his portraits and landscapes—apparently harmless vehicles for the sumptuous talents of Austria's irrevocably sensuous painter prince.

Gustav Klimt was born in Baumgarten, a country suburb of Vienna, on 14 July 1862, and was the oldest son among seven children. He and his two brothers Ernst (1864–1892) and Georg (1867– 1931) were introduced to art through their father's profession of engraver in gold and silver. Georg also became a goldsmith, but both Gustav and Ernst showed special talent for drawing and painting, and were accepted in the recently established Kunstgewerbeschule. The brothers' first and most influential professor was Ferdinand Laufberger, who gave them and their fellow student Franz Matsch (1861-1942) superb training in a variety of media, including al fresco painting and mosaic. Laufberger recommended the trio for several architectural decoration commissions and the Klimt brothers earned extra money by drawing portraits from photographs—developing a marked ability to render sharp natural likenesses. The trio helped execute Hans Makart's conversion of the sixteenth-century woodcut series of the Triumph of Maximilian I into a spectacular pageant honoring Kaiser Franz Josef's silver wedding anniversary in 1879, and Gustav's early exposure to the world of Dürer was to provide an unusual iconographic model for future use (Figs. 37 and 39). In 1893, at the completion of their studies, Matsch and the Klimt brothers moved into a joint studio, working on commissions for the decoration of villas and theaters, at first out of town (Fiume and Bucharest, 1885; Carlsbad, 1886) and then in Vienna when the trio was hired to paint scenes from the history of the theater in the pediment and ceiling areas of the two staircases of the newly completed Burgtheater on Vienna's elegant Ringstrasse. For his part in the project, which included during the years 1886-1888 depicting historical views of "The Cart of Thespis," "Shakespeare's Globe Theater in London," "The Theater of Taormina," "The Altar of Dionysus," and "The Altar of Apollo," Klimt immersed himself in the study of original sources and spent hours examining the collection of antique vases in the imperial museum.⁶ Just as Stuck did not hesitate to lift fauns and warriors off the classical vases in Munich's Glyptothek, so Klimt developed a marauding eye for handsome motifs which could serve the double cause of historicism and esoterica. He not only applied his new knowledge of forms of classical antiquity to the Burgtheater decorations, but also introduced classical artifacts such as the sacred Delphic tripod (Fig. 8) into the frames and borders of some of his first "photographic" portraits, such as those of the pianist Joseph Pembauer in 1890 (Pl. 1) and of the actor Josef Lewinsky of 1895 (Pl. 2). The combination of photo-

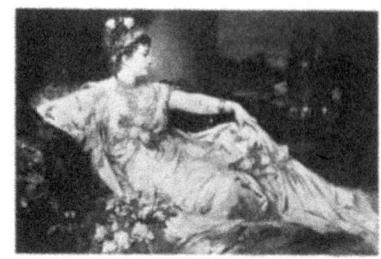

 Hans Makart, Charlotte Wolter as Messalina, 1876. Oil. Historisches Museum der Stadt Wien, Vienna. Compare with Pl. 3.

graphic realism and enigmatic frame "commentaries" produced an arresting effect which Klimt was later able to synthesize into powerful single images of simultaneous decorative and symbolic content (see for example Adele Bloch-Bauer I of 1907, Pl. 8). Klimt used the winged Delphic tripod motif once again in 1898 in his cover design for the third issue of the newly formed art magazine of the Secession, Ver Sacrum (Fig. 7).

The most influential event in Klimt's early career as an architectural painter, and one that alerted him to the vast inventory of ornamental forms to be found in earlier art, was the 1890 commission which the Klimt trio (the brothers and Matsch) received to complete the decoration of the staircase of the great new Kunsthistorisches Museum, left uncompleted by the untimely death at the age of fortyfour of Vienna's leading historical painter, Hans Makart (1840-1884). Makart's "heir" took on the new job with gusto. Even as a student he had admired Makart, and not always from a distance. Once, in their curiosity to see the master's giant works in progress, the trio had bribed Makart's servant to let them slip into the empty studio during the owner's daily siesta. It was not Makart's rococo style but his baroque excess that fascinated the young Klimt, inspiring him to similar efforts (Pl. 55). During the years in which he was to grapple with what Freud might have called a horror vacuii complex, Klimt drew on this Makartian overabundance to fill and flood his own environmental surrounds. The eight spandrels and three intercolumnar panels assigned to Klimt in the Museum were to span the history of art from Egypt of the Old Kingdom to Florence of the Cinquecento. It was back to the art books and local museum collections for Klimt and his colleagues, who prided themselves on historical authenticity.

Klimt, with his voracious visual appetite, had no trouble assimilating the forms and styles, and over the next two years he produced eleven elegant personifications, both male and female (including an Egyptian mummy, a goddess, an angel, and a child) set in archaeologically appropriate backgrounds. One of the female figures represented an aspect of Greek art—The Girl from Tanagra (Fig. 9). The Tanagra girl was actually a startlingly contemporary Viennese coquette, with heavy eyelids and an enigmatic, steady gaze, her figure arrested in the act of caressing a flower. Behind her is a large Attic black-figure amphora—a testimonial to Klimt's preference for Greek art and a precursor of a specific period quotation which the artist would include in the upper right half of his Pallas Athene of 1898 (Fig. 27 and Pl. 21). In the spandrels Athene appeared for the first time in Klimt's repertory, wearing a breastplate with a gorgon's head in the center, grasping a spear in the left hand and holding a small Nike figure in the right—all features which would reappear in Klimt's remarkable version of 1898. Notable for a certain cool aloofness as well as for their period authenticity, these handsome personifications became a mild sensation, for here certainly was the promise of a great and poetic proponent of familiar and trusted academic realism.

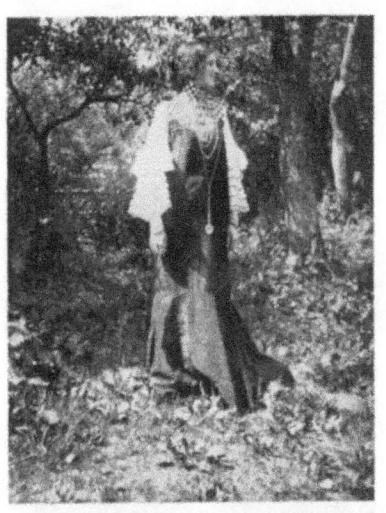

 Photograph taken by Klimt of Emilie Flöge, c. 1905. (From Deutsche Kunst und Dekoration, XIX: I, 1906-07) Compare with Pl. 5.

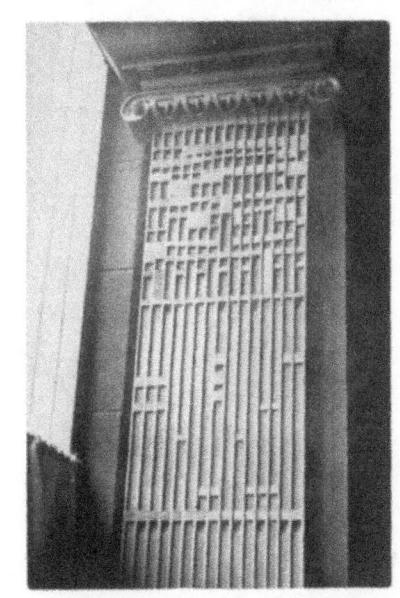

12. Charles Rennie Mackintosh, detail of pilaster from the Board Room of the Glasgow School of Art, 1907–10. (From D. Bliss, C. R. Mackintosh and The Glasgow School of Art, Glasgow, 1961) Compare with Pl. 5.

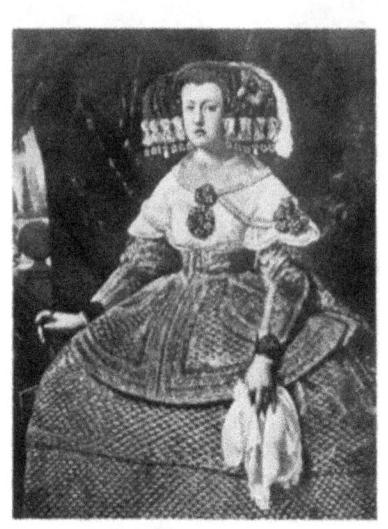

 Diego Velázquez (formerly attributed to), Portrait of Queen Mariana of Austria, 1646. Oil. Kunsthistorisches Museum, Vienna.

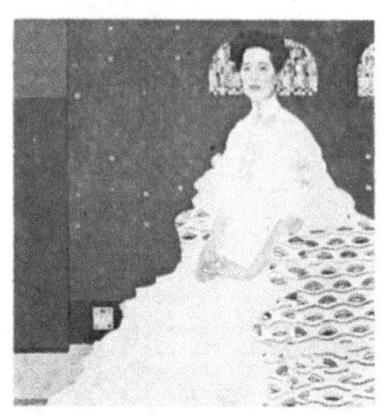

14. Klimt, Fritza Riedler, 1906.

The Girl from Tanagra can surely qualify as Klimt's first portrayal of the femme fatale—a theme he would develop to frightening intensity in the Judith I and Judith II icons created after the turn of the century (Pls. 23 and 31). The charming fair-haired Tanagra girl, still nameless, appears soon again in the 1892 In the Morning (Pl. 49). No longer passing as a Greek evocation but an undeniable fleshand-blood Viennese, she continues her sensuous association with flowers as she stands gazing melancholically at some blossoms in a mask-shaped vase on a high "Greek" table, of which one tall ornate leg can be seen. One flower, much taller than its neighbors, unfolds its petals around the luminous miniature face of a child—an interesting mixture of naturalism and symbolism (see also Pl. 50) which suggests the haunting formula of mysteriously sad females and mystic flowers employed so successfully by the Belgian painter Ferdinand Khnopff in his I Lock My Door Upon Myself of 1891. Klimt's stylization of the girl's fuzzy hair and prominent square jaw is also reminiscent of Khnopff's distinctive femme fatale type (Fig. 30). The motif in the large amphora in the background of The Girl from Tanagra appears as a background screen in In the Morning. Much later in the 1916 portrait of Friedericke Maria Beer (Pl. 13) an imposing "screen" behind the figure is not taken from one of Klimt's own large scrolls (Fig. 4) but is a magnification of a Korean vase in his collection. In all three works Klimt uses the psychological device of contrasting a ferociously active "painted" presence (the lively figures on the vase and screen) with the prominently passive aspect of the "real" subject.

Klimt's appreciation of Markart's painterly excess has been noted. A fine example of the younger painter's ability not only to update but to transform the highly popular Makart portrait formula may be observed in a comparison of Makart's 1876 portrait of the actress Charlotte Wolter as Messalina (Fig. 10) with one of Klimt's early portrayals of women, the 1898 Sonja Knips (Pl. 3). By retaining the asymmetrical figure placement and the foil of accompanying flower burst, and through the importance given to the handsome, two-dimensional body silhouette, Klimt has endowed the young socialite (she married a wealthy industrialist who installed the portrait in the dining room of their Josef Hoffmann-designed villa) with the same sensuous self-possession as that of Makart's Roman femme fatale. The Makartian "mood" of detachment—sometimes vacant, sometimes melancholy -was to become a hallmark of the manner in which Klimt's elegant women calmly eyed the world. Rejecting the close-up bust portrait (Pl. 50) for full-figure renditions, Klimt continued to elaborate on the Makart model of sensuous asymmetry, and the years 1901-02 found him experimenting with the individually applied, surface-filling, caressing brush strokes of Pointillism, as in the handsome portrait of Marie Henneberg (Pl. 53).7

As he lavished more attention on increasingly larger portrait canvases, Klimt's previous interest in providing additional decorative comment through the device of a wide border or frame (Pls. 1 and 2;

also Pl. 17, Love) diminished in favor of a heightened tension between three-dimensional figure and two-dimensional ground. The extension of environment to frame (a Pre-Raphaelite device much copied on the continent at this time) was carried out by Klimt's goldsmith brother, Georg, who provided the hammered copper frames for some of Klimt's early allegories (Pls. 21, 23). A brief flirtation with Whistler's white on white dissolving technique attempted to juxtapose the fixed reality of an individual persona with a complementary amorphic surround, as in the 1899 portrait of Serena Lederer (Pl. 4).8

A profound difference separates the Whistler-indebted Serena Lederer portrait of 1899 from Klimt's portrait of Emilie Flöge (Pl. 5) done three years later. Expressed in the simplest terms, external environment has here become interior definition. The diaphanous white surround of Serena Lederer is replaced by a specific body-filling swell of repeated decorative motifs. This is not the result of artistic distance or personal intimacy. Klimt knew both sitters well. Serena Lederer was a gifted amateur who admired and studied with Klimt and who encouraged her industrialist husband, August, to invest in what would one day be the largest private collection of Klimt works. Emilie Flöge was, in the words of Serena's son Erich, "Klimt's eternal love" and lifelong companion. Nevertheless the difference between the two portraits does not reflect the change in subject from patron to lover, but rather the birth of a novel concept—original with Klimt—of what could constitute portraiture.

In the years between the creation of the two portraits an extraordinary intellectual event had occurred in Vienna. Sigmund Freud's The Interpretation of Dreams (Die Traumdeutung) was published on 4 November 1899 in an edition of 600 copies. 11 Like so many of the voices raised to deliver urgent messages in that "isolation cell in which one was allowed to scream" (Karl Kraus's famous description of Vienna at the turn of the century), Freud's cry evoked only utter silence. The book was ins Leere gesprochen ("spoken into the void" the publication title Adolf Loos gave his Vienna public lectures of 1897-1900) and largely ignored, except for a sneering review in the Vienna Zeit six weeks later-written by the former director of the Burgtheater, Burckhardt, who for some inexplicable reason qualified as an expert on such matters. 12 It is not likely that Klimt—no great devourer of books-ever read a word written by Freud; but it is almost certain that, in the culturally incestuous Vienna of coffeehouse gossip, Klimt was soon aware of the sexual fixation of the writings of Herr Doktor Freud well before Karl Kraus's devilish condemnation of psychoanalysis as "the disease of which it pretends to be the cure." 13

Instinctively, and especially in the three University panels which so offended public taste, Klimt had been moving towards a cyclic conception of man, the natural world, and the cosmos in which everything was predicated on the single principle of fertility and regeneration. This was Nietzsche's lofty "eternal recurrence" theme as interpreted by Ernst Mach (1838–1916), popular lecturer and professor of

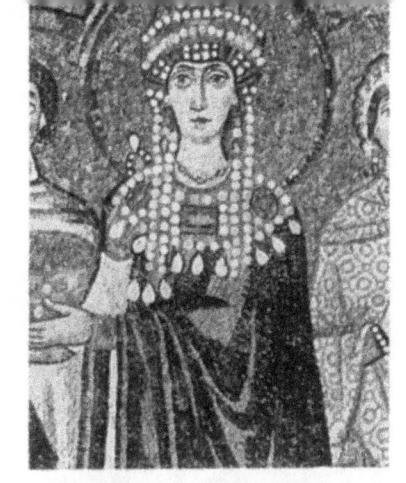

 Empress Theodora, detail, 546– 548. Mosaic. S. Vitale, Ravenna. Compare with Pl. 8.

 Jan Van Eyck, detail of the Virgin Mary from the Ghent Altarpiece, completed 1432, St. Bavo, Ghent. Compare with Pl. 8.

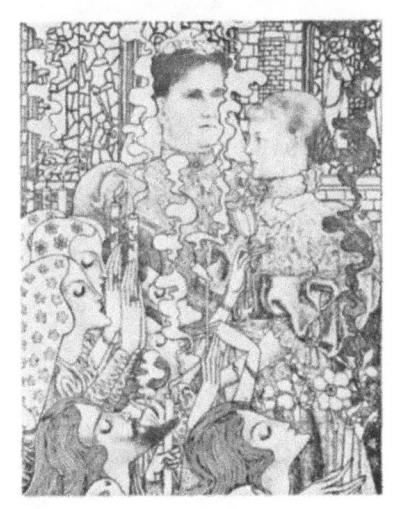

17. Jan Toorop, Verheugd Gouda, 1897. Lithograph. Rijksprentenkabinet, Amsterdam. Compare with Pl. 8.

 Friedericke Maria Beer in Wiener Werkstätte dress, c. 1916. (Photograph courtesy Mrs. F. Beer-Monti, Honolulu) Compare with Pl. 13.

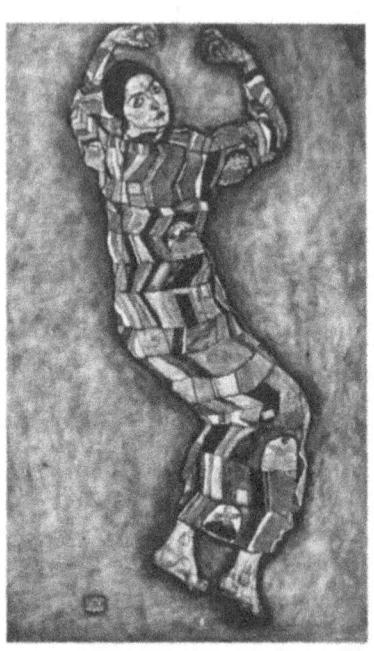

 Egon Schiele, Friedericke Maria Beer, 1914 (K.192). Oil.
 Collection Mrs. F. Beer-Monti, Honolulu. Compare with Pl. 13.

physics at the University of Vienna, who saw the life experience as a tenuous membrane through which passed a series of stimuli and sensation, sensation and stimuli, like glistening pearls strung out in an endless continuum of space and time. In Klimt's laconic vernacular this meant an *interpenetration* between the fecundity of nature and that of man. This proto-Futurist interpretation of the world was for Klimt primarily a *visual* manifesto upon which could be built, if one cared to (and Klimt happily left this to his friends and critics), a philosophical superstructure.

The extremely personal route towards this Eros-centered environmental definition of man can quickly be appreciated by examining one of a dozen photographs which Klimt took of Emilie Flöge posing outdoors (Fig. 11), eight of which were published under Klimt's name in the respected art magazine Deutsche Kunst und Dekoration. With tremendous sensitivity and pleasure the artist-photographer juxtaposes the organic complexity of luxuriantly varied natural forms with the arbitrary and sophisticated shapes of the dressmaker's fashion design. Klimt's oil portrait of Emilie accomplishes the nature osmosis of which the ordinary camera is incapable: the garden is internalized—rhythmically absorbed into the figure of the woman and her billowing "halo" (perhaps reminiscent of the more sinister shadows of Félicien Rops and Edvard Munch). Klimt's horror vacuii has for once sucked the environment bare, concentrating on a central core of decoration. This ornamental trunk functions cumulatively and simultaneously as both ornate overlay and symbolic definition of the figure. And what is the symbolism? Like Freud's dream imagery, interpretation of the shapes depends on an almost oversimplified visual equation with traditional male and female symbols. Just as Loos dared to state that all art was erotic and could be reduced to the horizontal (woman) and the vertical (man), just as Freud confidently and blithely read tumescence into every erect object and penetrability into every orifice, so Klimt painted pollen and pistils, spermatozoa and ova interpenetrating both humans and nature. It is this basic message of inevitable, cycle-perpetuating Eros that streams forth from not only many of Klimt's portraits, but also from his undulating allegories and genetically overpopulated landscapes.

Unlike Freud and Loos (and the painters of the younger Expressionist generation—Richard Gerstl, Oskar Kokoschka, and Egon Schiele), who aimed directly at the psyche, Klimt manipulated the facade—the mysterious surface-membrane of those "other appearances" which he had admitted were his greatest interest. But the facade, as in Schnitzler's artfully contrived psychodramas, not only contained the message for Klimt, it was Klimt's message. It was the cumulative force of his decorative symbolism that impressed itself upon the beholder's unconscious. Reversing Freud's process, in which interpretation went from manifest dream imagery to latent content (the supposed presence of repressed libidinous desires), Klimt proceeded to translate the manifest Eros of his world view into latent

sexual symbolism—a shimmering facade of voluptuous ornament which could be seen as just that or as more, according to what was reflected in the eye of the beholder. Thus even such drastically straightforward sexuality as that presented in The Kiss of 1907-08 (Pl. 30) was able not only to pass the imperial censor but also to be accepted by the general public, so seductively distracting was the beauty of the gold and silver overlay in which erect rectangles and oculated spirals explicitly acted out the ultimate implication of the painting's title. The picture of Emilie Flöge is the first portrait in which Klimt expressed his new definition of portraiture—a definition in which anatomy becomes ornament and ornament becomes anatomy in a biological definition of the person portrayed (see also the allegorical pictures, Pls. 26, 30, 32, 33, 35, and 60; and the sheet of composition studies, Pl. 80). A handsome parallel and possible tribute to the sensuous possibilities of Klimt's two-dimensional kaleidoscopic filling of form can be observed in the eight plastically treated pilasters, of which no two have an identical inner fill (Fig. 12), designed by Charles Rennie Mackintosh for the Glasgow School of Art after his 1900 visit to Vienna to meet the Secessionist artists.14

Klimt's organic "flower" fills, with their symbolic appeal to the unconscious and their immediate impact of visible opulence, caused the artist to become greatly sought-after as portrait painter to Vienna's elite (if not to government officials). The art-loving nouveaux riches, which included many successful industrialists' families, clamored for the flattering elegance which a portrait by Klimt promised. In 1905 the artist completed a handsome wedding portrait of Margaret Stonborough-Wittgenstein (Pl. 6)—a composite of past experiments with the Whistler and Khnopff standing-figure formulas-and in addition provided, by means of a long white gown, a subtle, almost sgraffito flower-fill. A member of the remarkable family that produced the ascetic philosopher Ludwig Wittgenstein, Margaret was to place her embellished portrait by Klimt in a most ironic setting—the austere, white, multiple-cubed "house turned logic" designed for her by her brother Ludwig in 1927-28 in the best, most severe Loos "crime as ornament" spirit.15

An ingenious eclectic with an unquenchable thirst for evocative shapes that were also beautiful in themselves, Klimt did not hesitate to raid other art works. This he did with verve when he lifted the familiar fanned-out headdress of seventeenth-century female royalty from Velázquez examples in the Kunsthistorisches Museum (Fig. 13). This headdress was adroitly transferred as a repetitive "wall-paper" motif (beginning on the far right of the canvas) to the 1906 portrait of the Berlin patron Fritza Riedler (Fig. 14 and Pls. 7 and 67), complementing the lady's upswept coiffure with an unforgettable (if recognizable) aggrandizement. The most extreme instance of Klimt's eclecticism, and the most formidable example of the novel metamorphosis which his creative assimilation could produce, is certainly the 1907 portrait of Adele Bloch-Bauer I (Pl. 8). Dubbed immediately—

Alma Schindler (-Mahler) posing with bearskin rug at beginning of her acquaintance with Klimt, c. 1898. (Photograph, private collection, New York)

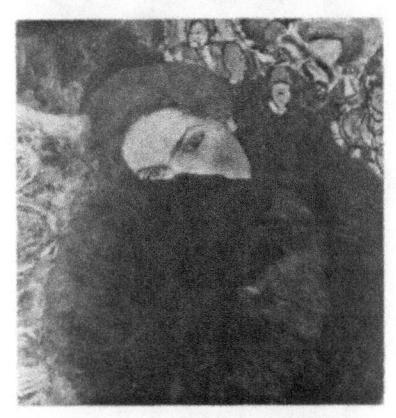

 Klimt, Lady with Muff, c. 1916-18 (D.207). Oil. Formerly Galerie Gustav Nebehay, Vienna, present whereabouts unknown.

22. Hellenistic terra-cotta comic mask, from Melos. British Museum. (From H. C. Baldry, Ancient Greek Literature in its Living Concept, London, 1968) Compare with Pls. 18, 56.

- Edmund Hellmer, Austria's Power on Land, 1897. Compare with Pls. 19, 58, and 59.
- 24. Klimt, *Jurisprudence*, (study), c. 1897–98, (D.86). Oil.
- Franz Stuck, Guardian of Paradise, 1889. Oil. Stuck Villa, Munich. (From O. J. Bierbaum, Stuck, Leipzig, 1899)

and correctly—"Byzantine" by Alma Mahler and others, this work was a confirmation of the lasting impression which the mosaic decorations of S. Vitale (Fig. 15) and other churches had made upon the artist during his 1903 trip to Ravenna. This "Byzantine" crowdedness and mosaiclike filling of surface had been distinguishing Klimt's landscapes for three years (see Pls. 39, 40, and 41) and would continue to enhance their glimmering jewellike intensity to the end of Klimt's career (Pls. 42–48; 64). In the Bloch-Bauer portrait the Byzantine invasion is so overwhelming that "impurities" such as the repeated Egyptian eye-triangle and the Mycenaean swirl (shown even in foreshortened view as part of the armchair definition on the right) escape notice at first glance. The taut contrast between the plasticity of the pale, rouged face and the two-dimensionality of the ornamental surround (employed in abridged form also in the portrait of Fritza Riedler) owes its pungency to a tension between realism and microscopic detail. This sort of tension had been present in Northern painting since the days of Jan Van Eyck, whose glittering Ghent Altarpiece figures (Fig. 16) indeed provide a formal precedent for Klimt's work, even to the inclusion of landscape greens alongside metallic sheens (see the single square of green just above Bloch-Bauer's head to the right and its repetition in the left foreground). The illusion of decapitation effected by the jeweled neck collar is a femme-fatale enhancing device that Klimt borrowed from his own earlier portraits (Pls. 5) and 50) and such allegorical works as his Judith I (see Fig. 59 and Pl. 23). The photographic realism of Klimt's organically isolated heads is also reminiscent of Jan Toorop's reliance on photography in his "portrait" lithograph celebrating the visit of Queen Regent Emma and Princess Wilhelmina to Gouda in 1897 (Fig. 17), a work in which the tension between surface flatness and three-dimensionality is stretched to the breaking point. The repetitive, stylized faces, tresses, ornaments, and flowers of Toorop-a favorite, along with Khnopff, of the Secession—were features carefully noted by Klimt. The flirtation of both Klimt and Toorop with photomontage effects parallels the new amusement park fad of being photographed with one's head poking out of an outlandish body or setting. (In 1913 even the generally morose Franz Kafka had himself photographed with three friends at the Prater "in" a cardboard airplane flying sedately over Vienna's giant Ferris wheel!)

Perhaps due to the influence of Emilie Flöge's Casa Piccola fashion shop activities, Klimt occasionally produced simpler portraits, such as *The Black Feather Hat* of 1910 (Pl. 9) and *Lady with Muff* of 1916–18 (Fig. 21), which were reassuringly and handsomely consonant with the latest fashions in women's wear and accessories, as seen in contemporary photographs showing real-life femme fatales (Fig. 20) coyly displaying the exaggerated hats or provocative fur muffs of the period.

The Byzantine victory in Klimt's portraiture was Pyrrhic. The tessera techniques which he had learned in the Kunstgewerbeschule

days proved more successful when translated into landscape painting than when allowed to overwhelm individual portrait sitters. The artist dipped into his reservoir again and came up with an inexhaustable supply of attractive objects and designs—this time from the Orient. Borrowing from his own prints (Fig. 4) and delving into his books on Japanese art (which included a collection of erotica), he began to lessen the density of his surface fill and with a much looser hand distributed here and there, in alternation with single flower blossoms, a supply of oriental birds, animals, and figures, as in the enchanting portrait (c. 1912) of the child Mäda Primavesi (Pl. 11). Klimt's enormous struggle to achieve a compromise between two- and threedimensional elements is attested in a sheet of compositional studies for the portrait (Pl. 69). His ubiquitous awareness of gender and biology is also noteworthy in these studies, where the central vanishing point of the landscape orthogonals insistently coincides with the little girl's groin (an effect which is muted but present in the final painting, and is psychologically and compositionally germane to Klimt—see also Pl. 80, and Figs. 1 and 2).

The loosened "dotted oriental" fashion proved so pleasing that in 1912 Frau Bloch-Bauer requested a second portrait of herself in the "new" style. Klimt complied (Pls. 10 and 68). With this portrait he abandoned the Makart asymmetrical seated format for the centrally placed standing composition of his earlier works (Serena Lederer, Emilie Flöge, and Margaret Stonborough-Wittgenstein). Around 1914 Serena Lederer's striking, dark-haired daughter Elisabeth turned up for her wedding portrait, Elisabeth Bachofen-Echt (Pl. 12), and Klimt posed her within a pyramidal mantle of showering flowers set against a large screen peopled by his favorite oriental personalities (compare with Fig. 4), some of whom gaze with interest at the giant prisoner of ornament standing in front of their static world. From now on, with four notable exceptions due in three cases to the age of the sitter (portraits of a Baby, Pls. 15 and 72, of Serena Lederer's mother, Charlotte Pulitzer, Pls. 54 and 70, and of the mother of Emilie Flöge, D.191, not reproduced here), all of the women who came to Klimt for their portraits would be painted standing, usually in the center of the picture space, and facing the beholder (Pl. 14).17 The other major exception to this rule was Amalie Zuckerkandl (Pl. 16), whose pyramid-shaped presentation was to remain unfinished, like that of the Baby (Pl. 15), because of Klimt's death.

"To be immortalized" had been the wish expressed by the timid Friedericke Maria Beer (Pl. 13 and Fig. 18) when she rode out to Klimt's Hietzing studio in November of 1915 to beg a portrait from Vienna's awesome painter prince. Her request was the result of an unusual circumstance. A wealthy and willful young presence on the periphery of the Viennese art world (she dressed exclusively in Wiener Werkstätte fabrics—Fig. 18), she had had her portrait painted two years before by the leading representative of the city's Expressionist artists, Egon Schiele (1890–1918). It was not Friedericke's admiration

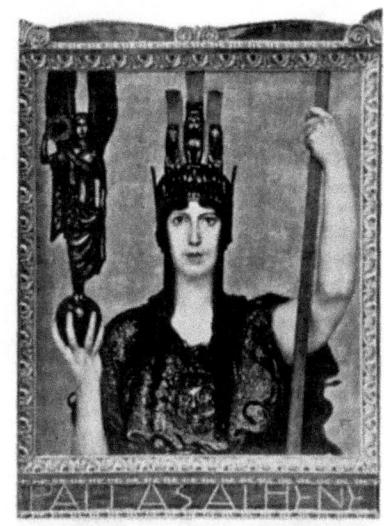

 Franz Stuck, Pallas Athene, c. 1897. Oil. (From O. J. Bierbaum, Stuck, Leipzig, 1899) Compare with Pl. 21.

27. Psiax, detail from Heracles Wrestling with the Nemean Lion, Attic black-figure amphora. (From J. Boardman, Greek Art, New York, 1964) Compare with Pl. 21.

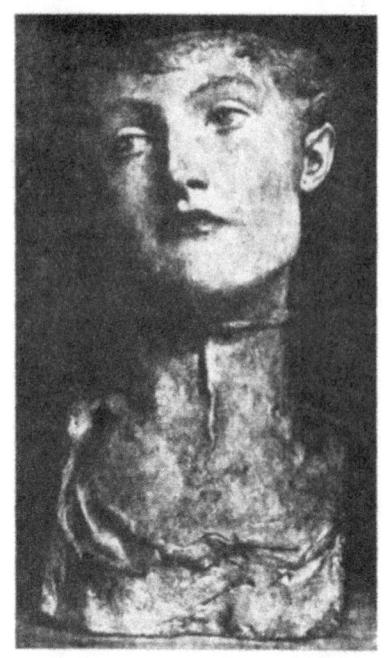

Ferdinand Khnopff, Mask, before 1898. Plaster. (From Ver Sacrum, I [1898], Vol. 12)
 Compare with Pl. 23.

30. Ferdinand Khnopff, Red Lips, before 1898. Colored drawing.

for the psyche-searing pinioning of her image in an angstful void, as portrayal in the new "pathological" Expressionist style guaranteed (Fig. 19), that had selected Schiele, but rather—and this by her own admission—her enthrallment by the troubled, wild good looks of the young bohemian painter. Klimt now accepted her commission and decided on the imaginary background of a screen device, which he had first used in *In the Morning* (Pl. 49) and had recently elaborated in the *Elisabeth Bachofen-Echt* portrait (Pl. 12). His instinct for psychological and painterly tension quickened as he realized the marvelous natural contrast Friedericke's bland, symmetrical face made with the vivacious feints and parries of his oriental warriors. Upon completing the work he remarked to Friedericke, "Now people can no longer say that I paint only hysterical women."

Klimt created in this portrait perhaps his greatest statement of decoration as content—an Art nouveau thesis utterly opposed to the new Expressionist rejection of the facade. Nevertheless had it not been for Klimt's extraordinary overloading of the facade, with its double cargo of symbolic and ornamental content, the way to the psyche might never have been so fruitfully revealed to the younger generation of painters.

The incorporation into Klimt's allegories and landscapes of a meaning-saturated environment paralleled the development of the charged facade in Klimt's portraiture. A multiplicity of sources—some briefly experimented with and abandoned, others transformed and perpetrated—is also evident. At first, as in the description once given of Stuck, Klimt "acted baroque, but appeared Hellenic." From the early frank paraphrases of Makart's grandiose figure swirls in his earliest allegories, such as Poet and Muse (Pl. 55) of around 1884—humble precursor to the "human tower" knots of figures that would appear in the University panels (Pls. 19, 58, and 59) and that would culminate in the later allegories (Pls. 26, 32, 33, and 35)—he moved in 1895 to the friezelike scheme of Music I (Pl. 18), with its classical vocabulary of comic mask (compare Fig. 22), lute, and sphinx (the latter two very close to contemporary renditions by Stuck). Clearly his familiarity with past art styles had provided the artist with a cornucopia of classical quotations. Three years later, when he designed *Music II* (Pl. 56) as supraporta for the Dumba music salon—the same room in which his "Austrian" Schubert at the Piano (Pl. 52) was to be installed—he changed the formerly demure lyre-strummer into a more vivacious and definitely Viennese musician, and endowed her with the fuzzy fair hair and large square jaw of her sister cocotte, The Girl from Tanagra (Fig. 9). The classical mask of comedy appears as a Dionysian faun face in the second version and has been moved nearer the Khnopfflike sphinx.

In contrast to the two-dimensional accomplishment of the friezelike conception of *Music I*, the lure of a cosmic funnel of unknown depths was simultaneously beckoning the artist in another direction, as shown in a second allegory of the same year, *Love* (Pl. 17). This
first statement of the embrace theme, which Klimt would develop in the University panels, the Beethoven frieze (Fig. 40), and the Stoclet decorations (Pl. 29) into the mighty "Byzantine" climax of The Kiss (Pl. 30), seems, with its dramatic lighting, to come right off the stage of Klimt's own Burgtheater panel "Shakespeare's Globe Theater in London." Shown at a happier moment than the death scene depicted in the "Globe Theater" version, this Austrian Romeo and Juliet (again Klimt has modernized his woman into a contemporary Viennese type) close in for their ecstatic embrace under the group gaze of a transformed Cornaro Chapel audience-no aristocratic Roman family in Klimt's version, but instead dramatic examples of the inevitable progression of the species female from eager small child to dreamy young (Viennese-via-Khnopff) woman, to gaping crone (four variants of the latter are given) to the final monitory skull. What will happen to Romeo is not made explicit, for Klimt is only interested in the ages of woman (see this theme as taken up again in 1905, Pl. 26); only rarely after 1909 does a male enter the same canvas with Klimt's women (the two notable exceptions are Adam and Eve, Pl. 34, and The Bride, Pl. 35). The doomed-to-transiency embrace in Love takes place in a central dark oblong which peaks in Klimt's first baroque figure suspension since Poet and Muse and is framed on both sides by oblong gold borders decorated with fat Makartlike pink roses. All of the intriguing cast of characters in the top half of Love will be met with again in Klimt's further allegories.

A key work containing the germinal expression of what was to be one of the most original and compelling components of the University panels—the simultaneous presentation of multiple dimensional scales—is the 1896 pencil drawing Sculpture (Pl. 73).19 Reminiscent of Klimt's nude image of Egyptian art at the Kunsthistorisches Museum, the new personification (an apple-holding "Eve") stands in front of a jumbled "Greek" altar loaded with sculpted objects such as the sphinx from Music I and crowned by a huge female head of the classic Athene type. Above this arrangement a circus maximus type of high bleacher wall extends, accommodating an attentive, if bizarre, audience of sculpted portrait busts in different media and from all art periods-an enthusiastic roundup in the name of Sculpture, even including a bust of Dante. While there are good reasons for the discrepancy in size of all these mutely staring heads, an irrational element in terms of both scale and theme makes its entrance on the extreme lower right of the picture—the "living" head at "Eve's" feet. Once again, as in Music I and Love, Klimt's introduction of a recognizably modern visage of a flesh-and-blood Viennese jostles all dimensions, in this case throwing doubt upon the previous norm of scale and reality, "Eve," forcing the beholder to ask whether she too is actually a statue.

In the meantime an unambiguously "real" sculpture was being hoisted into place in Vienna's Michaelerplatz (Fig. 23)—the Makartian baroque excess of which was to fire Klimt's imagination. Edmund

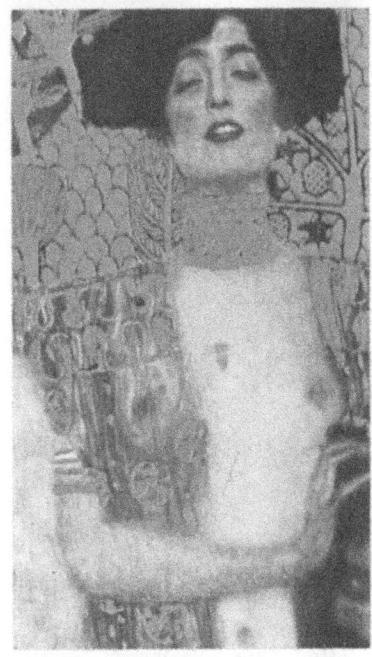

31. Penthouse magazine cover, April 1972.

- 32. Klimt, Judith I, 1901.
- 33. Detail from Assyrian palace relief of Sennacherib at Nineveh, 705-681 B.C. Compare with Pl. 23.

34. Gustav Mahler in 1897 at the age of 37. (Photograph, private collection)

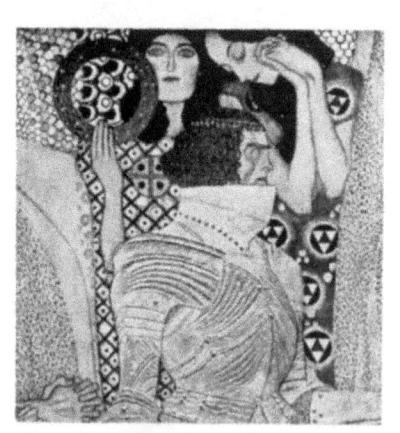

 Klimt, detail of the "Knight" (supposedly Gustav Mahler) from the Beethoven frieze, 1902.

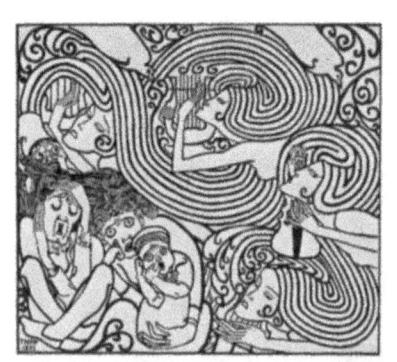

 Jan Toorop, Poster for Wagenaar's Cantata Schipbreuk, 1895. Lithograph. Compare with Pl. 57.

Hellmer's marble fountain of 1897 depicting Austria's Power on Land was a swashbuckling ensemble of naked, cascading bodies high above which triumphed the figure of "Austria." The sotto in su view of "Austria" versus the floating human tower was incorporated by Klimt during 1897-98 into the basic design of his University picture Medicine (Pl. 19). Dozens of sketches (Pl. 76b) experimented with the posture and relationships of the figures in Klimt's column of humanity, which was to take up two-thirds of the canvas (Pl. 77), and special attention was given to the single nude figure occupying the otherwise empty left side of the canvas—the personification of "Austria" converted by Klimt into a floating female figure seen from the provocative "up from below" perspective (Pl. 76a).20 The dramatis personae in Love, from babe to death's head (Pl. 77), make an impressive return in Medicine. In the final state, preserved now only in a photograph, Klimt introduced in the far upper right corner of the picture the pronouncedly pregnant nude woman who was to become a condensed statement of his Eros-generated cosmology in the drastic canvas Hope I (Pl. 24) and in the more "acceptable" version Hope II of 1907-08 (Pl. 60).

In his composition study (Pl. 75) for the University panel *Philosophy* (Pl. 58) Klimt again applied the coexistence of different figure-scales. This time the floating human column—composed of embracing couples, children, and Rodinlike despairing elderly figures—takes up a vertical strip on the far left side of the canvas and is opposed by a vast spangled area (Whistler's starry sky?) inhabited only by the huge blank-eyed female face we first saw as both sphinx and giant bust in *Sculpture*. And once again Klimt jolts the final logical cohesiveness of the ensemble by introducing, at the bottom left, the unmistakably modern face of a femme fatale mantled in her own flowing hair. The sphinx body of the large bust and the "philosophical" pose of the girl at the bottom of the compositional sketch were not carried over into the final state, which depended instead on a dramatic frontality for both staring visages.

The third University picture, Jurisprudence, was initially conceived of by Klimt as the single figure of a female Avenging Justice (Fig. 24) seen sotto in su. The image was unmistakably inspired by the painting that, a decade earlier, had made Franz Stuck famous overnight, the Guardian of Paradise of 1889 (Fig. 25). Again Klimt effects a gender transformation in his impressive paraphrase, but he retains that sense of contemporaneousness, in his square-jawed, bouffant-coiffured Justice, that had so impressed viewers of the Stuck picture in which many had read a self-portrait. In this first version of Jurisprudence another Klimtian character makes its first appearance—the tentacle-waving octopus in the lower portion of the picture. This bulgy-eyed apparition would soon appear just as a face, definitely male, voyeuristically accompanying the aquatic capers of Klimt's floating females in Moving Water of 1894 (Pl. 20) and would reappear in its most awesome (and now sexless) form in the final state of

Jurisprudence (Pl. 59). Moving Water took its cue from the seanymph frolics of Böcklin and Max Klinger, and its watery surround was to provide the symbol-polluted environment for two later versions of companionably close "swimming" females entitled Water Serpents (Pl. 25)—all images which, because of the multiple interpenetration invoked, served as models for the early Art-nouveau-obligated canvases of the Italian Futurist painter Carlo Carrà in, for example, his Swimmers of 1910 (Pittsburgh, Carnegie Institute).

The closest correspondence with a work by Stuck (Fig. 26)21 in Klimt's allegories is the latter's imposing Pallas Athene of 1898 (Pl. 21). A much more original conception than the earlier Athene spandrel for the Kunsthistorisches Museum, this new rendition of the militant protectress of the Secession exhibits the coevality which had become the hallmark of Klimt's recent works. A large-jawed, redhaired implacable modern countenance gazes out from under a golden helmet. In her left hand Athene holds a spear while in her right she supports a miniature fair-haired version of herself as naked Nike. This is a predictably Viennese and specifically Klimtian refinement of the larger, draped, rigid historical Nike figure in Stuck's black-haired Pallas Athene version and is indeed a factor in the inescapable eloquence of Klimt's highly personal conception, pervaded as it is by a more persuasive god, Eros. Both paintings are enclosed within specially inscribed frames (Georg Klimt executed the metal frame from his brother's design). Here the resemblance ceases, for despite the similar pose and attributes, Klimt's figure is enriched by an "incised" background frieze, stylistically indebted to, on the left, late archaic vase painting and, on the right, Athenian black-figure work such as that by Psiax (Fig. 27). Klimt's little scene on the right shows Heracles wrestling with Antaeus—a favorite episode in classical vase painting, and one which the artist adopted from a local museum example or book illustration. The differentiation of flesh tone between male and female which the artist had noted in archaic Greek vase painting and which appears in the background decoration of Pallas Athene was a feature that would show up again in the late work Adam and Eve (Pl. 34).

Klimt himself was so intrigued by the charms of his tiny fair-haired Nike in *Pallas Athene* that the following year, playing Pygmalion, he blew her up to life size and called her *Nuda Veritas* (Pl. 22). Now a snake substitutes for the octopus as symbol of male presence and desire (there are perhaps more "disguised" Klimt self-portraits than are generally acknowledged) and winds across the ornate title to encircle the feet of the not at all squeamish red-haired incarnation of naked truth. A legend at the top of the panel proclaims in the words of Schiller the lofty message of *Nuda Veritas*: "You can not please all through your actions and your art—do it right for the few. To please many is bad." That *Nuda Veritas* did contain universal as well as personal appeal is verified in the reminiscence of Klimt's friend Bertha Zuckerkandl, who associated the creation of the paint-

37. Klimt, detail of "Excess" from the Beethoven frieze, 1902.

 Aubrey Beardsley, cover design for "The Forty Thieves," 1897.

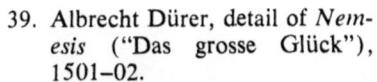

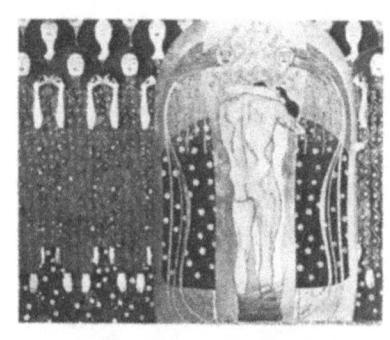

40. Klimt, detail of "Pure Joy" from the Beethoven frieze, 1902.

 Charles Dana Gibson, Design for Wall Paper Suitable for a Bachelor Apartment, 1903. (From Dover reprint, Gibson)

- Opposite top and center
 42. Auguste Rodin, She Who Was
 Once the Helmet-Maker's
 Beautiful Wife ("The Old
 Courtesan"), 1888. Bronze.
 Compare with Pl. 59.
- Mycenaean octopus motif on an amphora from Kakovatos, Triphylia, c. 1500-1425 B.C. National Museum, Athens. Compare with Pl. 59.

ing with the "fanatical cry for truth" excited by the reopening of the Dreyfus case in 1899. Another art critic friend of Klimt's, Hermann Bahr (vigorous defender of the University panels), showed his appreciation of *Nuda Veritas* by purchasing it for installation in the study of his Joseph Olbrich-designed villa. Before completion of the painting, Klimt published its basic design, with a different inscription at the top, in the third issue of *Ver Sacrum* (1898), along with a companion emblem representing "Envy" (*Der Neid*) (Pls. 74a and 74b) in which a gaunt old woman clutches the snake that ultimately preferred sharing the company of *Nuda Veritas* in the final oil.

The Pallas Athene of 1898 had been a symbol of the rational. Three years later Klimt's Judith I (Pl. 23) stunned and enthralled Viennese critics with its blatant decadence and terrifying invocation of the irrational. In spite of the artist's specially designed frame which identified the picture in large letters as "Judith and Holofernes," people simply could not or would not believe that Klimt had intended a portrayal of the pious Jewish widow and courageous heroine of the Apocrypha who, as Renaissance depictions had always shown, never actually delighted in her dreadful, heaven-directed mission of decapitating the plundering commander of the Assyrian army. Surely Klimt must have made a mistake; he must have meant Salome-that favorite fin-de-siècle femme fatale of Gustave Moreau, Oscar Wilde, Aubrey Beardsley, Franz Stuck, and Max Klinger (Fig. 28). Stubbornly, Judith I was listed throughout Klimt's lifetime in exhibition catalogues and magazine articles as "Salome," once even with the admonition that "Judith . . . would be better renamed Salome."24 What Klimt was interested in carrying over from Salome precedents, such as the Klinger marble statue of 1893, was the arresting quality of living presence—of confrontation with a flesh-and-blood fatal woman. And fatal woman Klimt's Judith I certainly was: his palpable answer to Stuck's great plastic variations of the serpent-caressing femme fatale of Sin. We have seen the prominent-chinned female face before in Klimt, and the kinship with Khnopff types (Fig. 30) has been noted. But now a second Khnopff feature, as expressed in the Belgian artist's sculpture (Fig. 29), was observed and put to good use by Klimt. This was the powerful effect of decapitation suggested by the high neck collar (and reinforced in the Khnopff bust by a lopping-off of the top of the head). With trenchant yet extremely subtle means Klimt communicates the phenomenon of mutilation on three levels: the decapitated head of Holofernes, the jeweled-collar cleaving of Judith's head from her body, and finally the compositional bisecting of Judith's torso by means of drapery placement. The latter torso "amputation" proved so compelling a strategem that it was adopted in toto by Schiele for his tortured self-portraits and pictures of thrashing female bodies, and it is still a basis of modern erotic titillation (Fig. 31). Klimt's Judith has half-closed eyes and parted lips (Fig. 59). This is an expression of rapture that goes back to his dreamy woman floating above the embracing couple in Love, and

back to Bernini's *The Ecstasy of St. Theresa*. There is no mistaking the climax expressed in both versions. What makes Klimt's Judith so "evil" in her orgasm is the hideous conditions under which it is achieved—at the expense, in fact the death, of her partner. The coupling of death and sexuality would fascinate not only Klimt and Freud, but also all the European audiences who in 1909 went to shiver at the spectacle of Richard Strauss's bloodthirsty "Mycenaean Majesty" Clytemnestra (Fig. 58)—an uncanny stage counterpart (sung with extraordinary success in Vienna by Hermann Bahr's wife Anna Bahr-Mildenberg) to Klimt's sinister Judith.

Lest his unequivocal "Judith and Holofernes" frame identification become separated from its contents (as indeed it did in most reproductions of the work—Fig. 32),²⁵ Klimt painted, with an archaeological slyness unremarked by contemporary viewers, a specific biblical site reference right into his picture. The cone-shaped mountain symbols, the fig trees and grapevines behind Judith's head are all direct quotes from the Assyrian palace relief of Sennacherib (Fig. 33).²⁶ The painting (with its frame) was taken out of the country almost immediately by its appreciative first owner, Ferdinand Hodler, Klimt's great Swiss contemporary and creator of forceful allegories (Fig. 44) which paralleled many of the gestural and rhythmic qualities of the work of the Viennese artist.

Klimt had informed his version of the Judith and Holofernes story with a potent sensualism, transferring the thwarted lust of the historic Holofernes into the eroticism of a modern femme fatale. Whether or not he was aware of the fact that he had tampered with tradition in presenting Judith as a Salome, one thing is certain: in Klimt's book it was Judith—personal slayer of lust—who was the more spellbinding representative of Eros. Perhaps sparked by the stage appearance of the most terrifying femme fatale to date, Fanchette Verhunk (Fig. 47), in the 1907 Vienna premiere of Strauss's Salome (sets by the artist's friend Alfred Roller), Klimt returned to the devouring woman theme (Freud's "castrating" female) in 1909. But it was still Judith and not Salome that the artist, with the biological figure-fill symbolism of his latest portraits, chose to depict in the life-size icon Judith II (Pl. 31).

Somewhere between the rational world of Pallas Athene and the sensual domain of Judith there existed another region which Klimt visited in his allegorical work. "If I can not budge the gods, then I will move Acheron," was the line from Virgil's Aeneid with which Freud had prefaced his Interpretation of Dreams. Klimt too essayed a pictorial trip into the infernal regions (Pl. 57) when he elected to create a seven-part frieze in symbolic paraphrase of Beethoven's Ninth Symphony as part of an extravagant "frame" for the Secession's April 1902 exhibition of Max Klinger's Zeuslike Monument to Beethoven. For the exhibition, Gustav Mahler (Fig. 34)—controversial (partly due to Vienna's rabid anti-Semitism) director of the opera—reorchestrated the fourth movement of Beethoven's

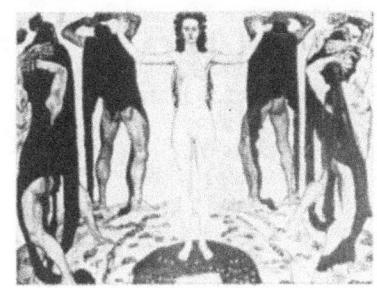

 Ferdinand Hodler, Truth II, 1903. Oil. Kunsthaus, Zürich. Compare with Pl. 59.

 Anna Pavlova in the "Syrian Dance." (Photograph by Van Riel, 1917) Compare with Pl. 28.

Margaret MacDonald, "The Opera of the Sea," 1903. Decorative inlay in colored gesso. Waerndorfer music salon, Vienna. (From Deutsche Kunst und Dekoration, XV, 1904–05) Compare with Pls. 25, 29, and 30.

Ninth for wind and brass instruments and conducted it with the Vienna opera chorus in front of Klinger's statue on opening day. Klimt's accompanying frieze, executed in casein on a stucco base with semi-precious inlay, exemplified the turn-of-the-century concept of Beethoven's music as struggle and triumph. It began with a state ment of mankind's longing for happiness, with the weak imploring the strong—a knight in shining armor (Fig. 35), identified by those in the know as representing Mahler himself²⁷—to take up the struggle for happiness as a hero marching to victory. Facing the knight on the opposite wall was what would be his consolation-Poetry-but before he could reach this solace he had to pass through "the infernal regions" where dwelt the hostile powers of sin and vice. The monster Typhon (Pl. 57) is shown as a giant ape, next to the three Gorgons. The starkly linear and rhythmic style of this gruesome ensemble (it was here, rather than in Judith I, that the public spotted an "Assyrian" flatness) took its inspiration not only from Hodler but also from Toorop—possibly his "Shipwreck" poster of 1895 (Fig. 36), done, as was the Beethoven frieze, for illustration of a musical work. Next in Klimt's lineup came a trio of sins: debauchery, unchastity, and excess (Fig. 37). "Excess" was a blithe tribute to Beardsley (Fig. 38) and a not quite so blatant homage to Dürer (Fig. 39). The frieze climaxed, as did Schiller's words and Beethoven's music, with joyas, leaving Acheron behind, man enters into a "kingdom not of this world," but a kingdom of pure joy. A choir of angels (Fig. 40) intones a line from Schiller's Ode, as "with a kiss for the whole world" pure love finds itself. Finally the Romeo of Love makes a longawaited curtain call as the heroic nude who embraces "pure" love. The noble motivation of this kiss was not appreciated by the public or by most critics, who condemned the frieze as an allegory of venereal disease; painted pornography fit only for a Krafft-Ebing temple! Once again Klimt was attacked not for artistic reasons, but on behalf of morality. A year later, in America, Charles Dana Gibson was to bottle and cap the erotic vapors of such continental extravagances in an eau-de-cologne spray of femmes fatales as "wall paper suitable for a bachelor apartment" (Fig. 41).

Auguste Rodin visited the Beethoven exhibition in June of 1902 and complimented Klimt on his "tragic and magnificent" frieze. The admiration was mutual, for the Austrian artist had already paid tribute to the Frenchman's Gates of Hell with the two despairing, head-clasping figures in the lower half of Philosophy's human tower (Pl. 58; see also Three Ages of Woman, Pl. 26). The following year Klimt made another Rodin figure (Fig. 42) the central motif of a new and monumental version of Jurisprudence (Pl. 59). The customary change of gender occurred: Rodin's shriveled hag became an emaciated old man, and the figure was shown sotto in su—a resigned prisoner of justice floating upwards in the prehensile grasp of a lilac-tinted octopus, a pulsating polyp whose artistic pedigree can be found in the tentacled motif of the Mycenaean vase painting (Fig.

43) admired by Klimt.²⁹ Two awesome spectacles greet the octopus's victim: around him are the three serpent-accompanied Eumenides—Tisiphone, Alecto, and Megaera; in the distance above another trio stands ready—Truth, revealing herself, Justice, garbed in red, and Law, holding her book. The drama's posterlike linearity may be indebted to Hodler (Fig. 44), but the message is Klimt's own: that vengeance stands in a much closer relationship to man than does the lofty concept of jurisprudence. Not exactly what the Vienna University law professors had in mind.

But even Klimt's first conception of Jurisprudence (Fig. 24) had been predicated on the idea of an Avenging Justice. While there seems to be no compensating connection between the happy, fulfilled aspect of the artist's private life with Emilie Flöge and the creation of so many femmes fatales and sensuous women (Danae, Pl. 27, The Virgin, Pl. 33, and The Bride, Pl. 35), the fact that Klimt's art had several times received official reprimands does seem to have provoked the very personal and pessimistic view of justice voiced in Jurisprudence. "Enough of censorship," the artist had declared. In 1905, eleven years after the fateful commission had been extended, he bought back from the government all three of the disputed University panels.

Creation of the dining-room wall mosaics for the Wiener-Werkstätte-designed villa of Adolphe Stoclet in Brussels during the years 1905-09 was a much more rewarding experience for Klimt. No ominous abstract needed to be pictorialized in this case. Instead, a Huysmanslike celebration of the senses was called for to accompany the formal dining of elegant society. The cartoons Klimt produced for the mosaic workers of the Wiener Werkstätte stemmed from his memory of the Ravenna church decorations. From the Byzantine spirals he raised a tree of life whose outstretched, curling branches encompassed two aspects of the greatest sensual experience: Expectation (Pls. 28 and 78) and Fulfillment (Pl. 29). Fulfillment was more than a clothed version of the "pure" kiss in the Beethoven frieze; it was Klimt's first chance to use the biological-ornament language of his latest portraits as visual definition of the merging of the two sexes. The emphasis on the exotic in the Stoclet decoration (M. Stoclet owned an exquisite collection of oriental art objects as well as a version of Khnopff's quixotic I Lock My Door Upon Myself) is seen in the "Egyptian" appearance of Expectation (referred to as "The Dancer" by a reviewer of 1912), whose frozen dance-step anticipates the impression of bas-relief silhouettes created by Anna Pavlova in her "Syrian Dance" of 1917 (Fig. 45).30

So successful was the statement of organic and decorative interpenetration in the Stoclet *Fulfillment* image that Klimt painted a life-size oil version in 1907–08 titled simply *The Kiss* (Pl. 30). The figures kneel on a flowery pedestal isolated in golden space, and the eventual culmination of mutuality of desire is beautifully enacted in the ornate intercourse of circular and vertical forms. The highly

47. Fanchette Verhunk as Richard Strauss's Salome in the Vienna premiere of 1907. (From R. Tenschert, Richard Strauss und Wien, Vienna, 1949) Compare with Pl. 31.

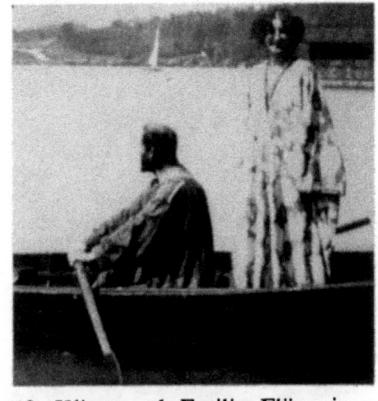

48. Klimt and Emilie Flöge in a rowboat on the Attersee, 1910. (Photograph, private collection, Oakland)

 Ferdinand Georg Waldmüller, The Schönberg, 1834. Oil. Private collection, Vienna. Compare with Pl. 43.

- 50 Ferdinand Hodler, Forest Stream, 1904. Oil. Kunsthaus, Zürich.
- Jean Dubuffet, The Geologist, 1950. Oil. Private collection, New York. Compare with Pls. 37, 42, and 43.

developed organic body-fill pervading and defining *The Kiss* may well have taken its original cue from the unusual flower-filled floating "kiss" precedent provided by a member of the Glasgow Four, Margaret MacDonald, whose decorative panel "The Opera of the Sea" (Fig. 46) was installed in 1903 in the music salon of one of the founders of the Wiener Werkstätte, Klimt's friend Fritz Waerndorfer.

With *The Kiss* Klimt parted company permanently with the robust forms of Rodin and declared his allegiance to the content-steeped, symbolic facade. His final allegories concentrated exclusively upon the Lucullan pleasure of painting overlays of sensual sign language on top of nakedly erotic images of themes and dreams (*Judith II*, Pl. 31, *The Virgin*, Pls. 33 and 79, and *The Bride*, Pl. 35; Figs. 1 and 2). Perhaps only the more sober allegory *Death and Life* (Pl. 32)—revised in 1915, in which the original gold background was overpainted with the stark blue of Alfred Roller's stage sky—gave any indication that Vienna's prince of Eros was aware of the world war thundering about him.

How did the symbol-saturated vocabulary of the portraits and the erotic syntax of the allegories find translation into Klimt's landscapes? For twenty years Klimt spent the summer months with Emilie Flöge and her family in nature, abandoning the stifling capital for the refreshing setting of small villages by Austria's sparkling Attersee (Fig. 48). An enthusiastic rower, Klimt often positioned his boat about thirty feet out from shore to obtain a private and uncluttered view of spots he wished to paint. Some of the first views, like Island in the Attersee (Pl. 37 and Fig. 54), are almost completely water scenes, and the loose brushstroke of Impressionism prevails. Common to both the early waterscapes and the first landscapes, such as Farmhouse with Birch Trees (Pl. 36), After the Rain (Pl. 61), and Tall Poplars II (Pl. 63), is the pronounced cutting of the canvas into unequal halves by either a very high or a very low horizon line. The two University panels Medicine and Philosophy depend on a similar asymmetrical dispersal of mass, and in fact, given a quarter turn, greatly resemble the top- or bottom-heavy landscapes painted during the same years. While such uneven distribution of space and volume is characteristic of the whole Art nouveau movement and of the oriental art from which so much of its spatial drama was obtained, there was a specific Austrian precedent which provided Klimt with a compositional trademark that so distinguishes even his earliest landscapes. This was the work of Ferdinand Georg Waldmüller (1793-1865). His landscapes, minutely-rendered but extensive in scope, such as The Schönberg (Fig. 49), frequently employed a narrow band of ground or sky as foil for dense motifs that could take up as much as six eighths of the picture area. This dramatic weighting of volume and the sheer beauty of Waldmüller's detailed surfaces opened Klimt's eyes to the pictorial tensions possible in the deliberate mixing of naturalism and schematism. The same antithesis of two-dimensional ornament versus three-dimensional subject matter in Klimt's portraits and allegories charged the artist's increasingly diagrammatic views of exuberant, mosaic-studded nature, as in *Pear Tree* (Pl. 39), Farm Garden with Sunflowers (Pl. 40), The Sunflower (Pl. 41), Poppy Field (Pl. 42), and Park (Pl. 43). The horizon-swallowing space-negating mosaic Park comes very close to solving the horror vacuii suggested by Waldmüller, obsessive with Klimt, and still haunting later artists like Fritz Hundertwasser and Jean Dubuffet (Fig. 51).

Another pictorial precedent that contributed to the mesmerizing quality of Klimt's landscape densities was the rhythmic grouping of elemental verticals and horizontals in the "parallelism" practiced by Hodler in his landscapes, such as *Forest Stream* (Fig. 50). The multiple verticals of Klimt's forest scenes, as in *Beech Forest I* (Pl. 38), with its high "Waldmüller" horizon, is a basically corporeal response to the spiritual message of Hodler's eurhythmy and shares the rich carpetlike effect of repeated silhouettes and shapes.

Klimt composed his landscapes by using a small grid, through which he studied prospective scenes. A perfect square, usually 110x110 cm., became the preferred format for these schematized views of nature. The result of this squaring-off of vistas in nature (Fig. 55) was a stacked condensation of elements, glimmeringly beautiful in its tessera-filled articulation, as in Church at Unterach on the Attersee (Pl. 48). The sensuous pulsation of the artist's airless, unpeopled landscapes is particularly striking viewed up close (Fig. 53), and the palpable networks built up by Van Gogh's separated brush stroke (Fig. 52), which did so much to energize surface in modern painting, are indeed precursors to Klimt's nature mosaics. The difference is one of empathy versus harvest: nature for the desperate Van Gogh was a vibrant reassurance of existence within a cosmic void; for Klimt the plentitude of nature offered a cyclic variety of stimuli and sensations. Like a honeybee, the Austrian artist collected and stored in multifaceted display a precious hoard of sense impressions. Unaffected by time of day, light, or shade (Pls. 44-48), his impenetrable landscape facades sifted and solidified the phenomenon of fecundity. Schnitzler had stated that the natural state is chaos. Freud explored the symbolism of dreams and suggested a rational explanation for the irrational. Klimt faced the plurality of those "other appearances" and sought to paint the manifestto-him content of a latent world force. Seizing upon the biological principle in nature, he studded his environments as he had his portraits with overlapping symbols of fertility and growth. Sometimes certain powerful forms correspond to the surface message of vitality, as in The Black Bull (Pl. 62) and Tall Poplars II (Pl. 63). At other times an early theme such as chickens in a garden (After the Rain, Pl. 61) will be reworked with magnified flower language and symbolic intensity, as in Garden Path with Chickens (Pl. 64). The anthropomorphic quality of Klimt's weeds and flowers, especially sunflowers (The Sunflower-Pl. 41), is undeniable and closely parallels the environmentabsorbing portrait statements of pictures like Emilie Flöge (Pl. 5) and

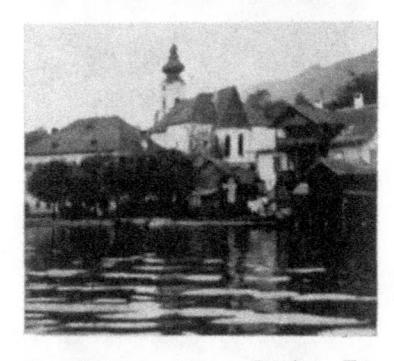

- Vincent Van Gogh, Tree Trunks and Flowering Grass, 1890. Oil. Kröller-Müller Rijksmuseum, Otterlo.
- 53. Klimt, detail from *Park*, before 1910.
- 54. Island in the Attersee, Austria. (Photograph by the author) Compare with Pl. 37.
- Church in Unterach on the Attersee, Austria. (Photograph by the author) Compare with Pl. 48.

Adele Bloch-Bauer I (Pl. 8). Just as he had summed up the Eroscentered conception of himself in the little self-portrait as genitalia (Fig. 57), so Klimt, caresser of all living things (Fig. 56), defined the omnipresent sensuality of nature in the following quatrain:

Die Wasserrose wächst am See Sie steht in Blüte Um einen schönen Mann ist weh Ihr am Gemüte.

The water-lily grows by the lake It is in bloom The yearning for a handsome man Is in her soul.³¹

So Klimt saw the world, others, and himself—all "in bloom" and all a part of the inexhaustible panorama of Eros. As observer of the greatest spectacle of all—Life—Klimt was indeed a grand voyeur.

- Klimt and his cat in the garden of the Josefstädterstrasse studio, c. 1912–14.
- Klimt, Self-Portrait as Genitalia, c. 1915. Drawing. Private collection, Geneva.

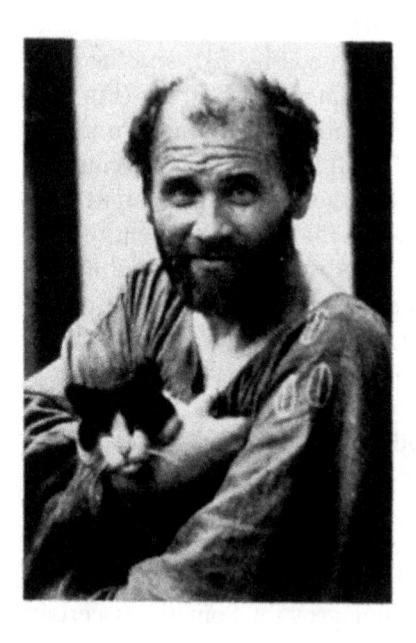

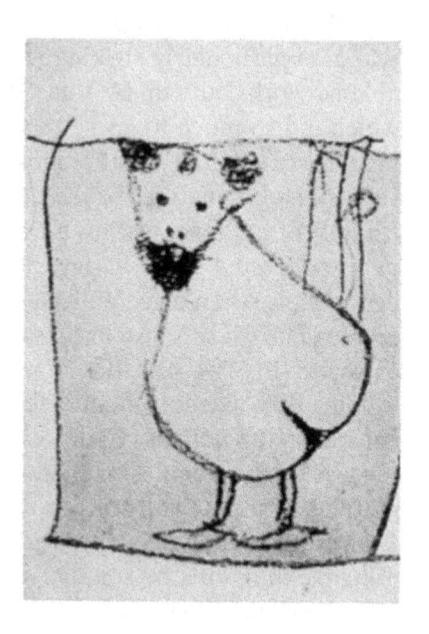

NOTES

1. Adolf Loos, Sämtliche Schriften, ed. Franz Glück. Vienna, 1962, I, p. 277 and p. 283. Author's translation.
2. Emil Pirchan, Gustav Klimt, Vienna, 1956, p. 22.
3. Bertha Zuckerkandl, Zeitkunst: Wien 1901–1907, Vienna, 1908, p. 165.
4. Klimt, typescript commentary for a nonexistent "Self-Portrait," no date, Bibliothek der Stadt Wien, Vienna, as quoted in Nebehay, Klimt Dokumentation, p. 32. Author's translation.

Kilmt Dokumentation, p. 32. Author's translation.

5. Alma Mahler Werfel, And the Bridge is Love, New York, 1958, p. 12.

6. The drawing of motifs from Greek vases in the imperial collections was not Klimt's only museum copy work. As was traditional in all European capitals during this period, young artists spent a good deal of their time painting copies of the old masters from originals. In the summer of 1962, while leafing through an ancient permission-to-copy book at the Vienna Kunsthistorisches Museum in hopes of coming across just such an entry, I found under the date 28 April 1885, the signature of Gustav Klimt requesting permission to make an oil copy of Titian's Isabella d'Este (Entry reproduced in Nebehay, Klimt Dokumentation, p. 100).

copy of Ittan's Isabelia a Este (Litty reproduced in Nebehay, Klimt Dokumentation, p. 100).

7. Herr Henneberg, who commissioned Josef Hoffmann to build a villa on Vienna's exclusive Hohe Warte in 1901, was the owner of a sizeable Japanese print collection admired by Klimt, Two photographs showing the Klimt portrait in place over the fireplace of the Henneberg villa were published as early as 1903 in Das Interieur, Vol. 4, pp. 136-7.

8. See also Klimt's portrait of Trude Steiner, 1898 or 1899 (D. 104), the vivid face and dark hair of which were apparently painted post-humously from a photograph. Both white-on-white portraits may be fruitfully compared with their obvious forerunner, Whistler's The White Girl of 1862, in the National Gallery of Art, Washington, D.C. The influence of Ferdinand Khnopft's portraiture is also evident (See Khnopft's Portrait of the Artist's Sister, 1887, Bernard Thibaut de Maisières collection, Brussels).

Khnopfi's Portrait of the Artist's Sister, 1887, Bernard Thibaut de Maisières collection. Brussels).

9. Stored in what was thought to be a safe depot during World War II, almost all the works in this exquisite collection, which included many landscapes, Music II, and Schubert at the Piano, were destroyed by fire in the final days of the war.

10. Letter to me from Erich Lederer, 20 April 1975. I wish to acknowledge my great debt to Herr Lederer who, during my several visits to Geneva to study his important Klimt and Schiele collection, shared his extensive knowledge and vivid memories of Klimt and Schiele with me.

11. The publisher, Franz Deuticke, arbitrarily placed the date 1900 on the title page.

12. Ernest Jones, The Life and Work of Sigmund Freud, Garden City, 1963, p. 229. During the first six weeks after publication 123 copies of the book were bought; after that it took eight years before the remaining copies of the first edition of 600 were sold. A second edition was not published until ten years later.

13. Karl Kraus, Die Fackel, Nos. 376-7 (June 1913). p. 8. Kraus was attacking not Freud himself, but the extravagant claims made for psychoanalysis by Freud's disciples. Kraus and Freud—as clear-sighted critics of the sexual hypocrisy of Viennese society—held each other in mutual esteem, and the extent to' which Kraus's searing articles on contemporary sexual practices served Freud has yet to be determined. See further my book Egon Schiele's Portraits (Berkeley, 1974) in which the instinctive grasp of the results of sexual repression by artists such as Klimt and Schiele is discussed as a phenomenon parallel to the theories and writings of Otto Weininger and Freud. In neither case do I believe that Klimt or Schiele ver actually read Freud, although they may well have looked at Weininger's Geschlecht und Charakter—notorious overnight—simply out of curiosity, due to the sensational suicide of the disturbed young author following the book's publication in 1903.

14. This interesting visual equation was o

odist University in the summer of 1971. For an analysis of Mackintosh's impact on Vienna, see the essay by Eduard F. Sekler, "Mackintosh and Vienna," in J. M. Richard and Nikolaus Pevsner (eds.), The Anti-Rationalists, Wisbech, 1973, pp. 136-142.

15. For an anecdote concerning the ludicrous discrepancy between Ludwig's unkempt appearance and the aristocratic elegance of his sister in Klimt's portrait, see the family reminiscences of Hermine Wittgenstein (Ludwig's oldest sister—an amateur painter and good friend of Klimt) as published in Bernhard Leitner, The Architecture of Ludwig Wittgenstein—a Documentation, Halifax, 1973, p. 22.

16. The astute art critic Ludwig Hevesi was the first to remark on Klimt's use here of a Velázquez device, relating it to the painting of the Infanta Maria Teresa; see Hevesi, Alt-kunst-Neukunst, Vienna, 1909, p. 318.

17. In the unfinished Portrait of a Lady, although the head faces the beholder, the profile turn of the body is a rare exception to the completely frontal portrait format now adopted by Klimt. Dobai does not identify the sitter, but Erich Lederer recalls that she is Maria Munk, daughter of a Viennese industrialist and fiancée of the writer Hans Heinz Ewers (letter to me of 20 April 1975).

18. Friedericke Maria Beer, in conversations and letters to me over the past eleven years. For a full account of the Friedericke Maria Beer portraits by Schiele and by Klimt see my Egon Schiele's Portraits, pp. 127-132.

19. One of a series of drawings made by Klimt for eleven design contributions "in Renaissance style" for Martin Gerlach's two-part publication Allegorien und Embleme, Vienna, 1882 ff; issued in installments, with a Neue Folge, from spring 1896, in which Klimt's Sculpture was plate 66.

20. Pl. 76a may well be Klimt's first notation of the floating female figure for Medicine; the pencil sketch was jotted down on a piece of letter paper. Klimt had already used a mild form of sotto in su perspective for the nudefemale in his "Altar of Dionysus" lunette for the Burgthe

stellung (June-October) in the Munich Glaspalast.

22. Berta Szeps (-Zuckerkandl, My Life and History, New York, 1939, pp. 182-3.

23. Already photographed in place and reproduced in Das Interieur, 1901, Vol. 2, p. 30 and Vol. 10, p. 163.

24. Die Kunst, 1901, Vol. 3, p. 540. See also the "Salome" identified color reproduction facing the article on Klimt by Hugo Haberfeld in Die Kunst, 1912, Vol. 25, opp. p. 173. The Salome theme's interest for contemporary art historians was demonstrated by an article authored by E. W. Bredt, "Die Bilder der Salome," in Die Kunst, 1903, Vol. 7, pp. 249-54, with reproductions of the works of Beardsley and Klinger, among others.

25. Reproduced without its frame as in Fig. 32 of this book in the Haberfeld article cited above, note 24.

26. I am indebted to Professor Robert Alexander of the University of Iowa for his interest and alertness in pointing out to me this previously unnoticed Klimt borrowing. I am also grateful to his colleague, Professor Charles Cuttler, for sharpening my awareness of the important Judith-versus-Salome concept of this painting.

27. Alma Mahler, Gustav Mahler, Memories

painting.
27. Alma Mahler, Gustav Mahler, Memories and Letters, New York, 1969 (revised ed.), p.

348.

28. Szeps (-Zuckerkandl), My Life and History, p. 181.

29. Instances of Mycenaean-inspired motifs in Klimt were first noted by Jaroslav Leshko, "Klimt, Kokoschka und die. Mykenischen Funde," Mitteilungen der Österreichischen Galerie, 1969, XIII; Vol. 57, pp. 16-40.

30. Pavlova's early collaborator, Diaghilev, was in fact one of the signers of M. Stoclet's guestbook.

31. Poem dated 10 July 1917, in Klimt's flourishing script; illustrated in the Albertina Museum Klimt Gedächtnisausstellung catalogue (October-December), Vienna, 1962, opp. Pl. 1.

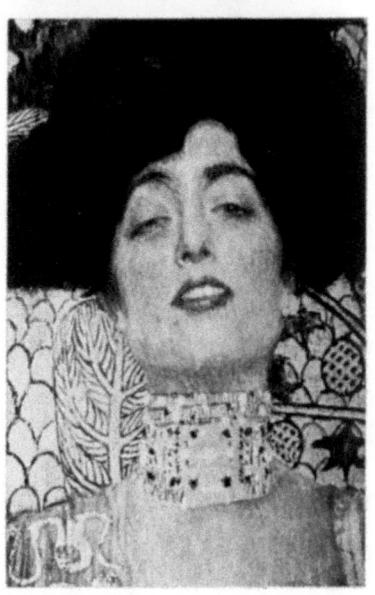

- 58. Anna Bahr-Mildenburg as Clytemnestra in Richard Strauss's Electra, Vienna, 1909. (From Du, April 1963)
- 59. Klimt, detail from Judith I,

LIST OF PLATES

- 1 JOSEPH PEMBAUER, 1890, D.58. Oil on canvas, 69x55 cm. Tiroler Landesmuseum Ferdinandeum, Innsbruck.
- 2 JOSEF LEWINSKY, 1895, D.67. Oil on canvas, 64x77 cm. Osterreichische Galerie, Vienna.
- 3 SONJA KNIPS, 1898, D.91. Oil on canvas, 145x145 cm. Österreichische Galerie, Vienna.
- 4 SERENA LEDERER, 1899, D.103. Oil on canvas, 188x83 cm. Collection Erich Lederer, Geneva.
- 5 EMILIE FLÖGE, 1902, D.126. Oil on canvas, 181x84 cm. Historisches Museum der Stadt Wien, Vienna.
- 6 MARGARET STONBOROUGH-WITTGENSTEIN, 1905, D.142. Oil on canvas, 180x90 cm. Neue Pinakothek, Munich.
- 7 FRITZA RIEDLER, 1906, D.143. Oil on canvas, 153x133 cm. Österreichische Galerie, Vienna.
- 8 ADELE BLOCH-BAUER I, 1907, D.150. Oil on canvas, 138x138 cm. Österreichische Galerie, Vienna.
- 9 THE BLACK FEATHER HAT, 1910, D.168. Oil on canvas, 79x63 cm. Private collection, Graz.
- 10 ADELE BLOCH-BAUER II, 1912, D.177. Oil on canvas, 190x120 cm. Österreichische Galerie, Vienna, on loan to Museum des 20. Jahrhunderts, Vienna.
- 11 MÄDA PRIMAVESI, c.1912, D.179. Oil on canvas. 150x110 cm. Private collection, New York.
- 12 ELISABETH BACHOFEN-ECHT. c.1914,
 D.188. Oil on canvas, 180x128 cm. Formerly collection August Lederer, Vienna, present whereabouts unknown.
- 13 FRIEDERICKE MARIA BEER, 1916, D.196. Oil on canvas, 168x130 cm. Collection Mrs. F. Beer-Monti, Honolulu.
- 14 PORTRAIT OF A LADY, 1917–18, unfinished, D.209. Oil on canvas, 180x90 cm. Neue Galerie der Stadt Linz Wolfgang-Gurlitt-Museum. Linz.
- 15 BABY, 1917-18, unfinished, D.221. Oil on canvas, 110x110 cm. Private collection, New York.
- 16 AMALIE ZUCKERKANDL, 1917-18, unfinished, D.213. Oil on canvas, 128x128 cm. Private collection, Vienna.
- 17 LOVE, 1895, D.68. Oil on canvas, 60x44 cm. Historisches Museum der Stadt Wien, Vienna.
- 18 MUSIC I, 1895, D.69. Oil on canvas, 37x44.5 cm. Neue Pinakothek, Munich.
- 19 MEDICINE, composition study, 1897-98, D.88. Oil on canvas, 72x55 cm. Private collection, Vienna.
- 20 MOVING WATER, 1898, D.94. Oil on canvas, 52x65 cm. Private collection, New York.
- 21 PALLAS ATHENE, 1898, D.93. Oil on canvas, 75x75 cm. Historisches Museum der Stadt Wien, Vienna.

- 22 NUDA VERITAS, 1899, D.102. Oil on canvas, 252x56.2 cm. Theatersammlung der Nationalbibliothek Wien, on loan to Museum des 20. Jahrhunderts, Vienna.
- 23 JUDITH I, 1901, D.113. Oil on canvas, 84x42 cm. Österreichische Galerie, Vienna.
- 24 HOPE I, 1903, D.129. Oil on canvas, 181x67 cm. The National Gallery, Ottawa.
- 25 WATER SERPENTS, c.1904-07, D.139. Mixed technique on pergament, 50x20 cm. Österreichische Galerie, Vienna.
- 26 THREE AGES OF WOMAN, 1905, D.141. Oil on canvas, 180x180 cm. Galleria Nazionale d'Arte Moderna, Rome.
- 27 DANAE, c.1907-08, D.151. Oil on canvas, 77x83 cm. Private collection, Graz.
- 28 EXPECTATION, c.1905-09, D.152 B. Mixed media with silver, and gold leaf on paper, 193x115 cm. Österreichisches Museum für Angewandte Kunst, Vienna.
- 29 FULFILLMENT, c.1905-09, D.152 I. Mixed media with silver and gold leaf on paper, 194x121 cm. Österreichisches Museum für Angewandte Kunst, Vienna.
- 30 THE KISS, 1907-08, D.154. Oil on canvas, 180x180 cm. Osterreichische Galerie, Vienna.
- 31 JUDITH II, 1909, D.160. Oil on canvas, 178x46 cm. Galleria d'Arte Moderna (Cà Pesaro), Venice.
- 32 DEATH AND LIFE, before 1911, revised 1915, D.183. Oil on canvas, 178x198 cm. Collection Frau Marietta Preleuthner, Vienna.
- 33 THE VIRGIN, 1913, D.184. Oil on canvas, 190x200 cm. Národní Galerie, Prague.
- 34 ADAM AND EVE, 1917–18, unfinished, D.220. Oil on canvas, 173x60 cm. Osterreichische Galerie, Vienna.
- 35 THE BRIDE, 1917-18, unfinished, D.222. Oil on canvas, 166x190 cm. Private collection.
- 36 FARMHOUSE WITH BIRCH TREES, 1900, D.110. Oil on canvas. 80x80 cm. Österreichische Galerie, Vienna.
- 37 ISLAND IN THE ATTERSEE, c.1901, D.117. Oil on canvas, 100x100 cm. Collection Dr. and Mrs. Otto Kallir, New York.
- 38 BEECH FOREST I, c.1902, D.122. Oil on canvas, 100x100 cm. Moderne Galerie, Dresden.
- 39 PEAR TREE, 1903, later revised, D.134. Oil on canvas, 100x100 cm. Busch-Reisinger Museum, Harvard University, Cambridge, Mass.; gift of Dr. Otto Kallir.
- 40 FARM GARDEN WITH SUNFOWERS, c. 1905-06, D.145. Oil on canvas. 110x110 cm. Österreichische Galerie, Vienna.
 41 THE SUNFLOWER, c.1906-07, D.146. Oil
- 41 THE SUNFLOWER, c.1906-07, D.146. Oil on canvas, 110x110 cm. Private collection.

- 42 POPPY FIELD, 1907, D.149. Oil on canvas, 110x110 cm. Österreichische Galerie, Vienna.
- 43 PARK, before 1910, D.165. Oil on canvas, 110x110 cm. The Museum of Modern Art New York; Gertrude A. Mellon Foundation.
- 44 SCHLOSS KAMMER ON THE ATTERSEE, III, 1910, D.171. Oil on canvas, 110x110 cm. Österreichische Galerie, Vienna.
- 45 AVENUE IN SCHLOSS KAMMER PARK, 1912, D.181. Oil on canvas, 110x110 cm. Österreichische Galerie, Vienna.
- 46 MALCESINE ON LAKE GARDA, 1913, D.186. Oil on canvas, 110x110 cm. Formerly collection August Lederer, Vienna, destroyed by fire 1945.
- 47 SCHONBRUNN PARK, 1916, D.194. Oil on canvas, 110x110 cm. Private collection, Graz.
- 48 CHURCH AT UNTERACH ON THE ATTERSEE, 1916, D.198. Oil on canvas, 110x110 cm. Private collection, Graz.
- 49 IN THE MORNING, 1892, D.61. Watercolor on paper, 38.5x14 cm. Formerly collection Lobmeyr, Vienna, present whereabouts unknown.
- 50 PORTRAIT OF A LADY (Frau Heymann?), c.1894, D.65. Oil on wood, 39x23 cm. Historisches Museum der Stadt Wien, Vienna.
- 51 CHILDREN WITH FLOWERS, 1896, D.76. Oil on canvas (?), dimensions unknown. Whereabouts unknown.
- 52 SCHUBERT AT THE PIANO, 1899, D.101. Oil on canvas, 150x200 cm. Formerly collection August Lederer, destroyed by fire 1945.
- 53 MARIE HENNEBERG, 1901-02, D.123. Oil on canvas, 140x140. Formerly collection Henneberg, Vienna, now at City Gallery Moritzberg, Halle.
- 54 CHARLOTTE PULITZER, 1915, D.190. Oil on canvas, 98x98 cm. Formerly collection August Lederer, whereabouts unknown since 1945.
- 55 POET AND MUSE, c.1884, D.19 A. Oil on cardboard, 31.5x30 cm. Collection Dr. F. Ephraim, Lugano.
- 56 MUSIC II, 1898, D.89. Oil on canvas, 150x200 cm. Formerly collection August Lederer, destroyed by fire 1945.
- 57 BEETHOVEN FRIEZE, 1902, D.127. Casein colors on stucco with semi-precious inlay divided into seven compartments on three walls, 220x2,400 cm. Osterreichische Galerie, Vienna.
- 58 PHILOSOPHY, final state, 1899-1907, D.105. Oil on canvas, 430x300 cm. Formerly Österreichische Galerie, Vienna, destroyed by fire 1945.
- 59 JURISPRUDENCE, 1903-07, D.128. Qil on canvas, 430x300 cm. Formerly Osterreichische Galerie, Vienna, destroyed by fire 1945.
- 60 HOPE II, 1907-08, D.155. Oil on canvas, 110x110 cm. Private collection, Vienna.

- 61 AFTER THE RAIN (GARDEN WITH CHICK-ENS IN ST. AGATHA), 1899, D.107. Oil on canvas, 80x40 cm. Osterreichische Galerie, Vienna, on loan to Neue Galerie der Stadt Linz Wolfgang-Gurlitt-Museum, Linz.
- 62 THE BLACK BULL, 1900-01, D.115. Oil on canvas. Private collection, Vienna.
- 63 TALL POPLARS II (APPROACHING THUNDERSTORM), 1903, D.135. Oil on canvas, 100x100 cm. Private collection, Vienna.
- 64 GARDEN PATH WITH CHICKENS, 1917, D.215. Oil on canvas, 110x110 cm. Formerly collection Erich Lederer, Geneva, destroyed by fire 1945.
- 65 STUDY FOR PORTRAIT OF SONJA KNIPS, 1898. Pencil and black crayon, 45.2x 32.4 cm. Historisches Museum der Stadt Wien, Vienna.
- 66 STUDY FOR PORTRAIT OF ADELE BLOCH-BAUER I, c.1900. Black crayon, 45x31 cm. Albertina, Vienna.
- 67 STUDY FOR PORTRAIT OF FRITZA RIEDLER, 1906. Black crayon, 45.2x31.6 cm. Historisches Museum der Stadt Wien, Vienna.
- 68 STUDY FOR PORTRAIT OF ADELE BLOCH-BAUER II, 1912. Pencil, 56.7x37.2 cm. Albertina, Vienna.
- 69 TEN COMPOSITION STUDIES FOR MÄDA PRIMAVESI, c.1912. From E. Pirchan, Gustav Klimt.
- 70 STUDY FOR PORTRAIT OF CHARLOTTE PULITZER, c.1915. Pencil. Collection Viktor Fogarassy, Graz.
- 71 STUDY FOR PORTRAIT OF A WOMAN, 1914–16. Pencil, 56.9x37.5 cm. Albertina, Vienna.
- 72 BABY STUDIES, 1917-18. Pencil. Collection Viktor Fogarassy, Graz.
- 73 SCULPTURE, 1896. Black crayon and pencil with white chalk and gold, 41.8x 31.3 cm. Historisches Museum der Stadt Wien, Vienna.
- 74a, Drawings for TWO EMBLEMS FOR VER
 74b SACRUM: NUDA VERITAS AND DER NEID,
 1898. Courtesy, Galerie Welz, Salzburg.
- 75 COMPOSITION STUDY FOR PHILOSOPHY, 1898-99. Black crayon and pencil, 89.6x63.2 cm. Historisches Museum der Stadt Wien, Vienna.
- 76a FLOATING FEMALE STUDY FOR MEDICINE, c.1898. Private collection, Dallas.
- 76b STUDY OF EMBRACING FIGURES FOR MEDICINE, 1898–1900. Pencil, 43x29 cm. Albertina, Vienna.
- 77 COMPOSITION STUDY FOR MEDICINE, 1899-1900. Black crayon and pencil, 86x62 cm. Albertina, Vienna.
- 78 STUDY FOR EXPECTATION, c.1906. Pencil, 55.8x36.9 cm. Collection Dr. Hermann Goja.
- 79 STUDY FOR THE VIRGIN, 1913. Pencil, 56.6x37 cm. Drawing Collection of the Federal College of Technology, Zurich.
- 80 SIX POSTER DESIGNS FOR OTTO WAGNER EXHIBITION, c.1914-16. Pencil. Collection Erich Lederer, Geneva.

The Plates

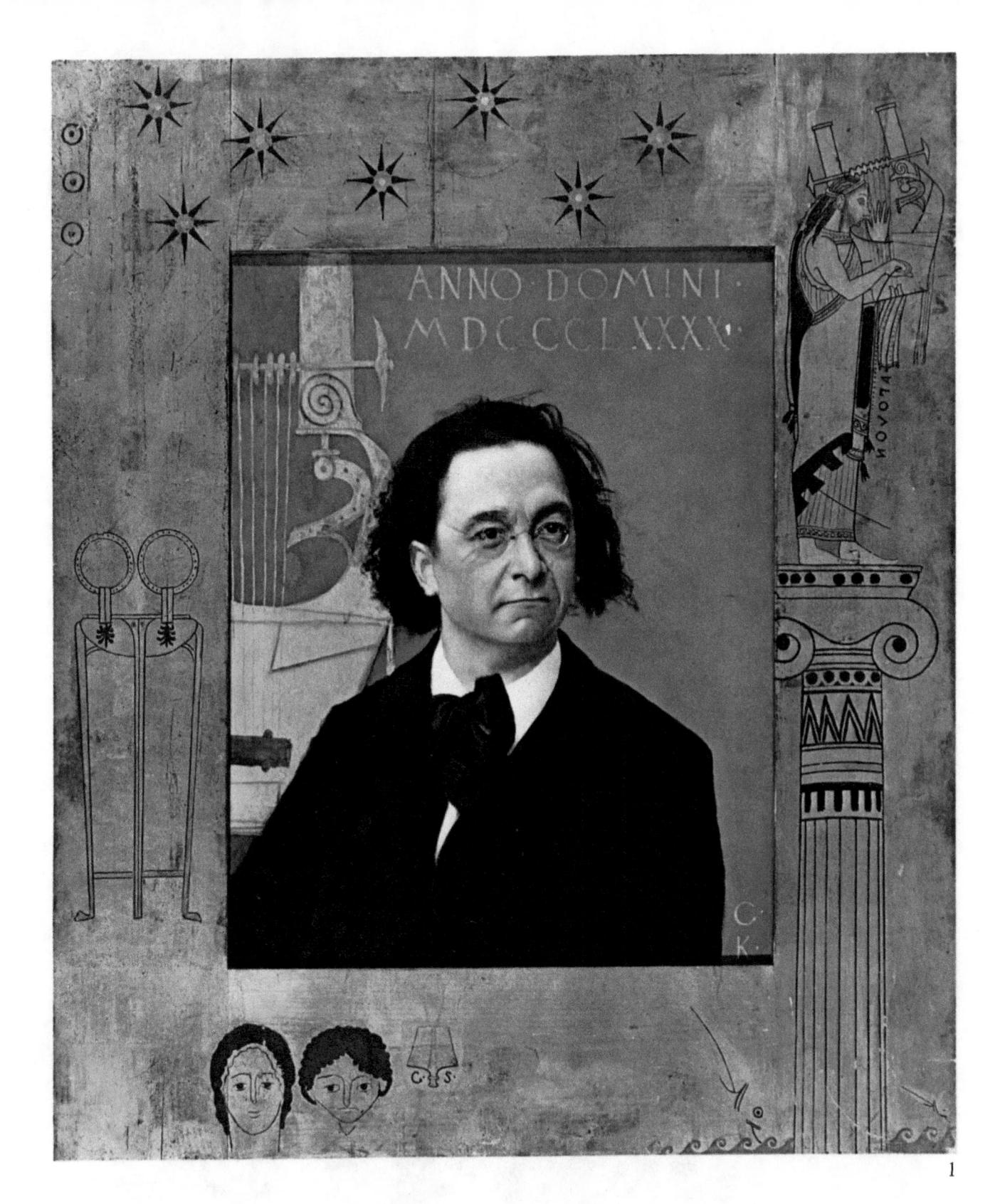

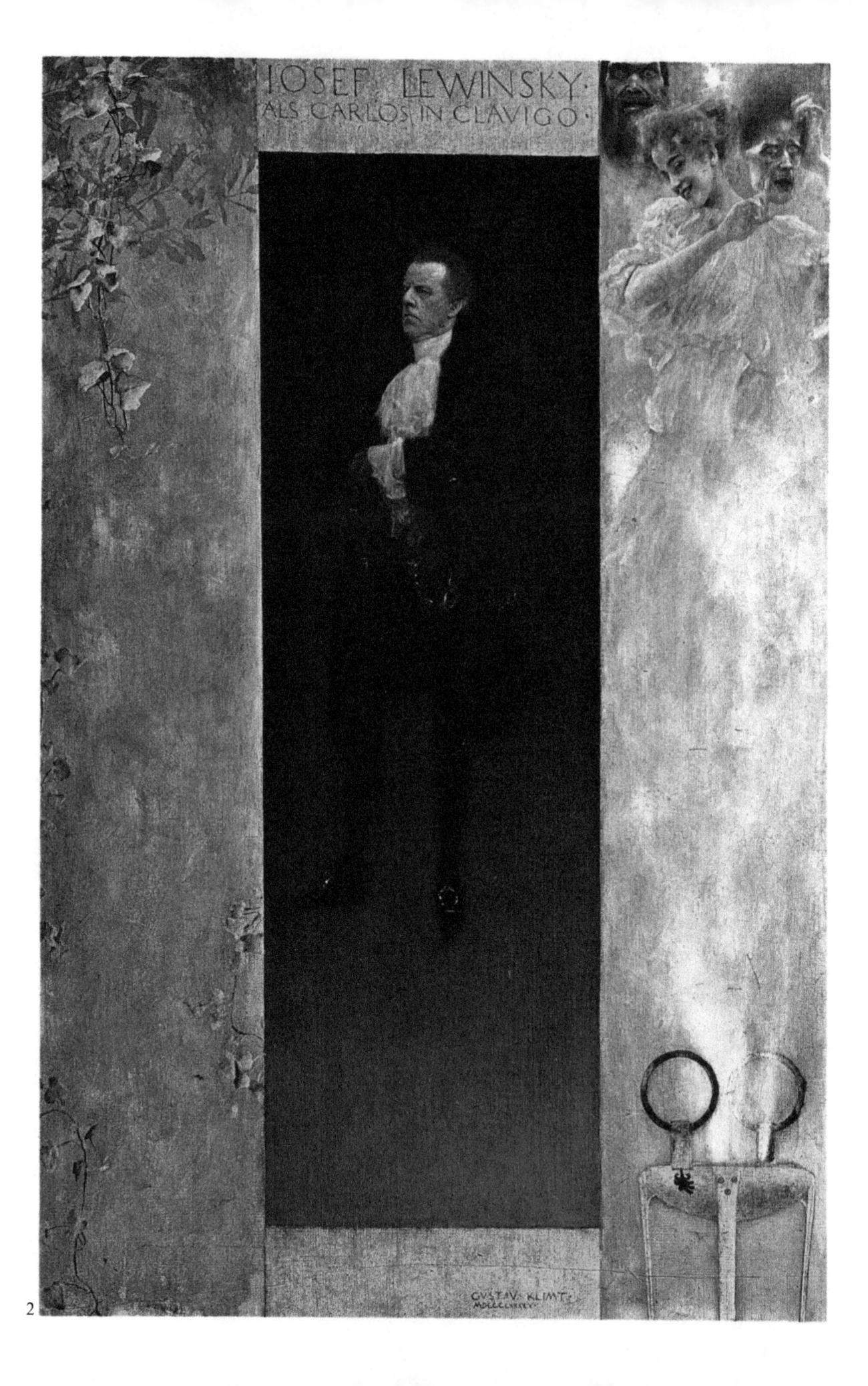

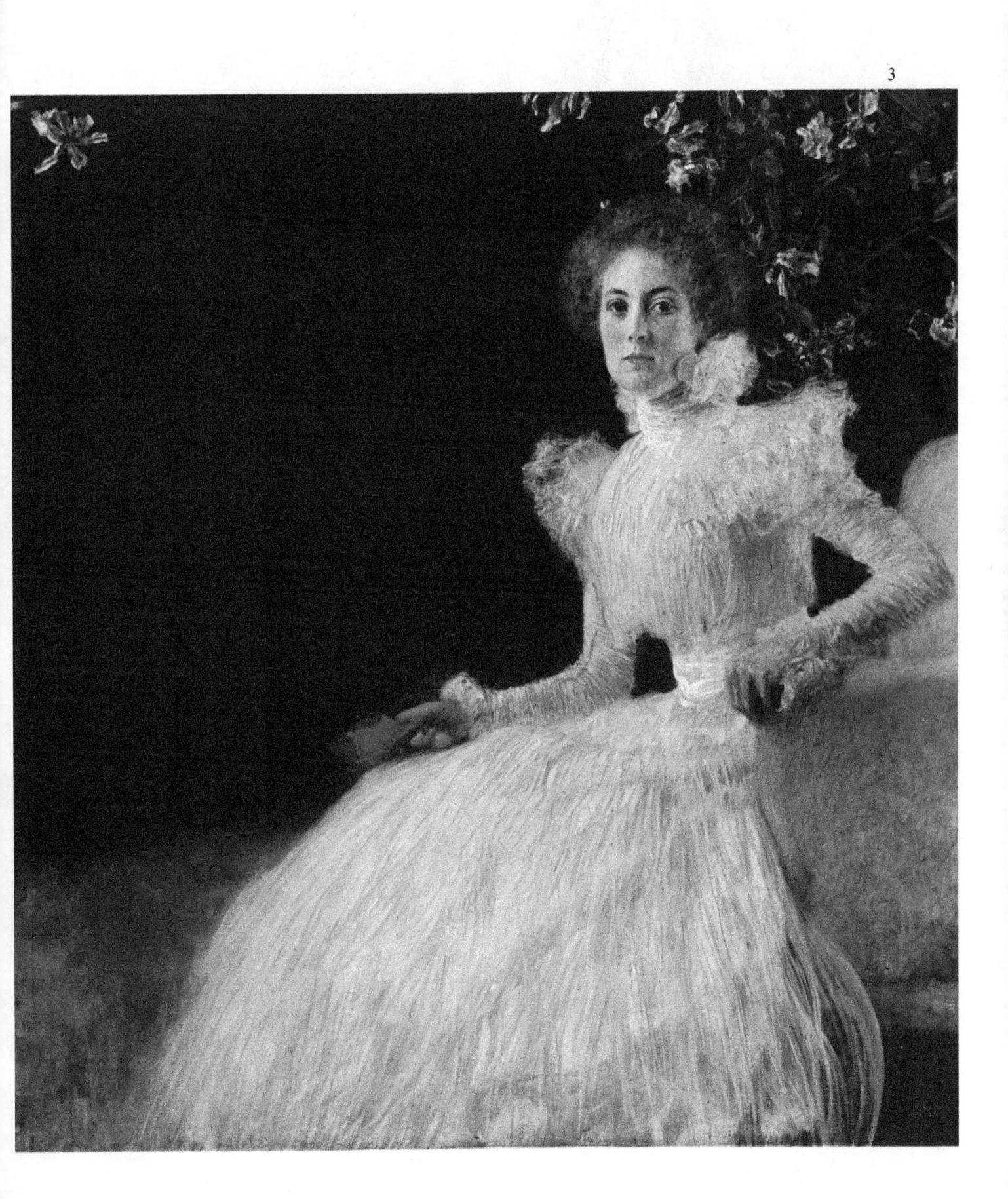

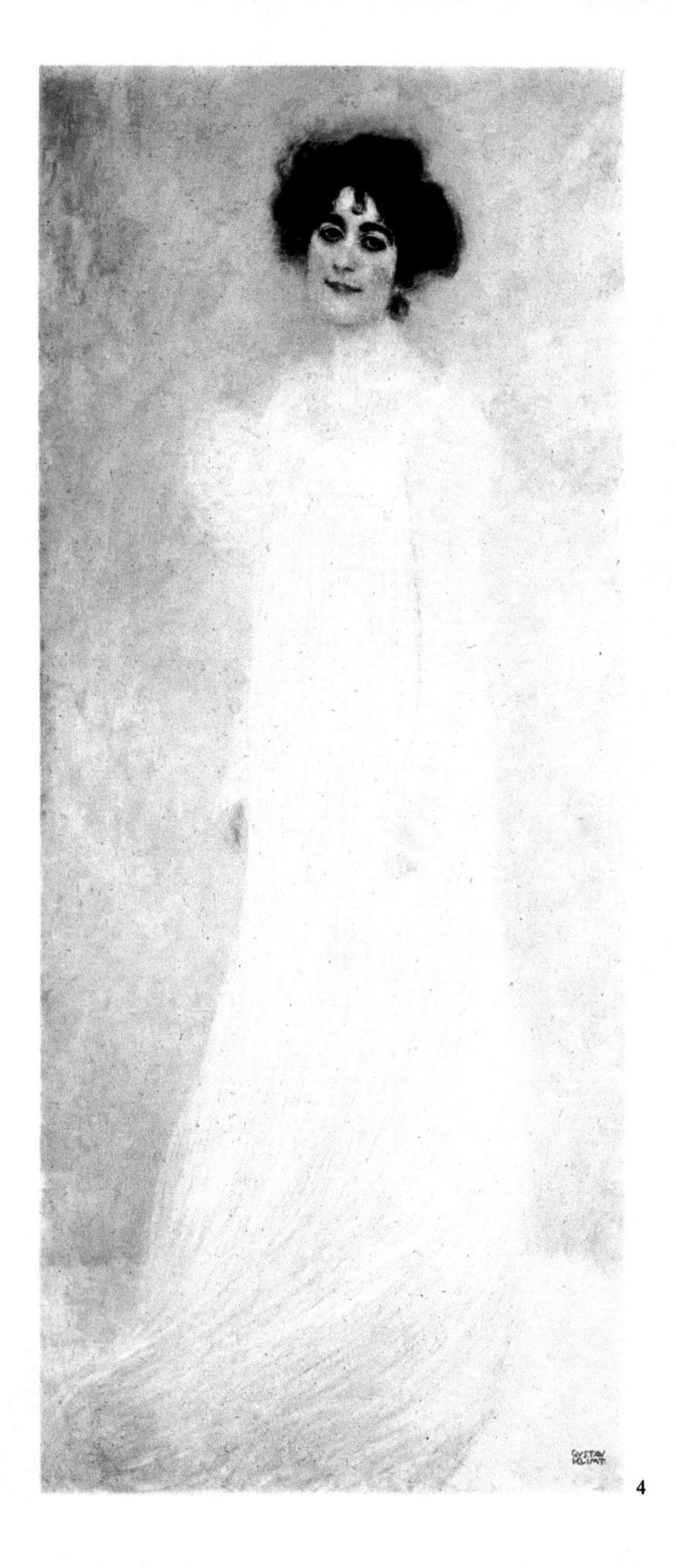

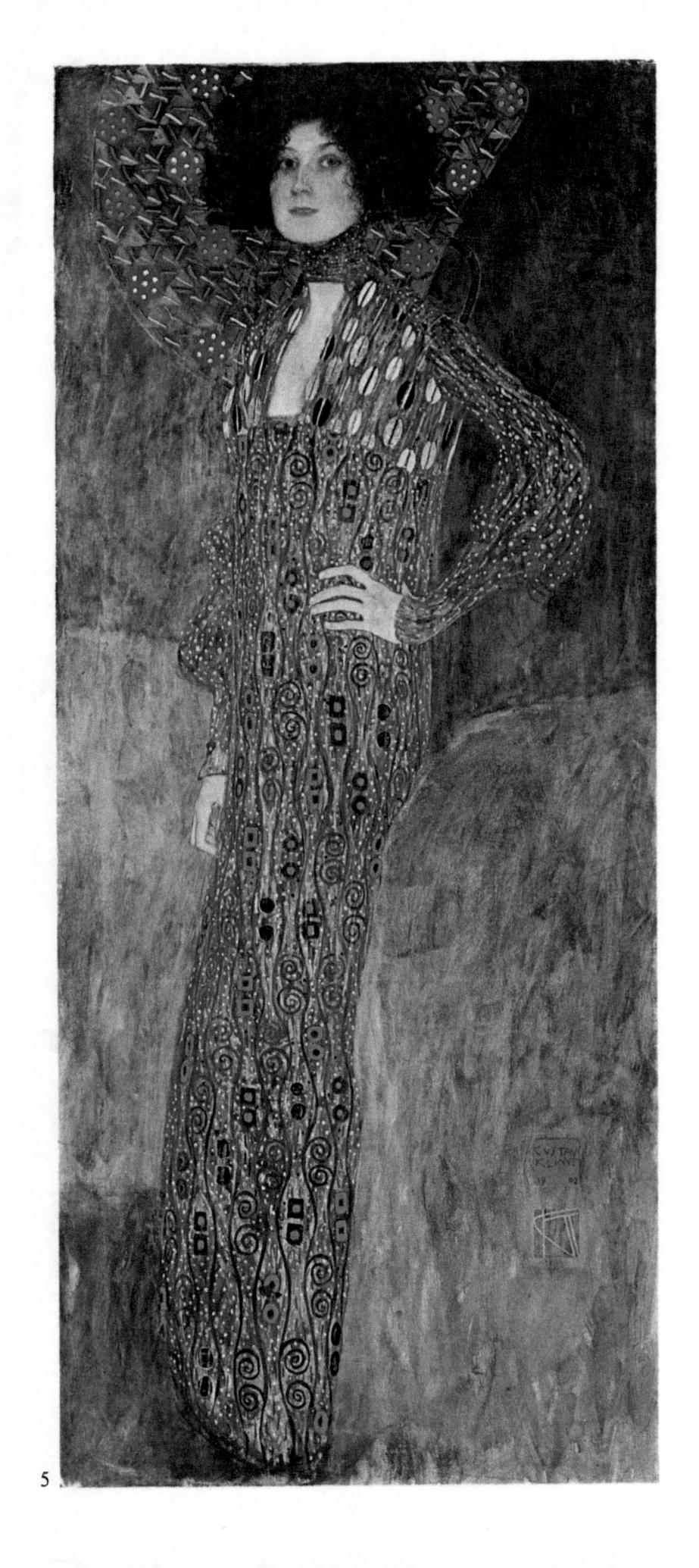

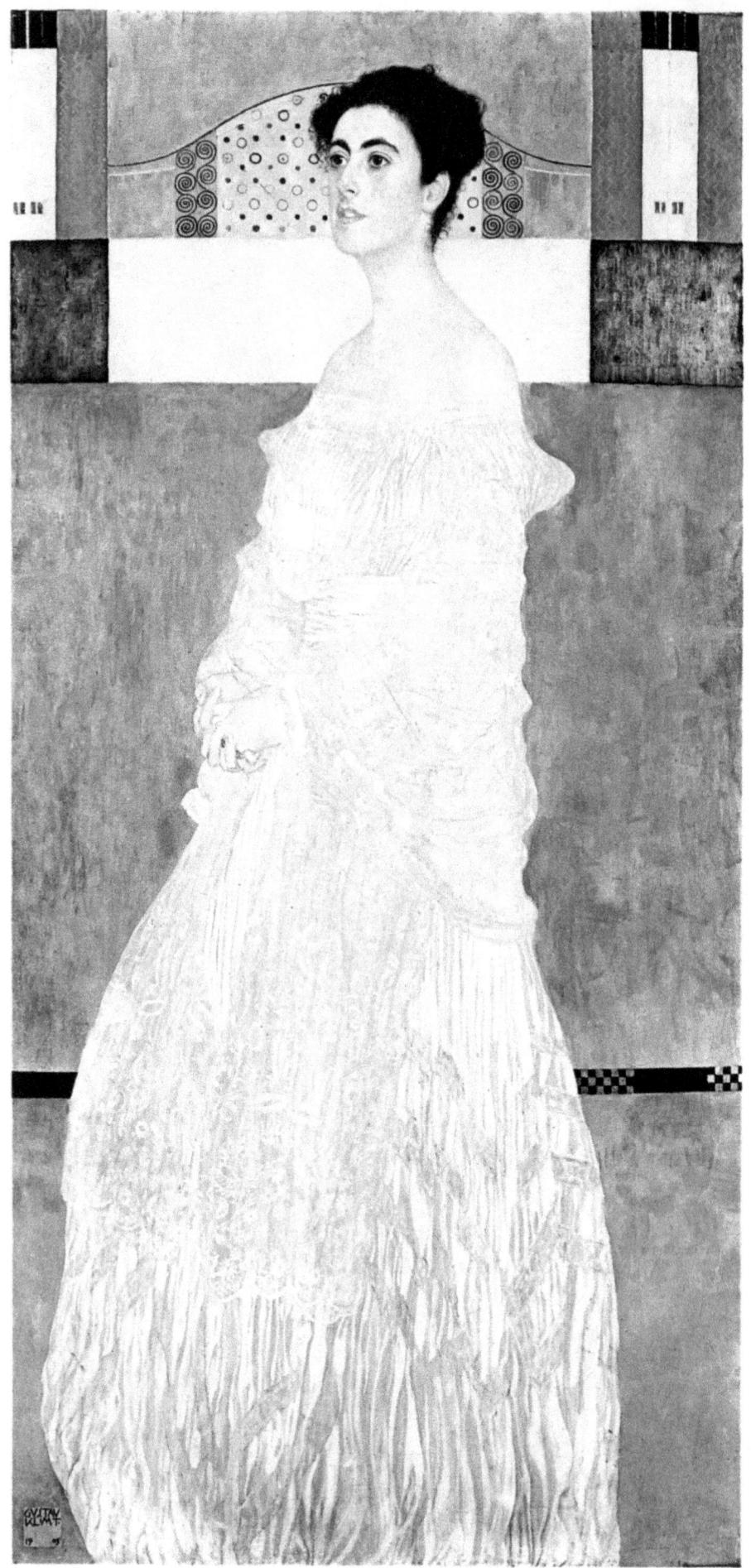

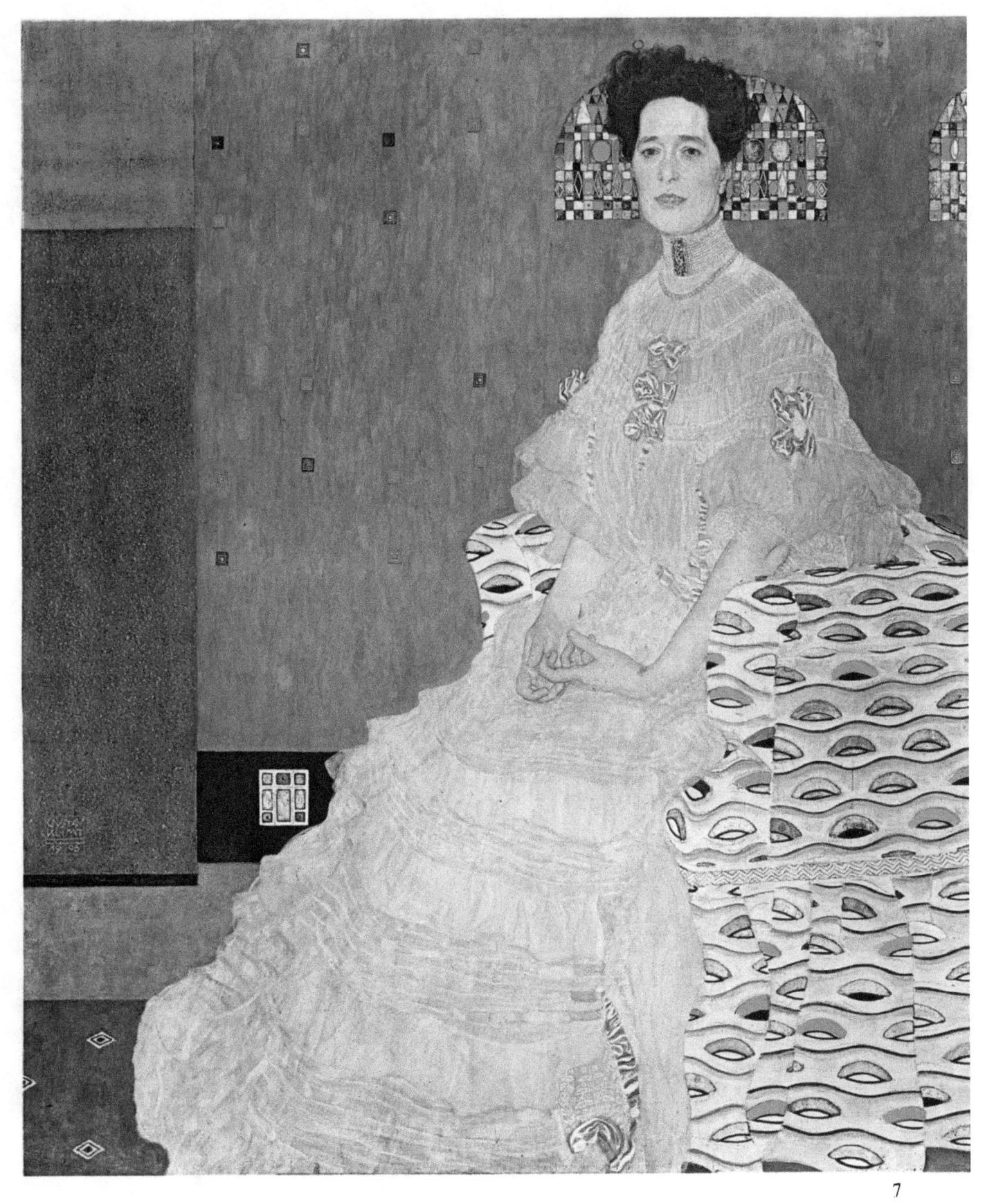

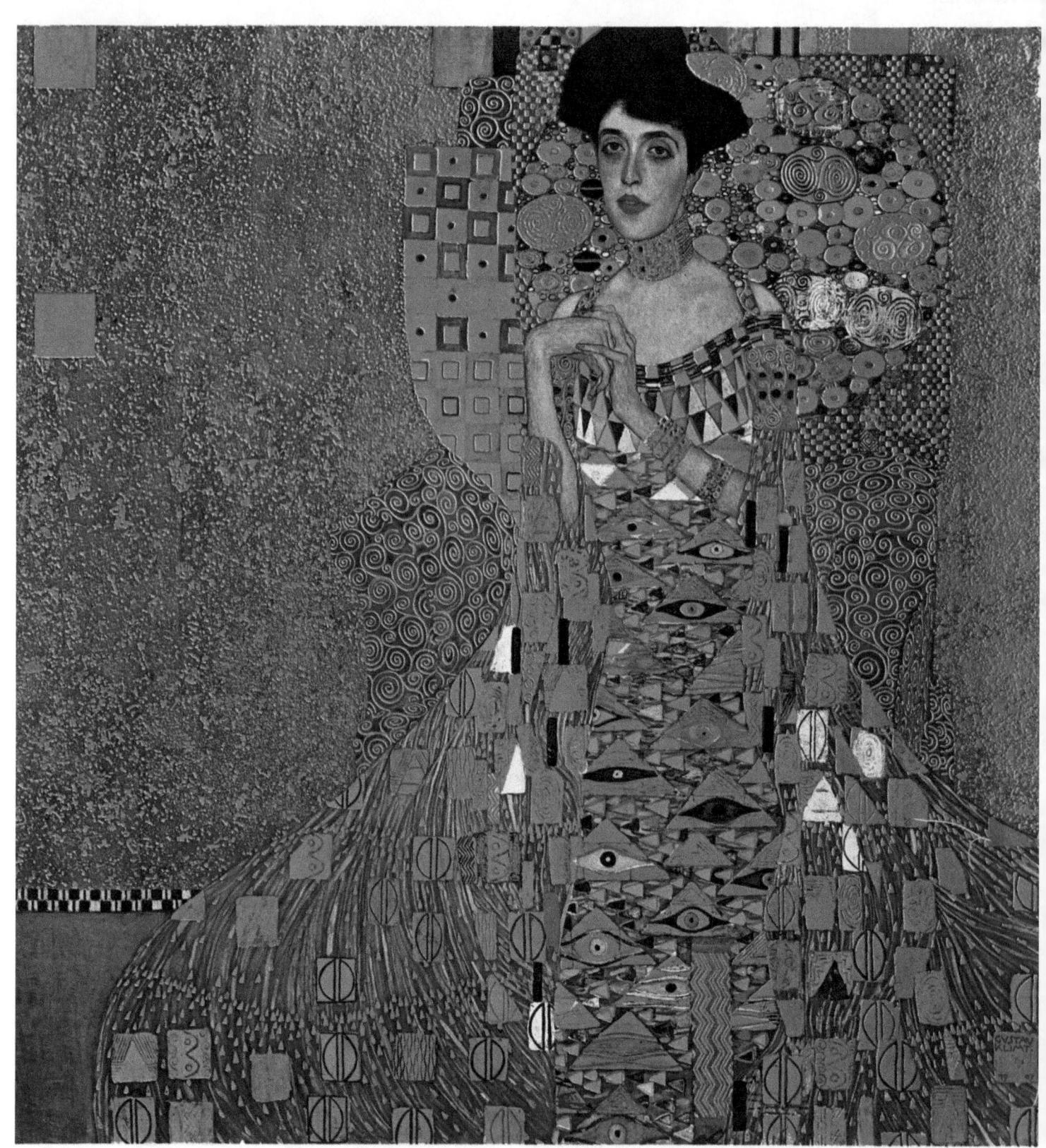

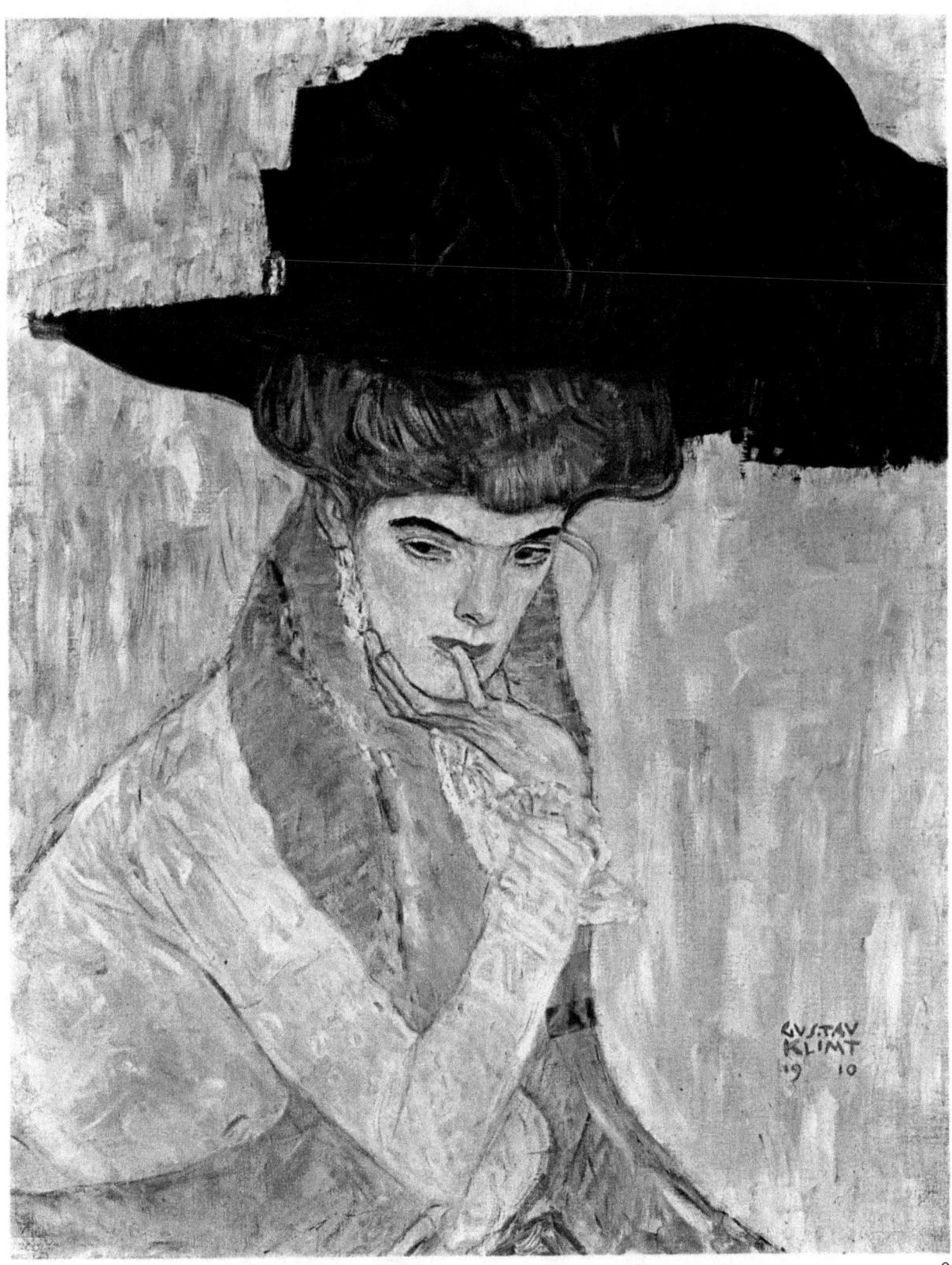

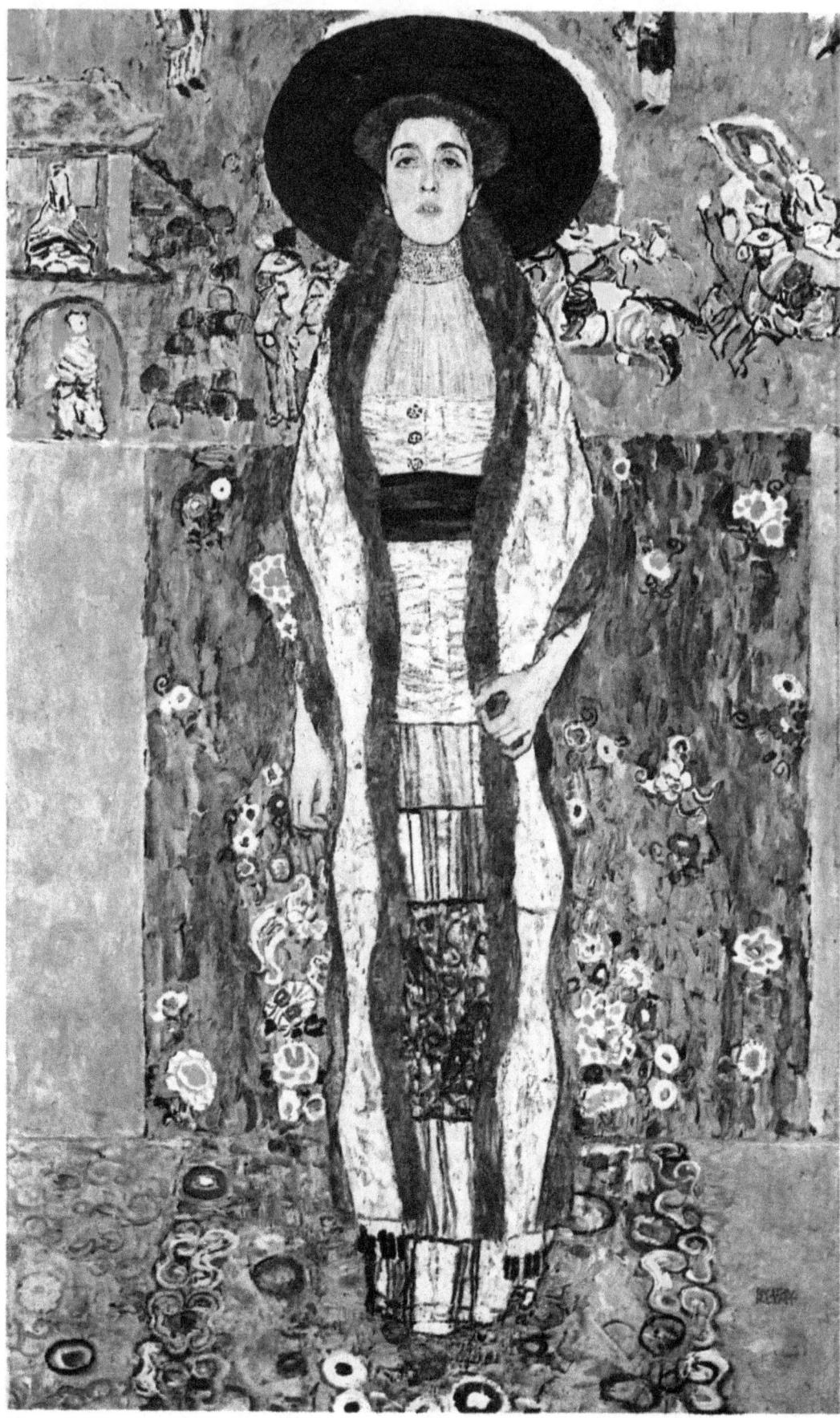

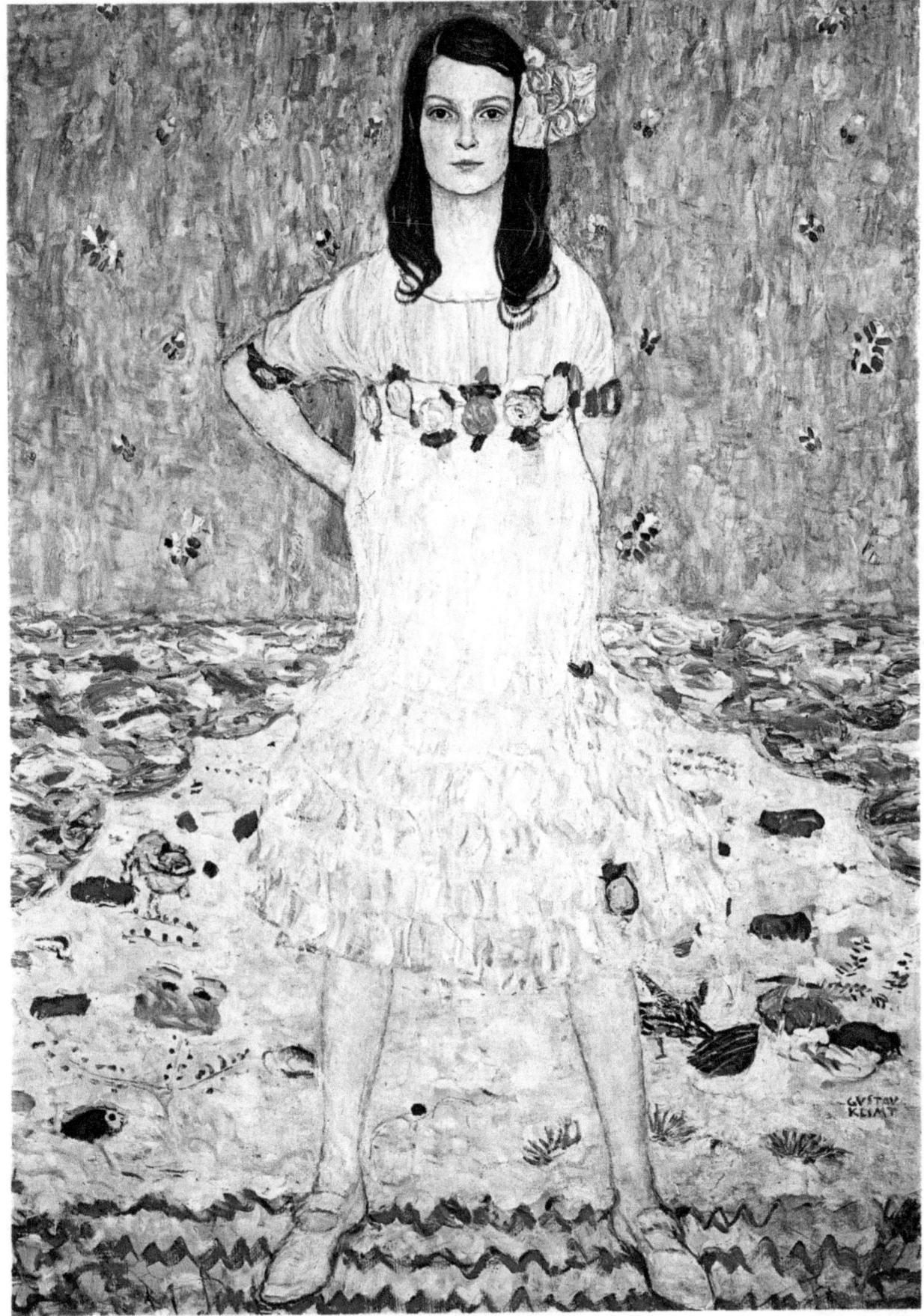

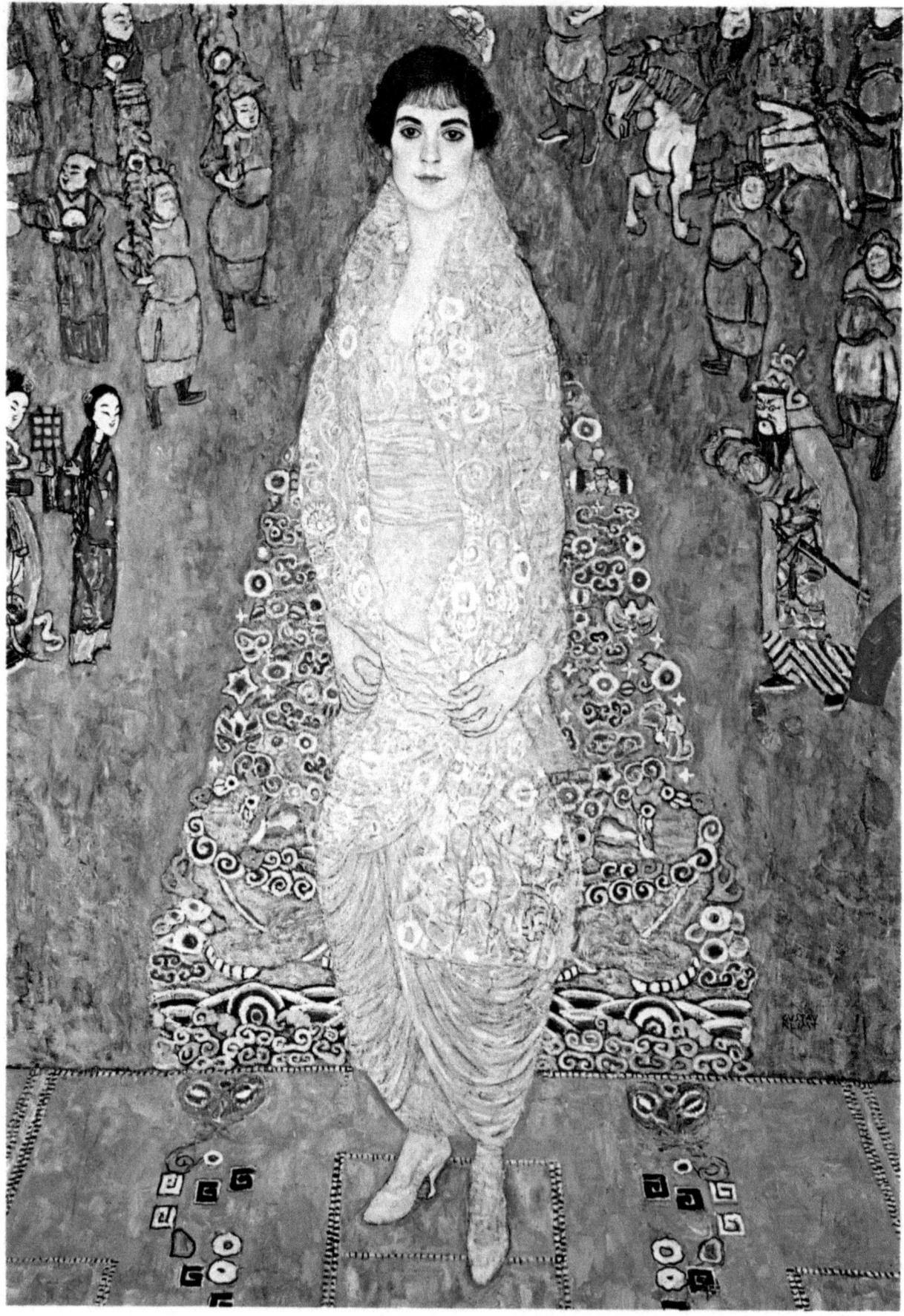

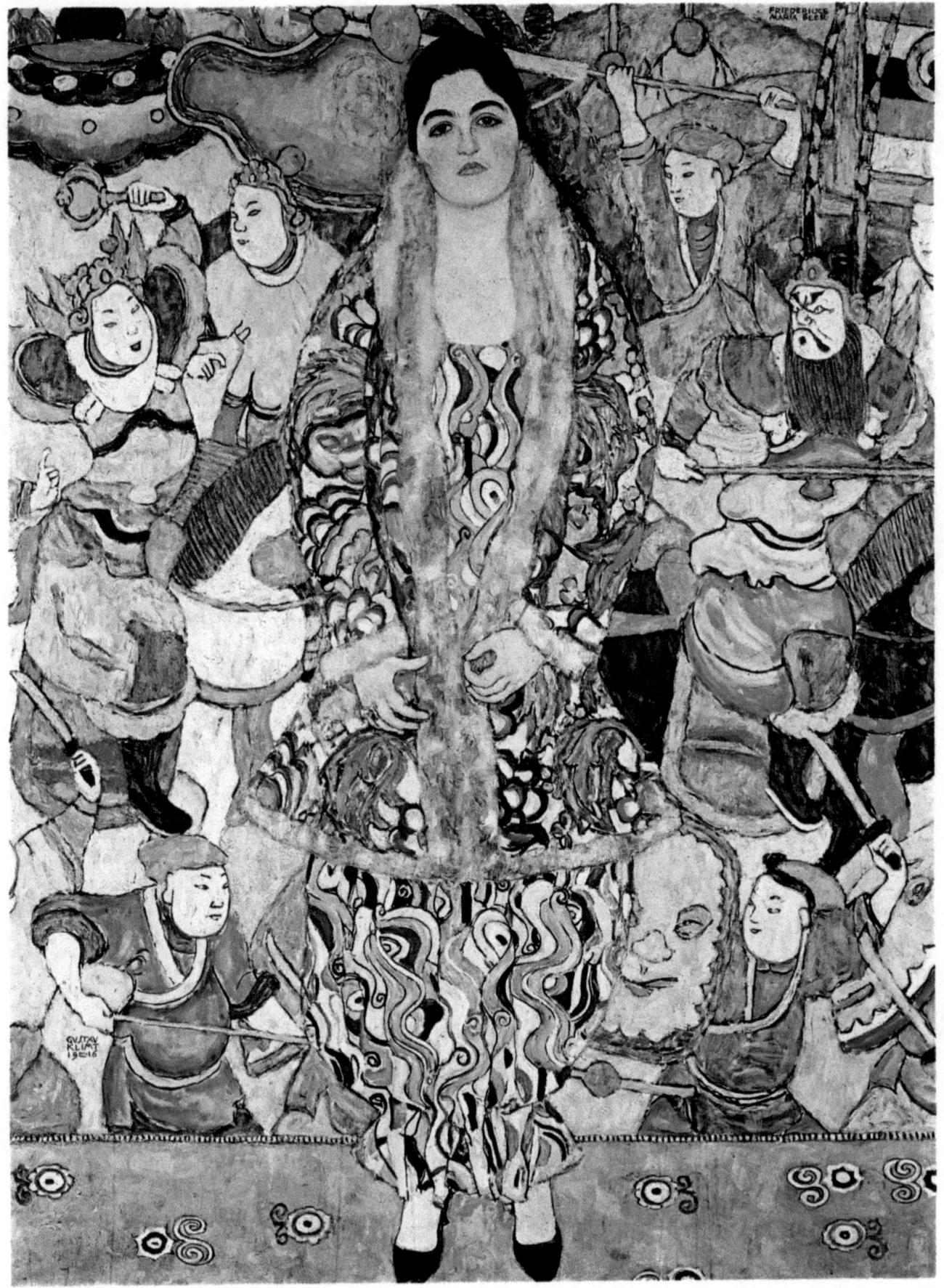

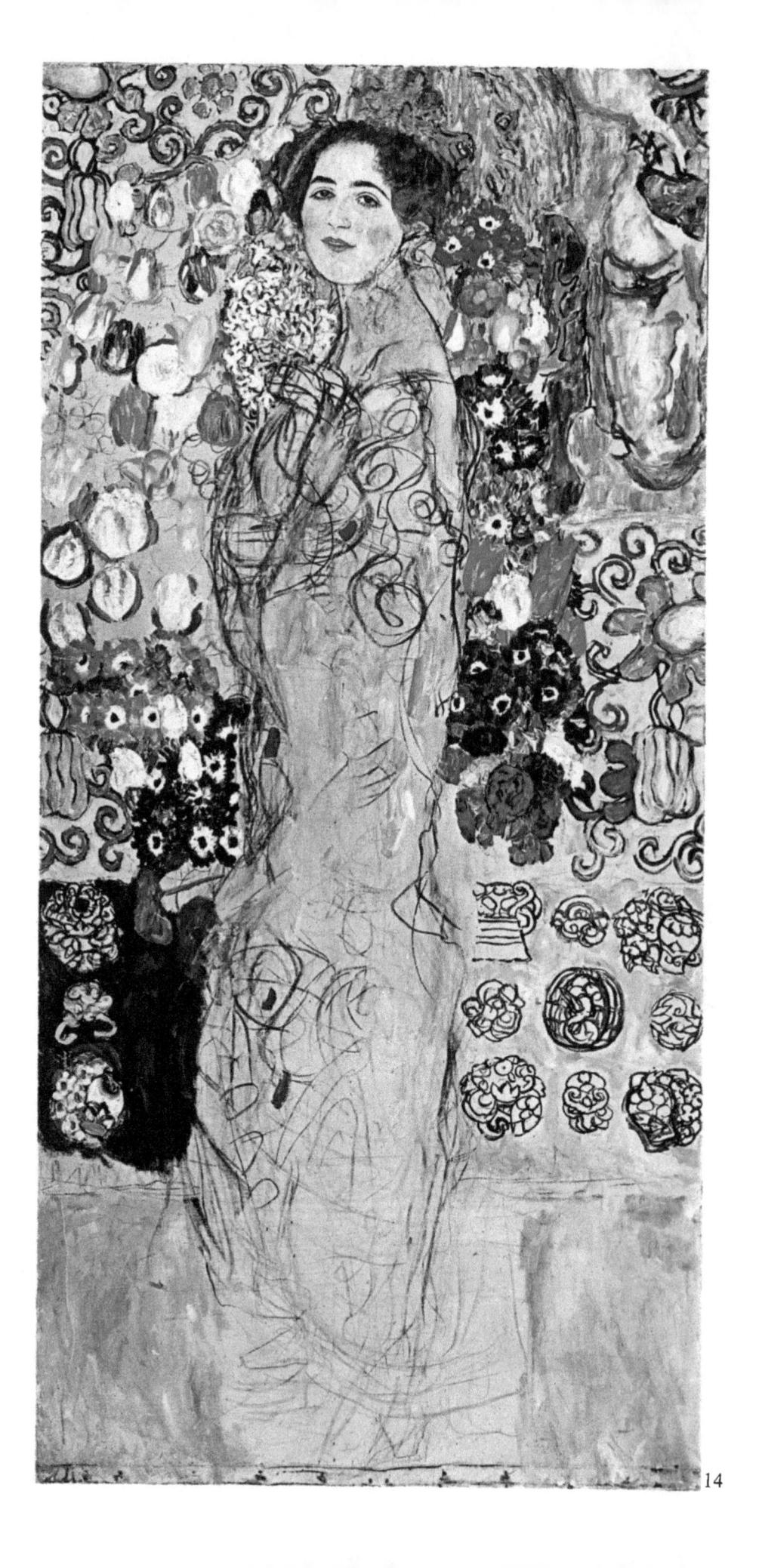

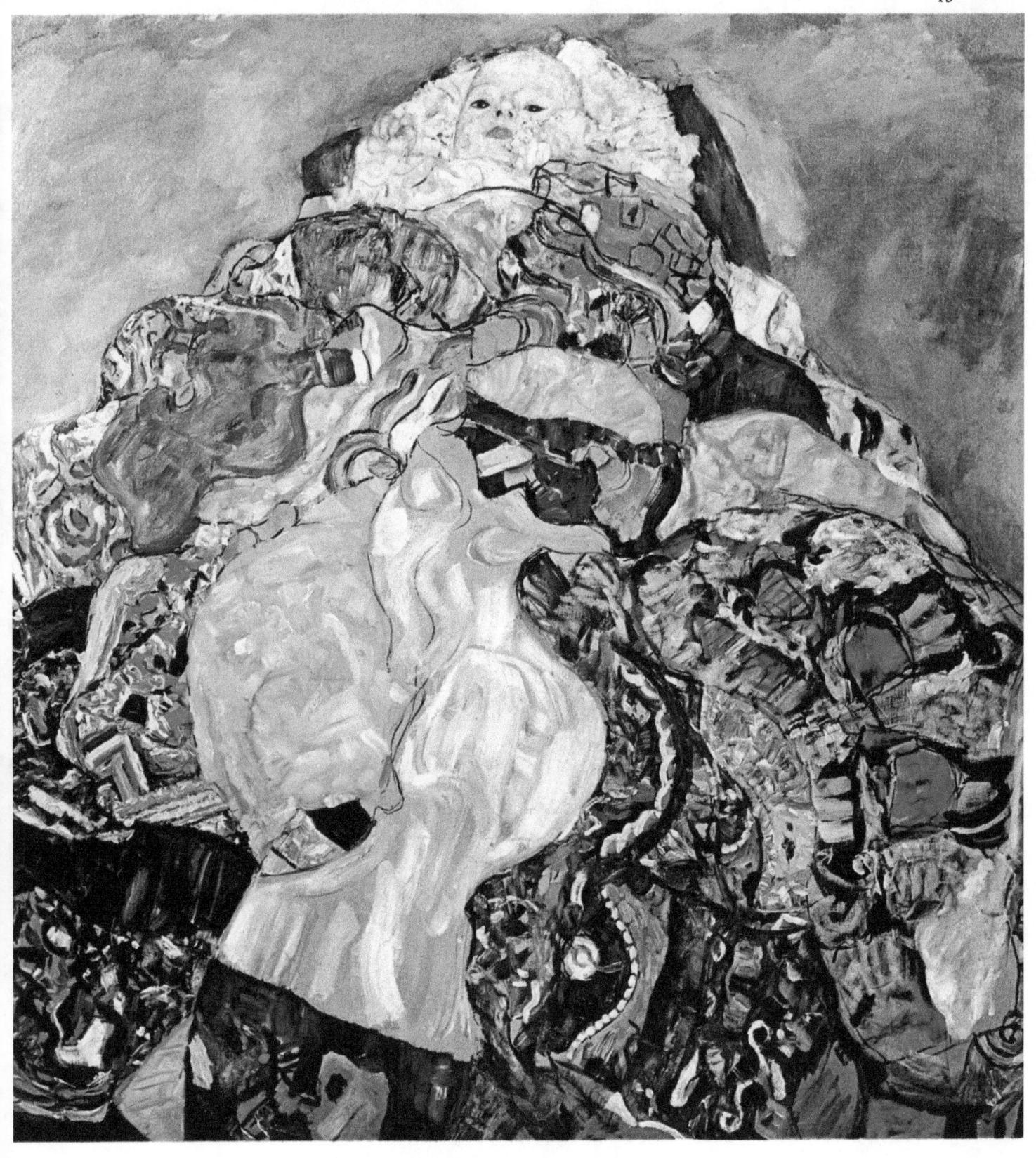

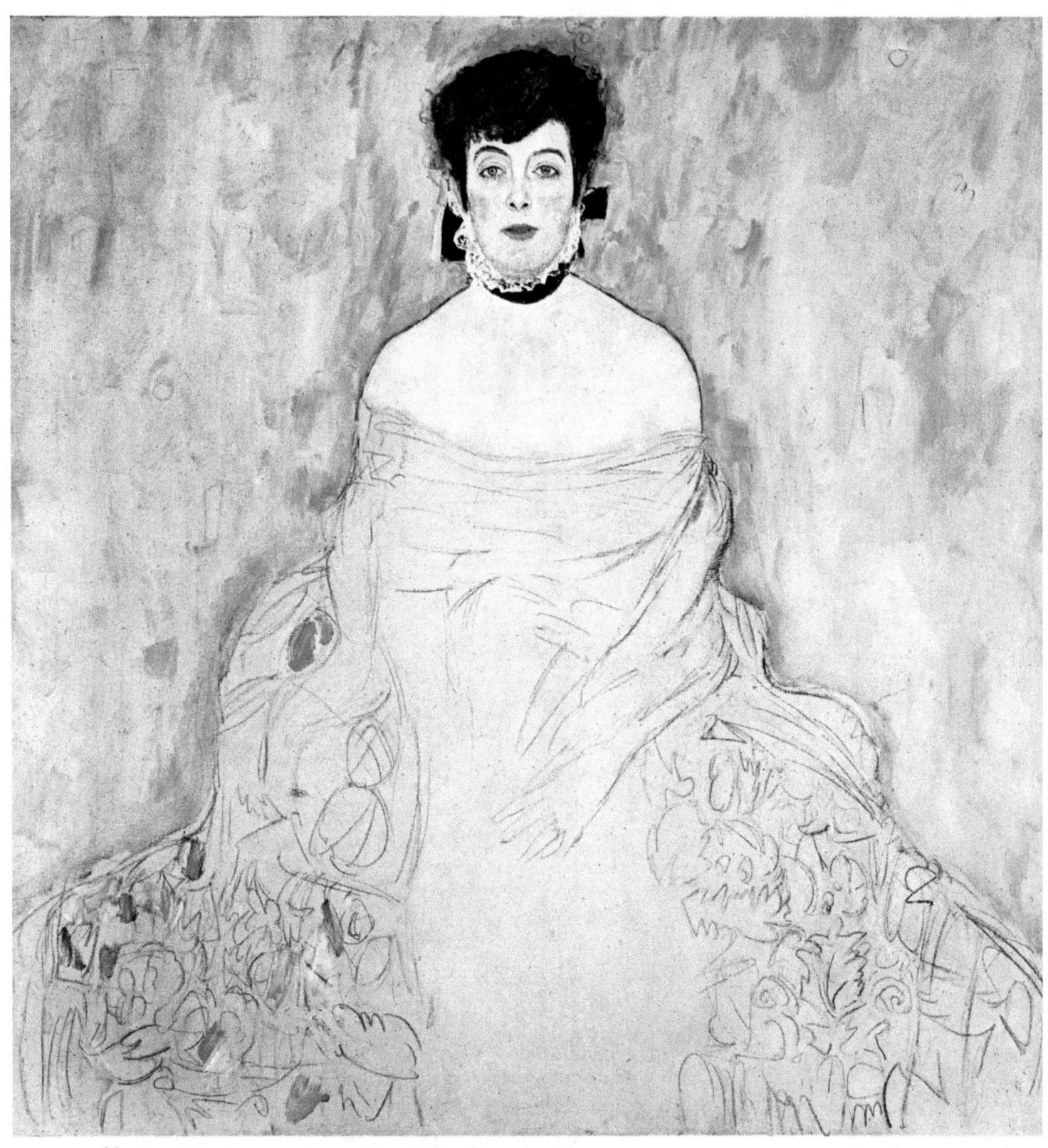

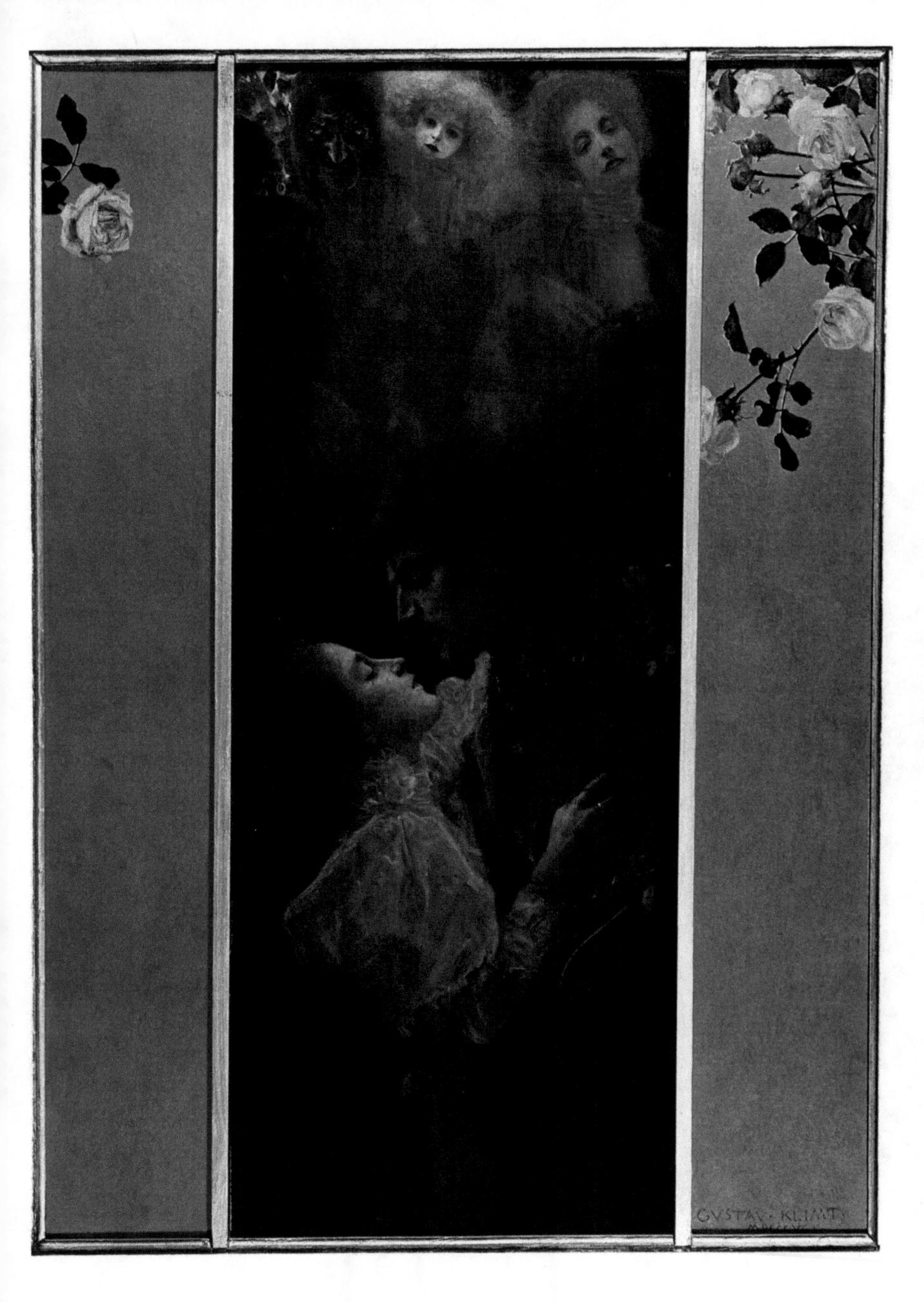

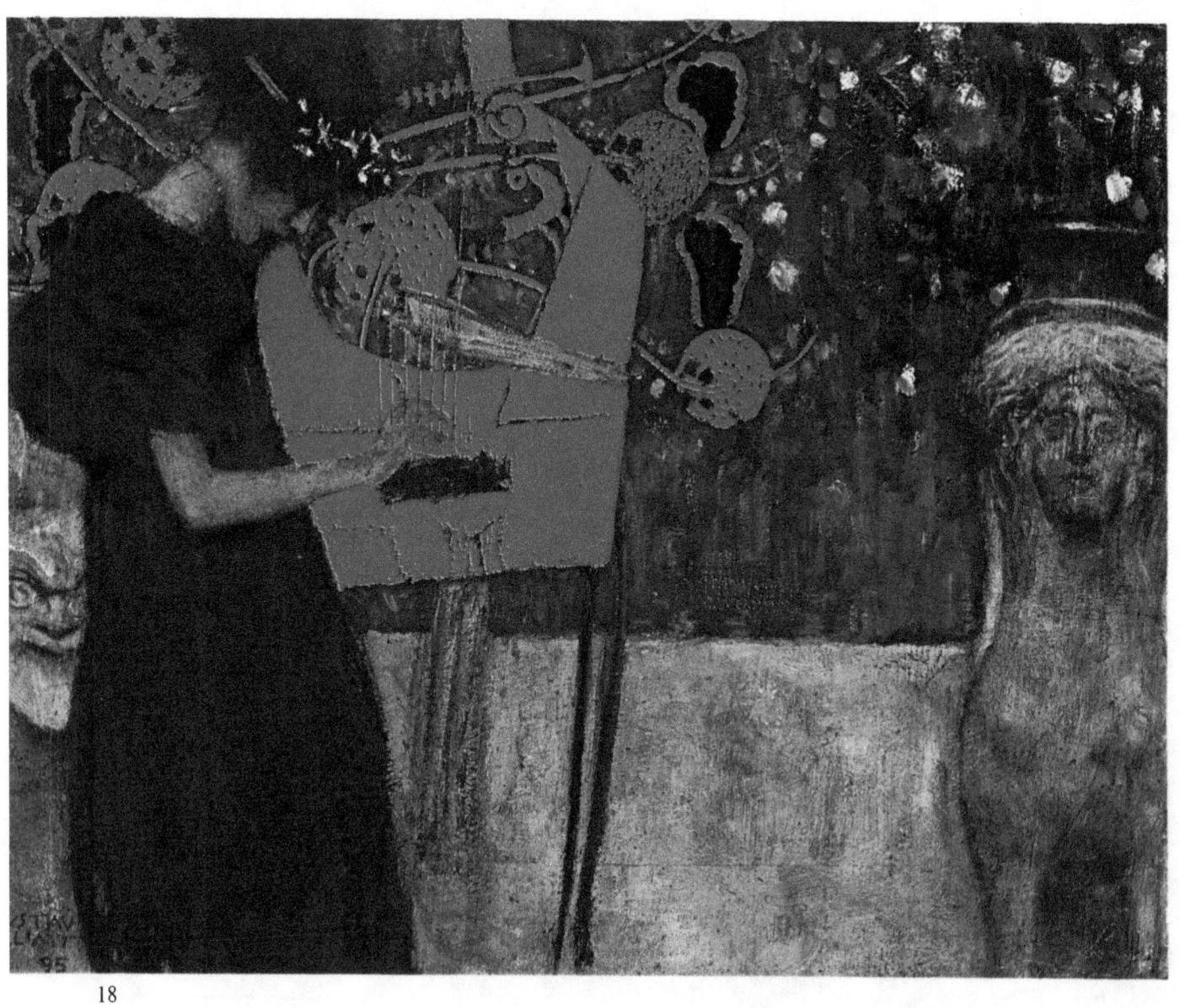

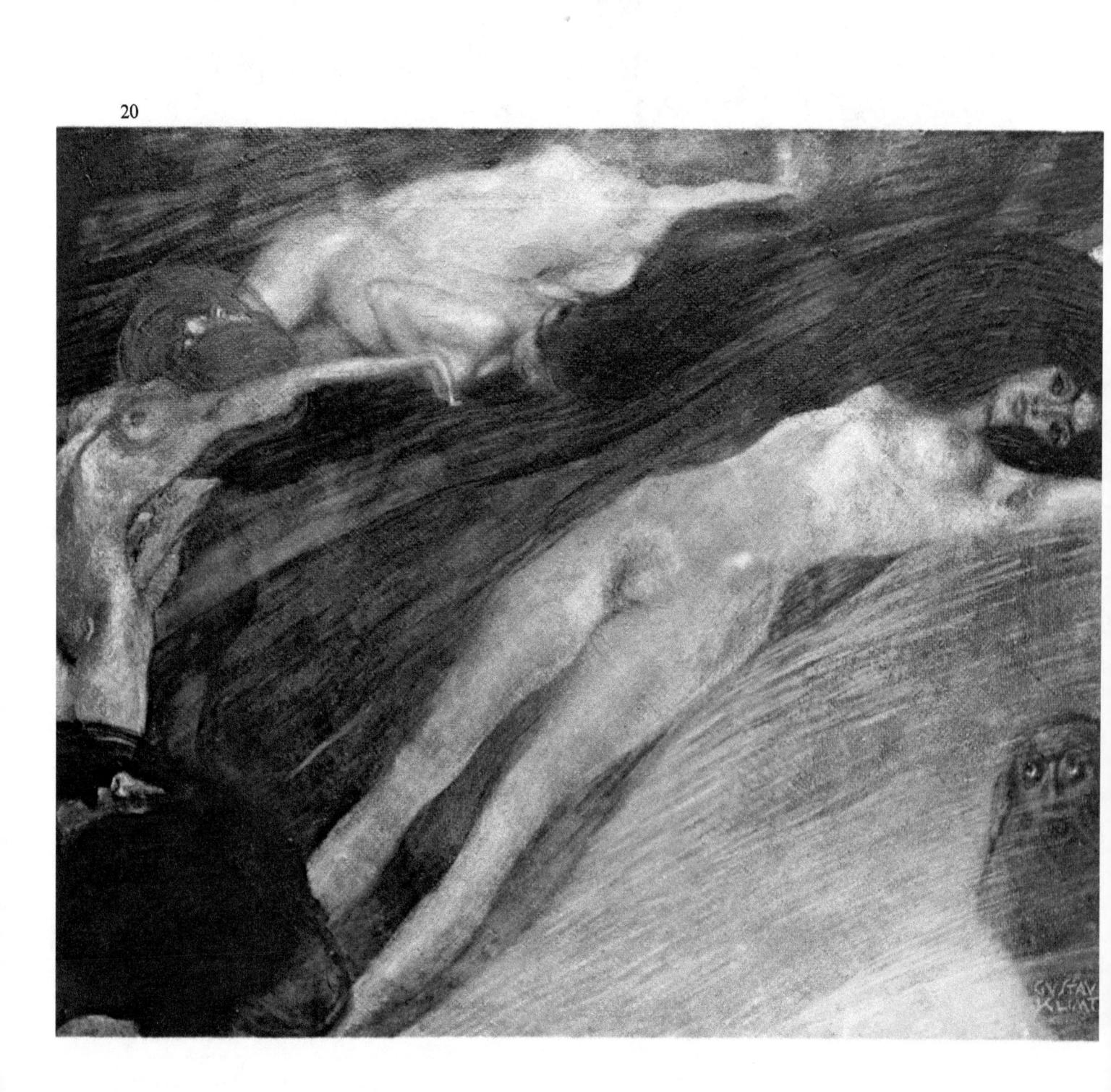

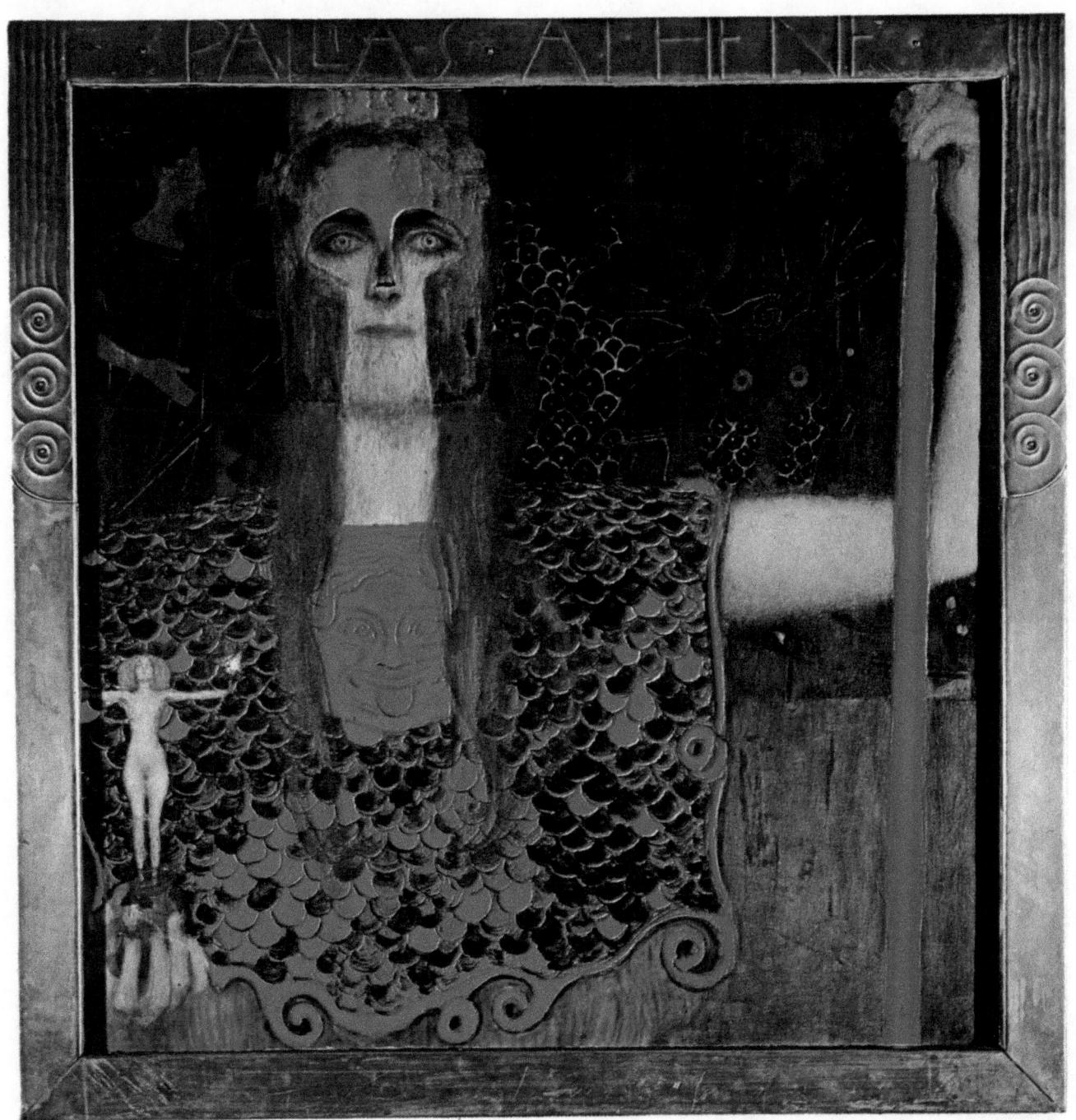

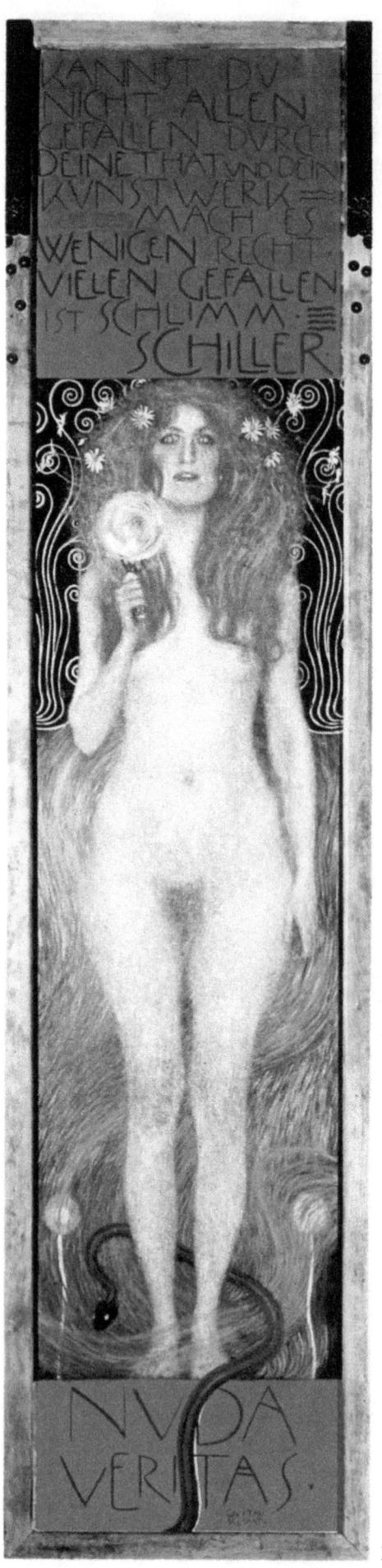
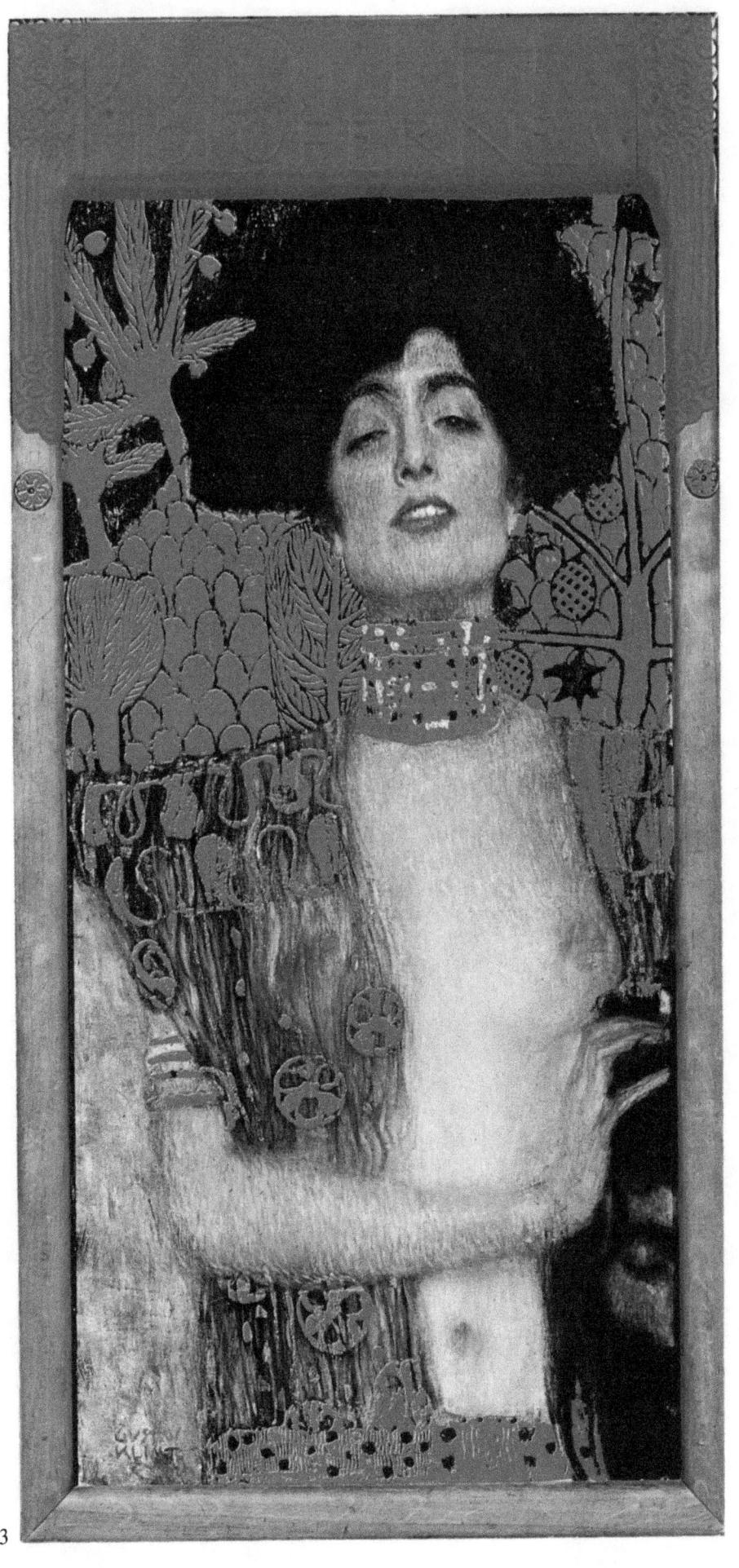

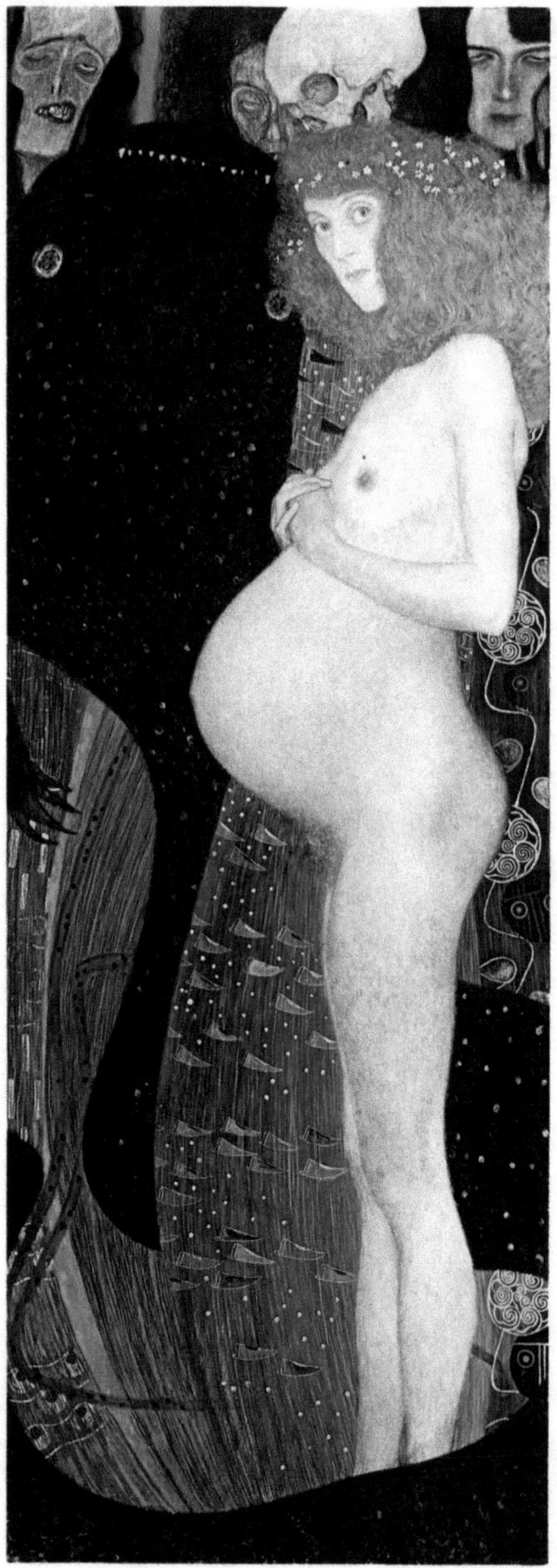

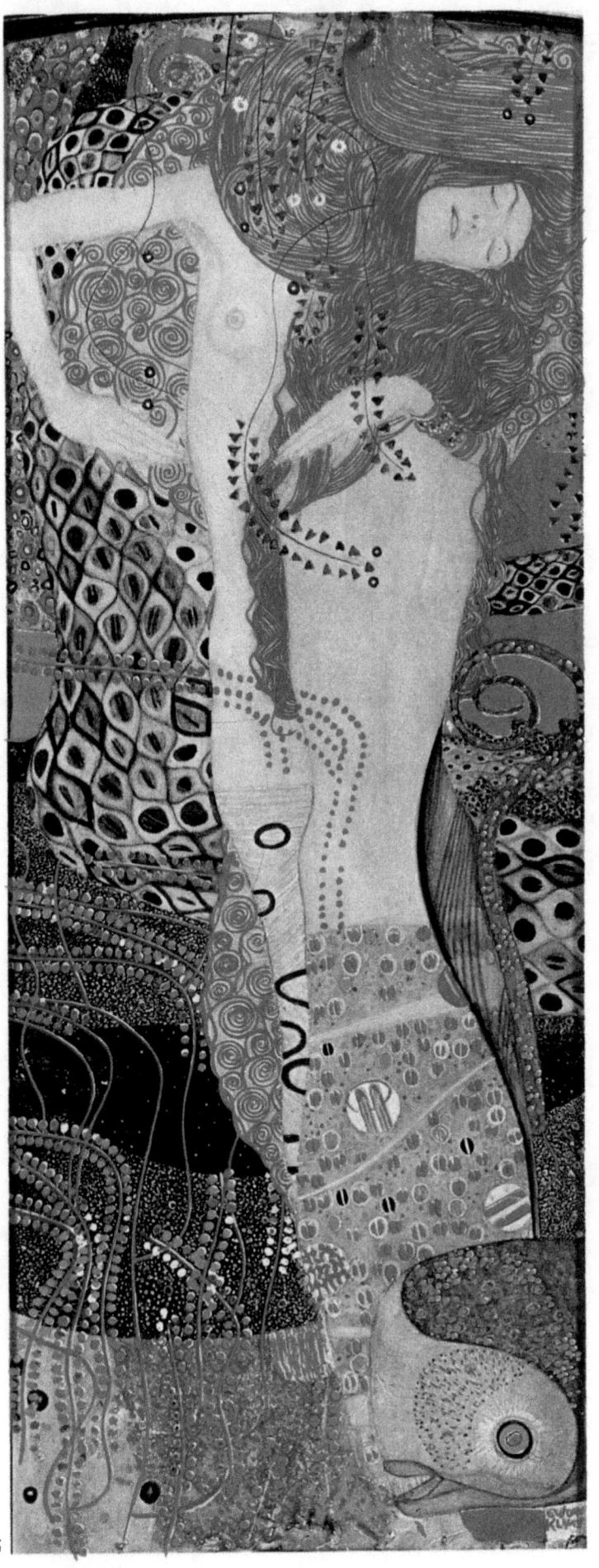

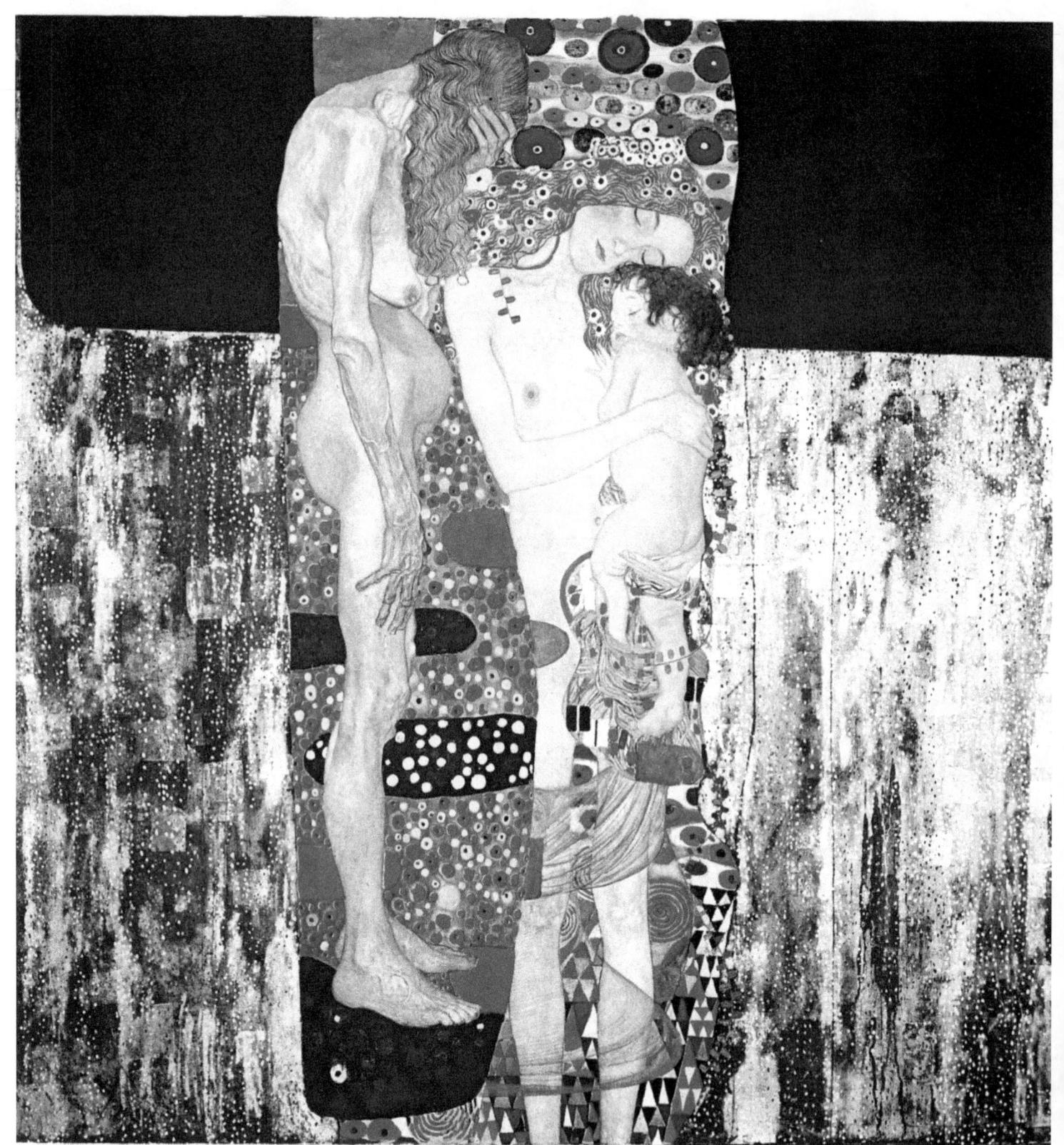

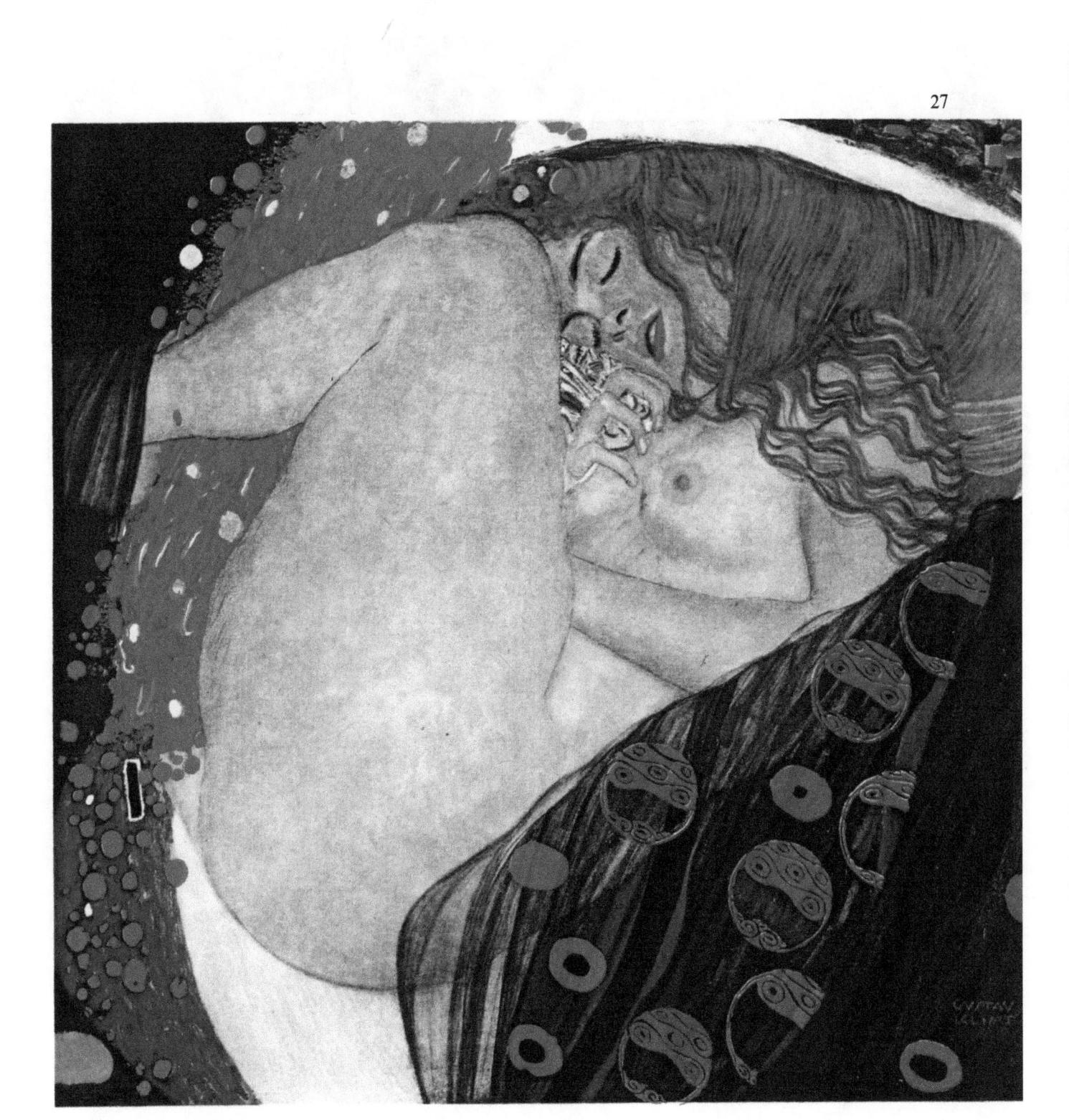

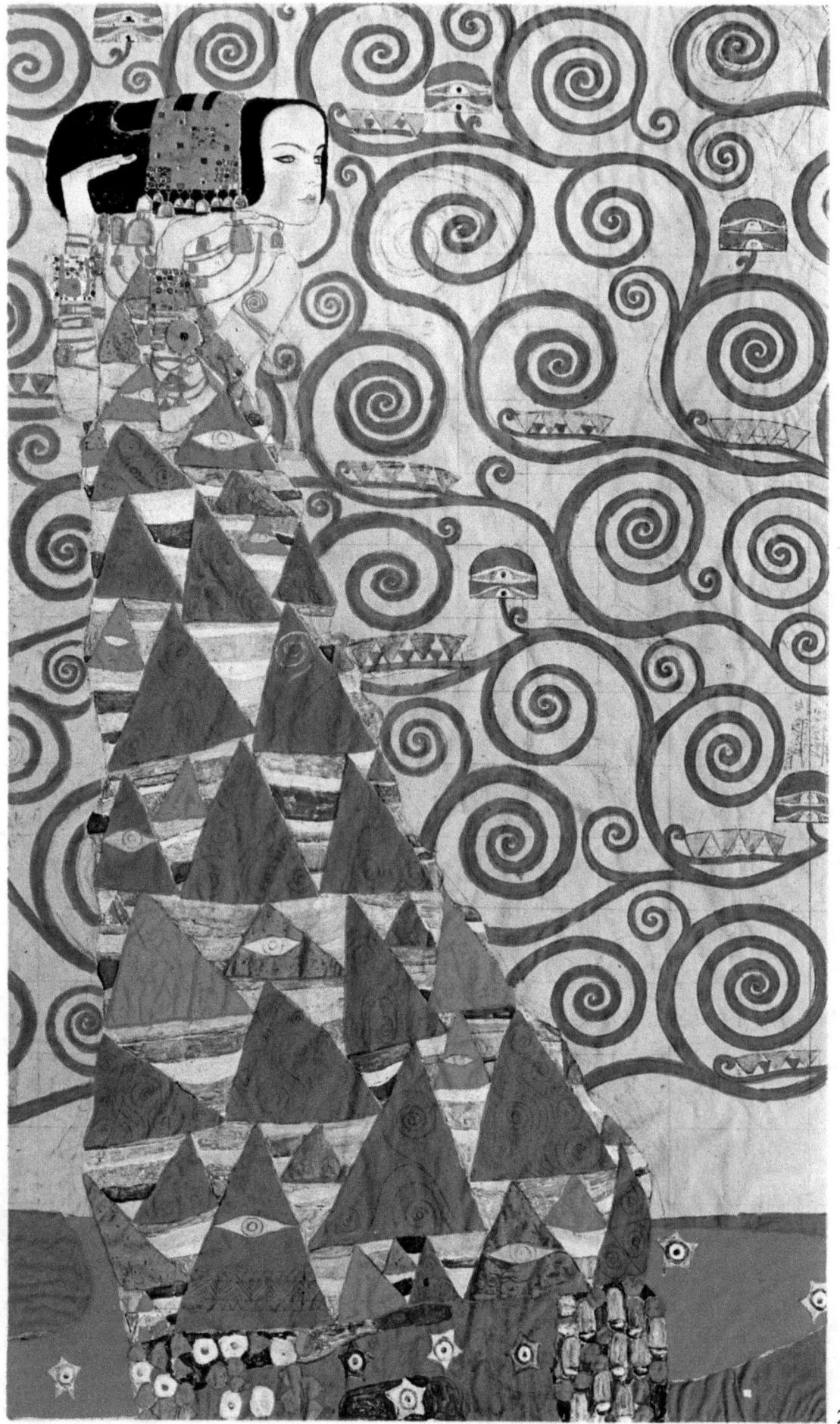

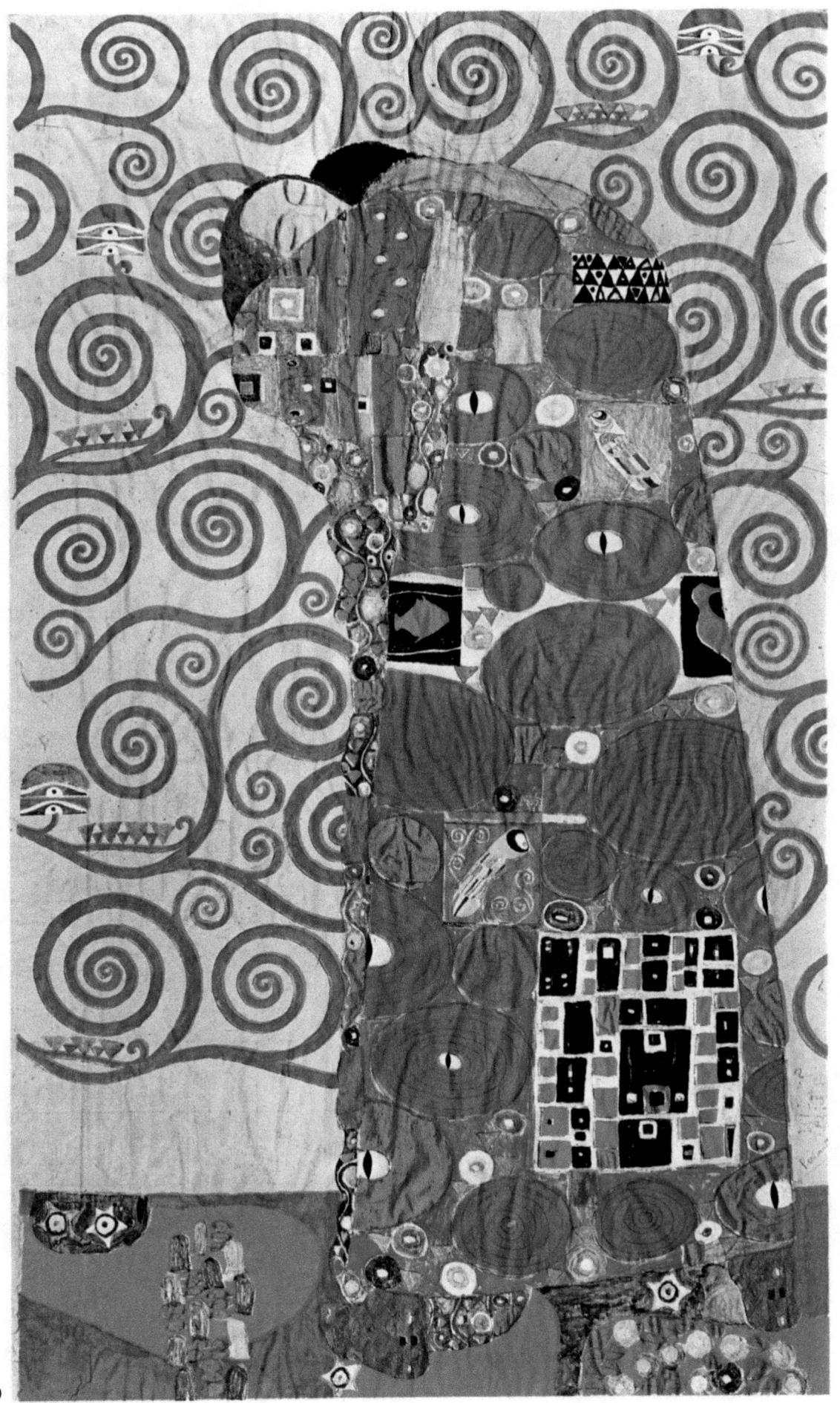

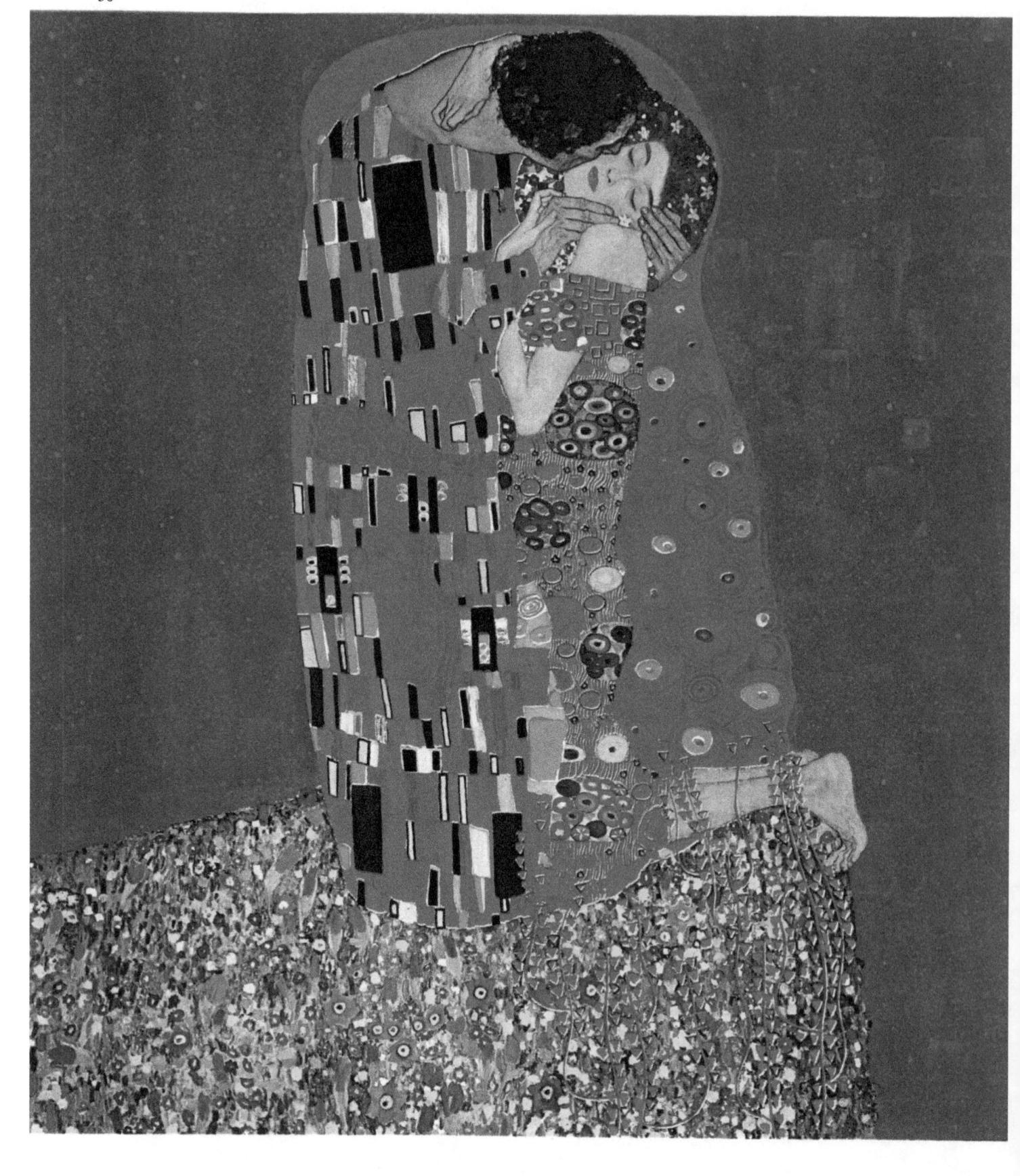

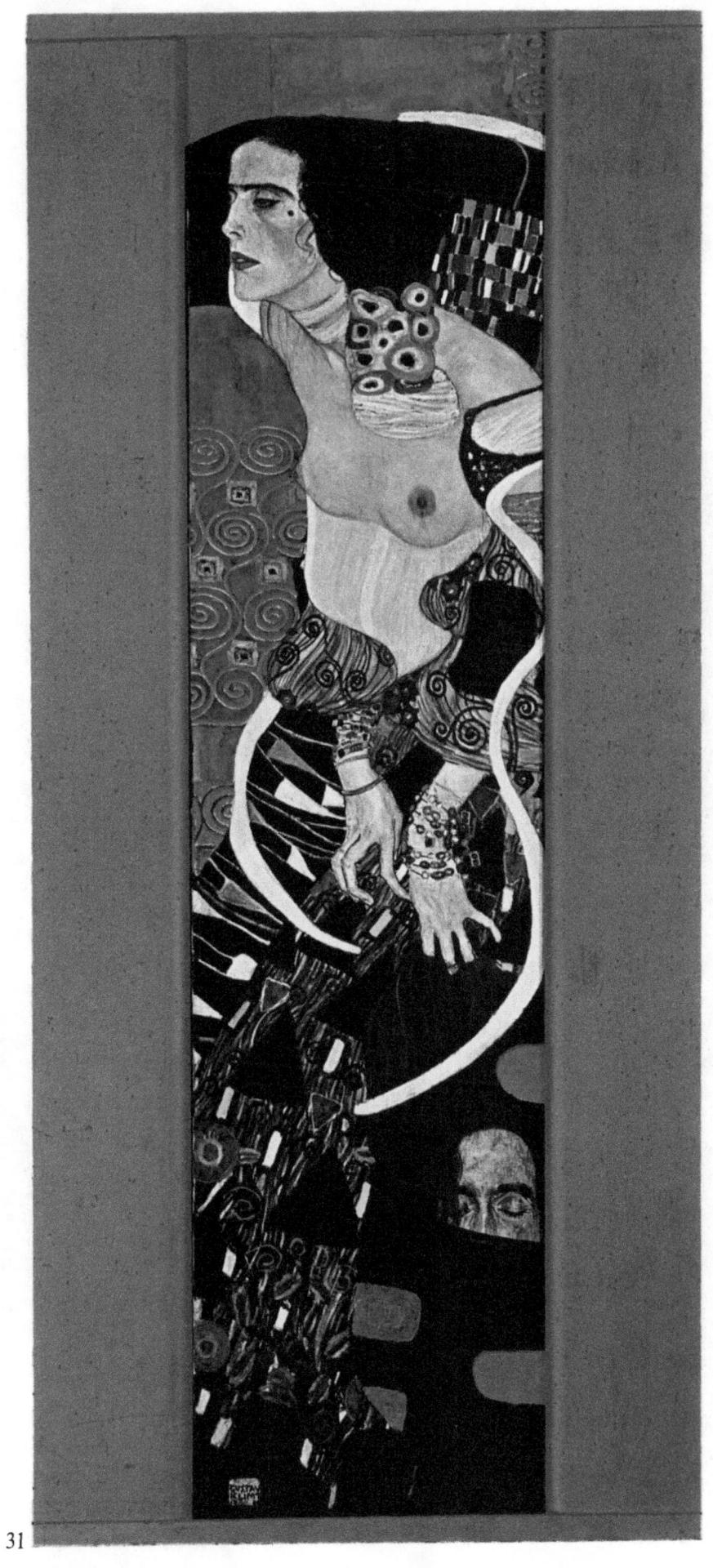

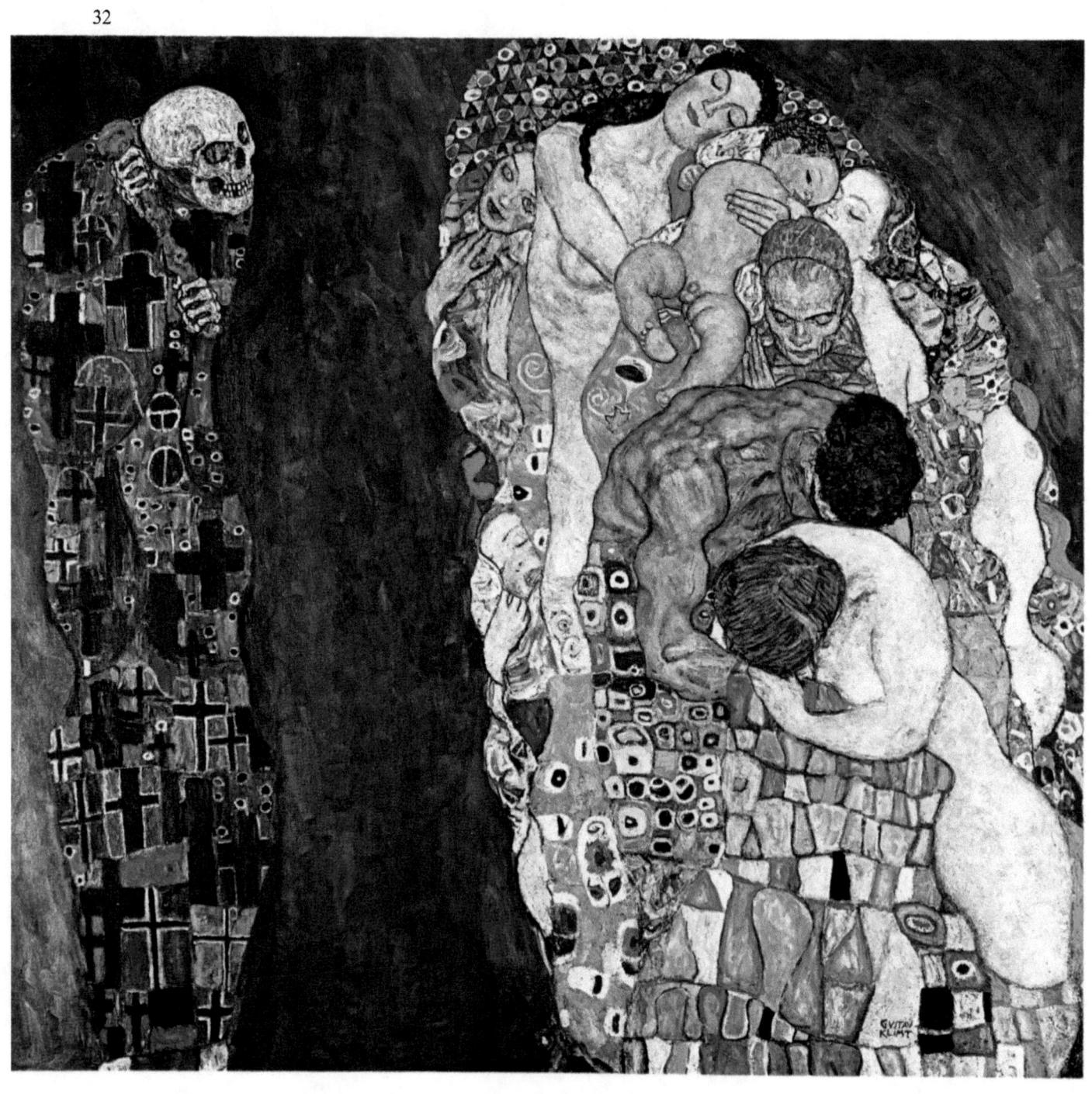

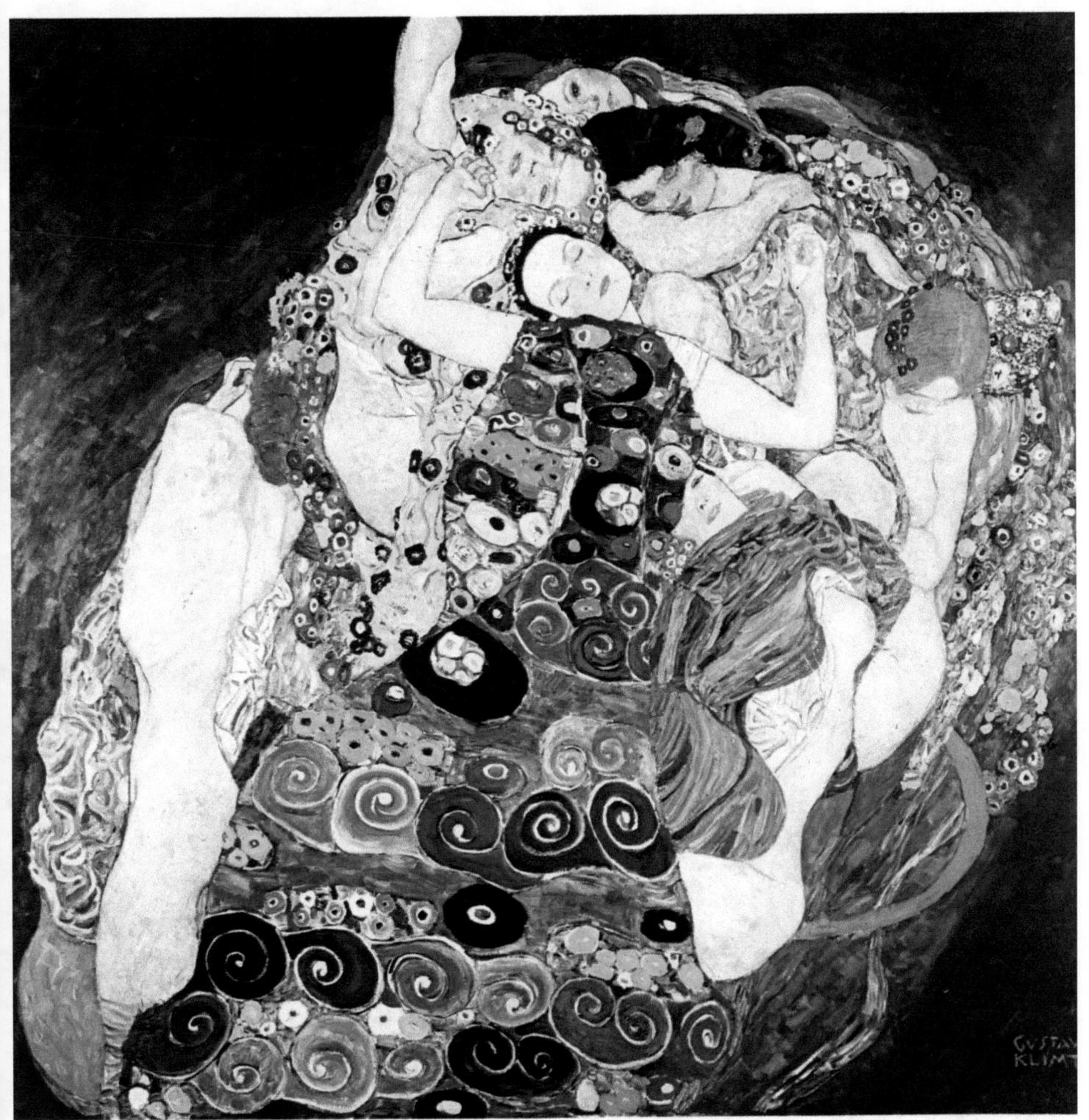

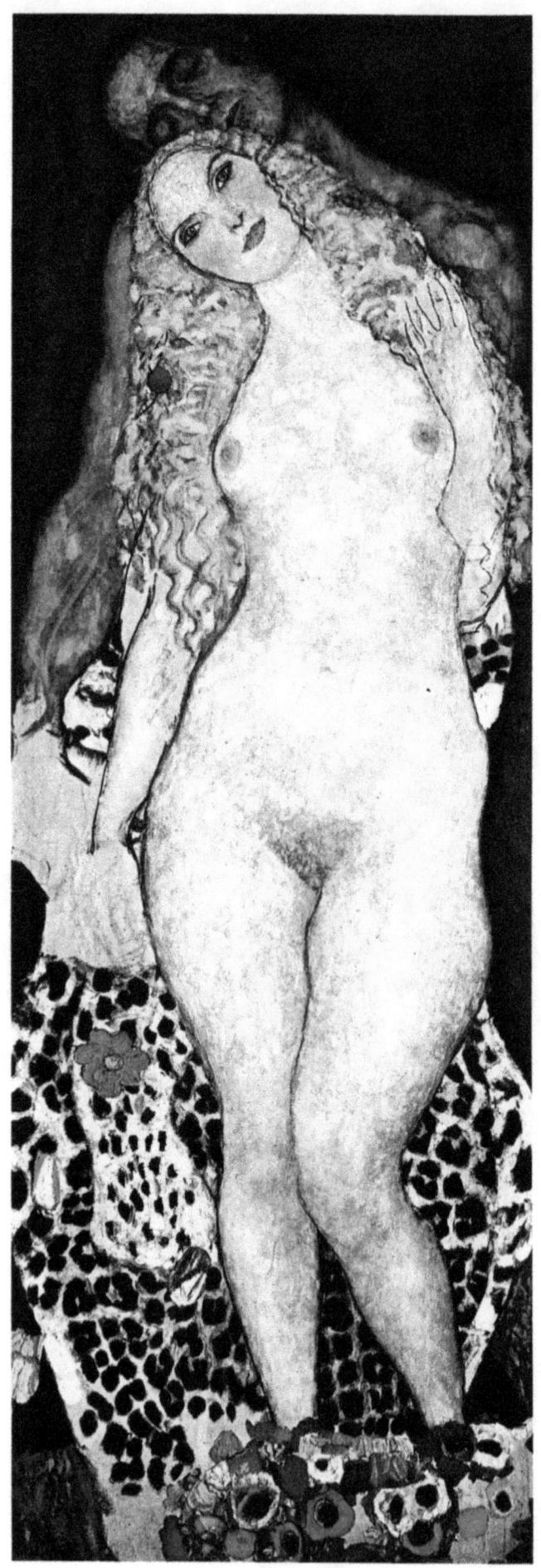

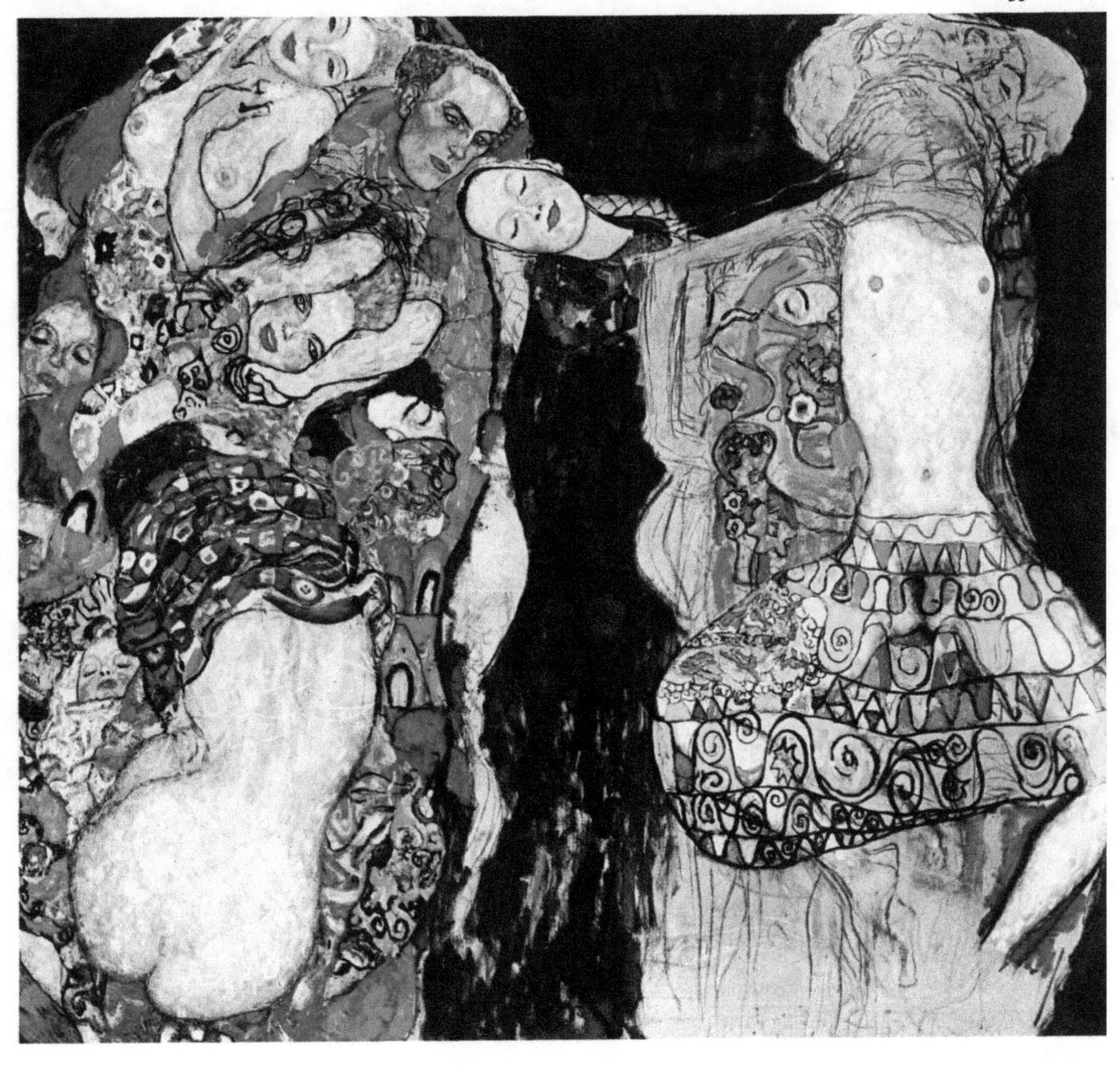

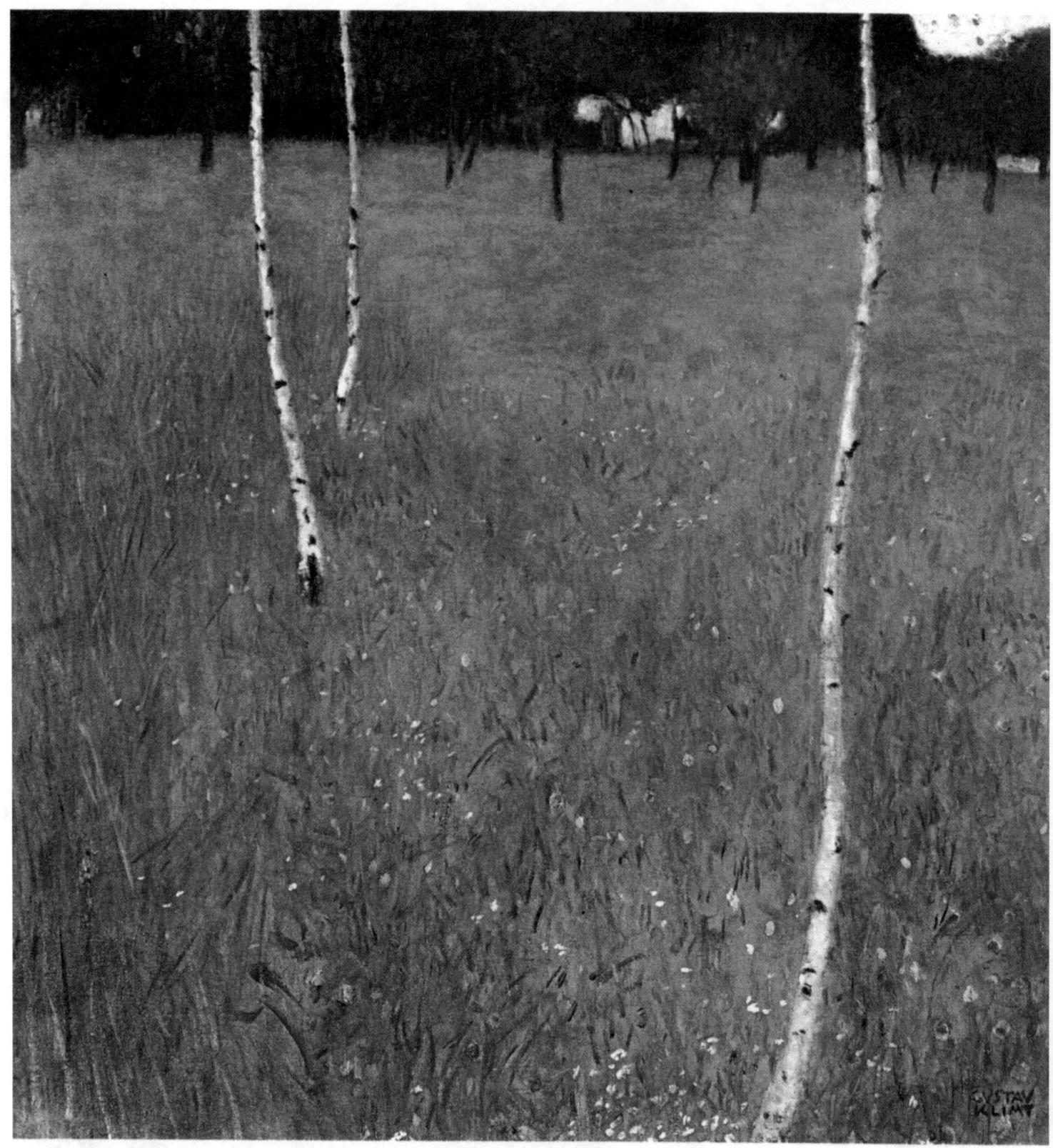

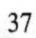

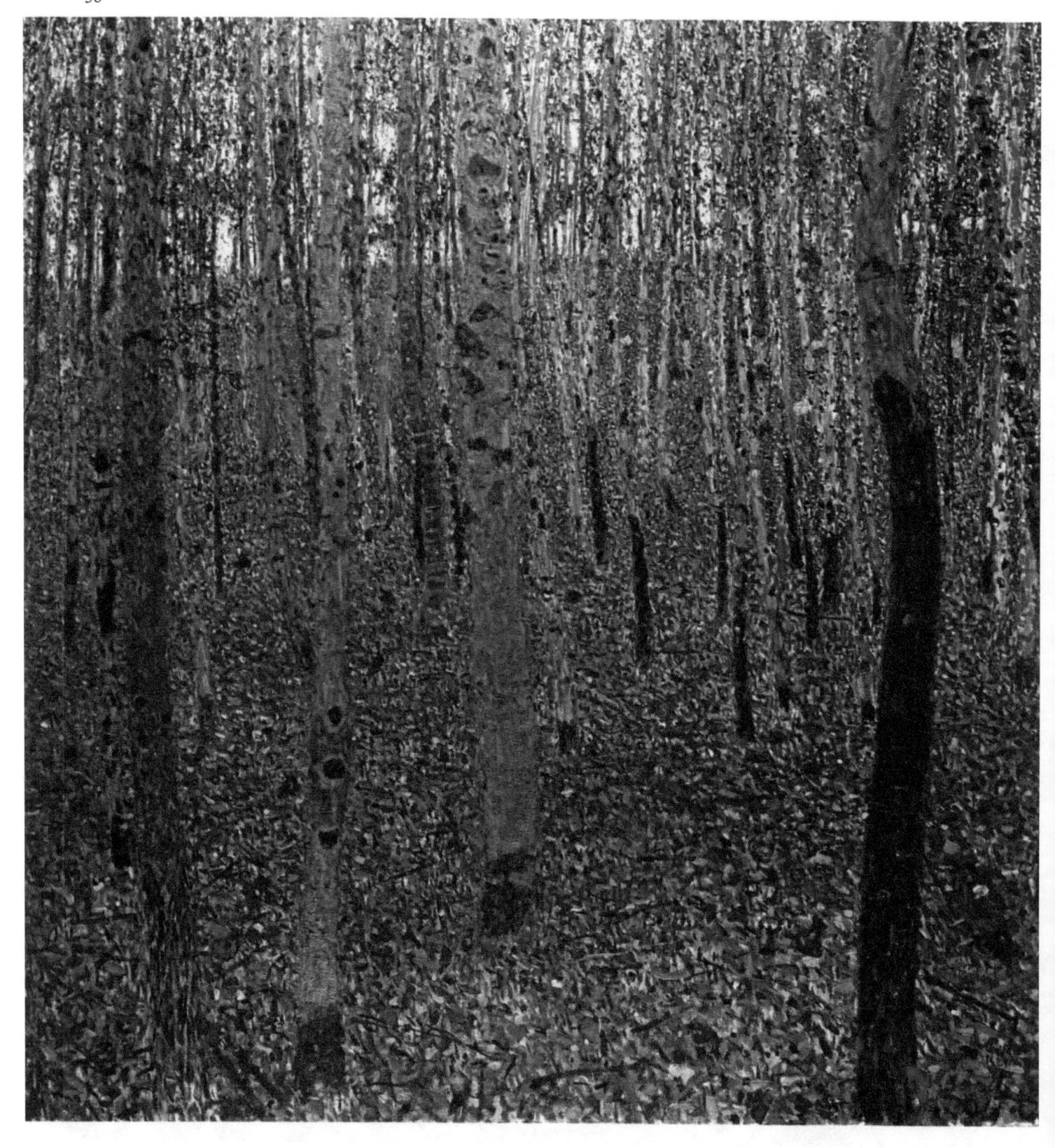

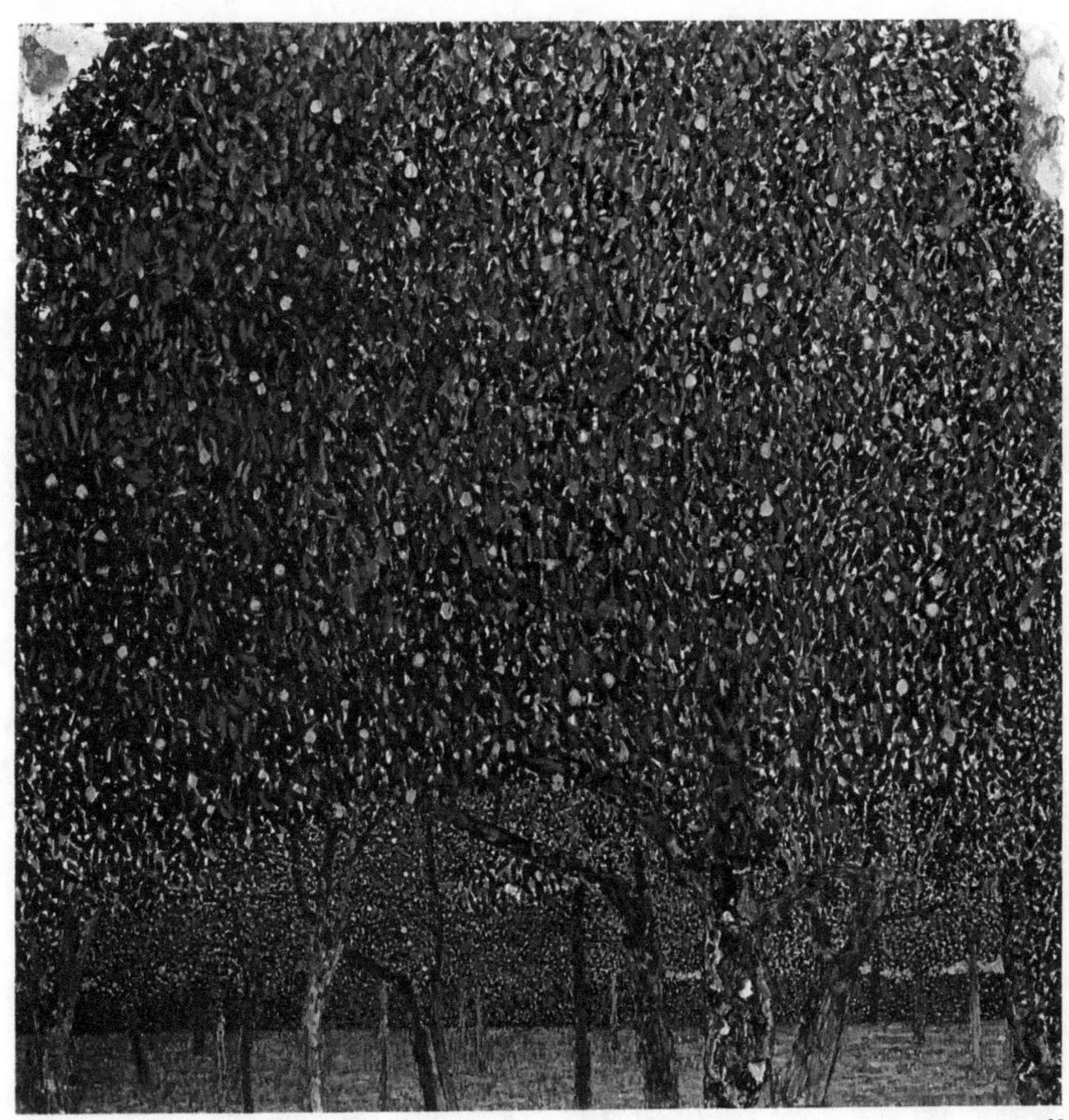

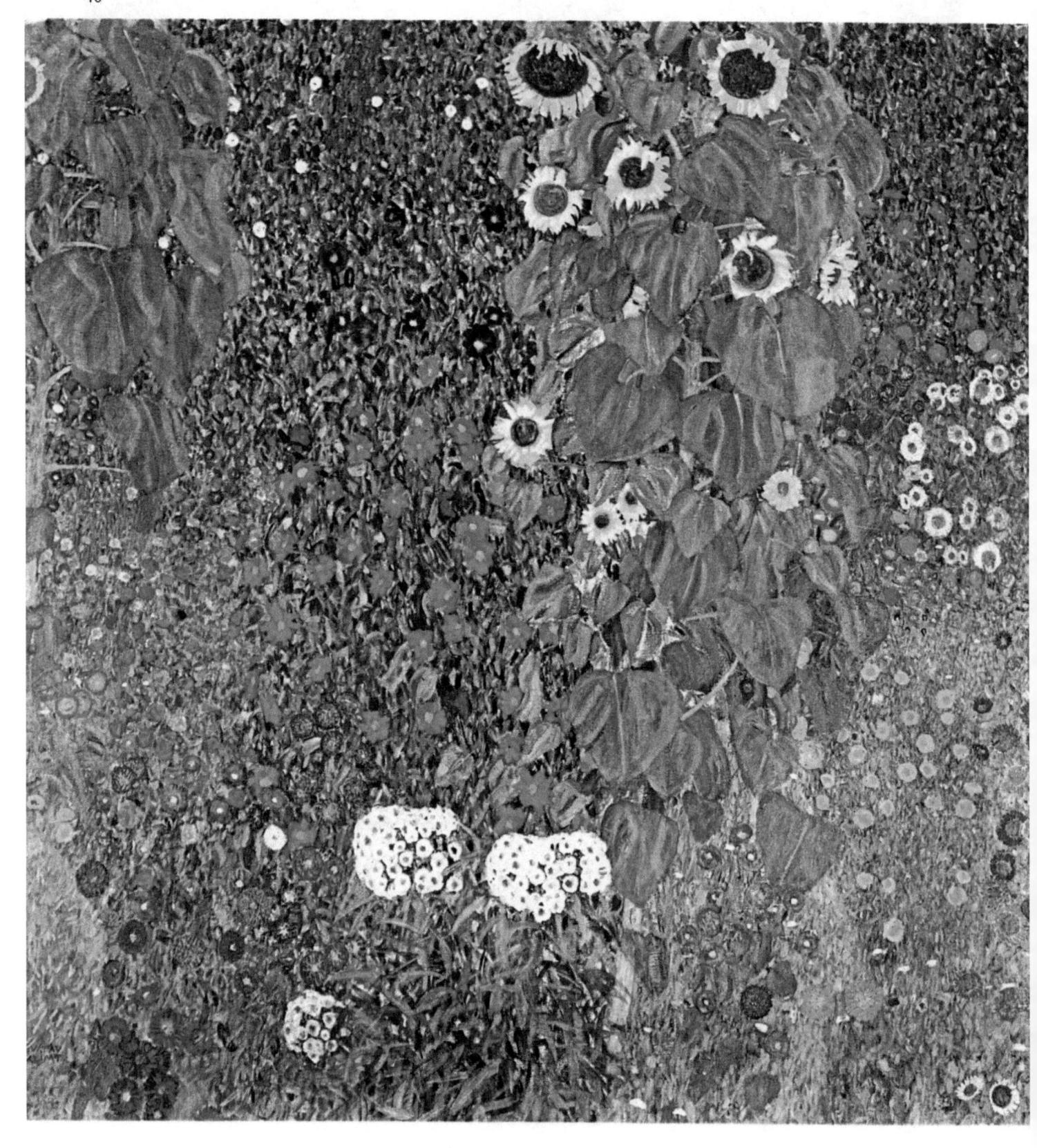

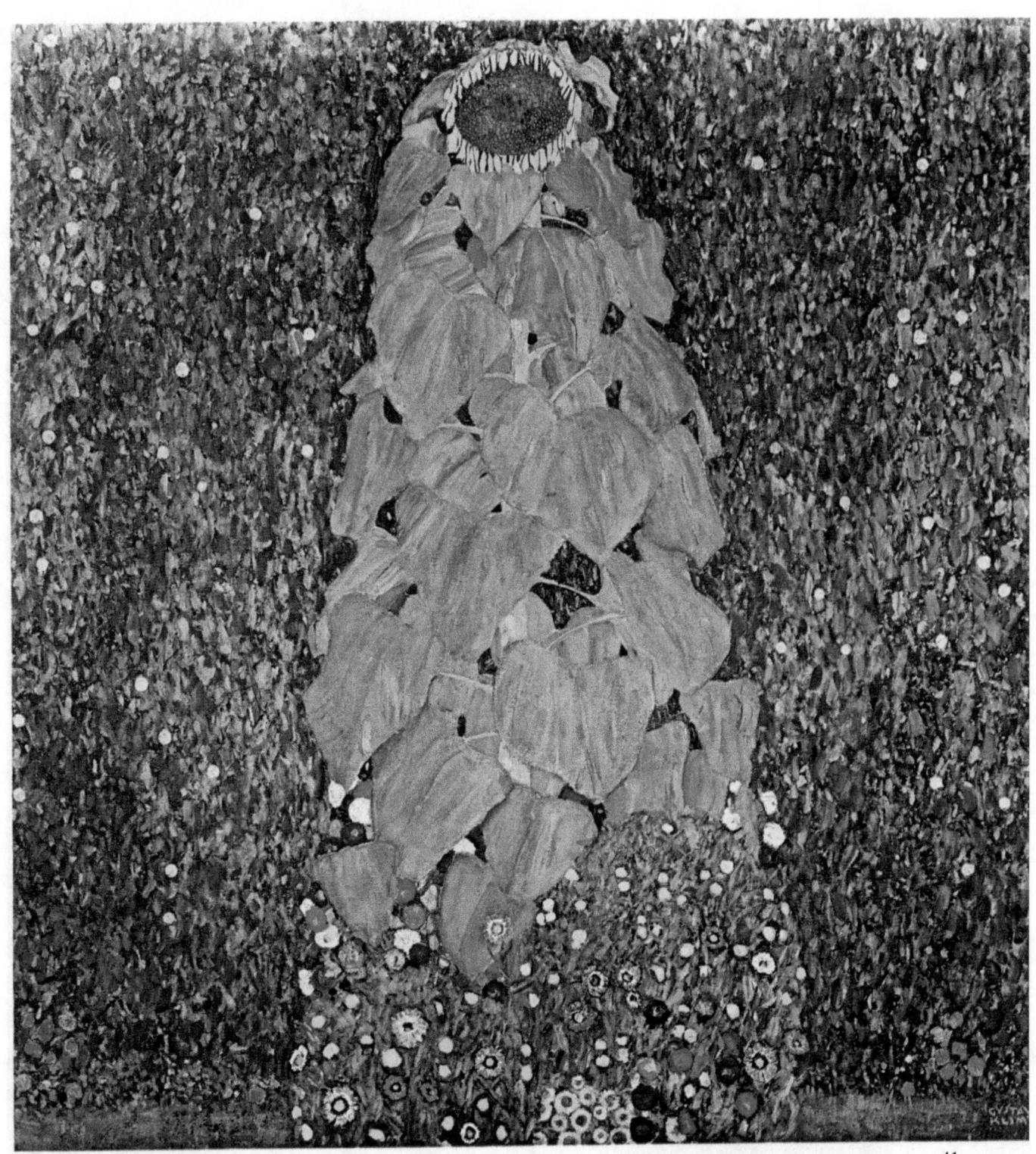

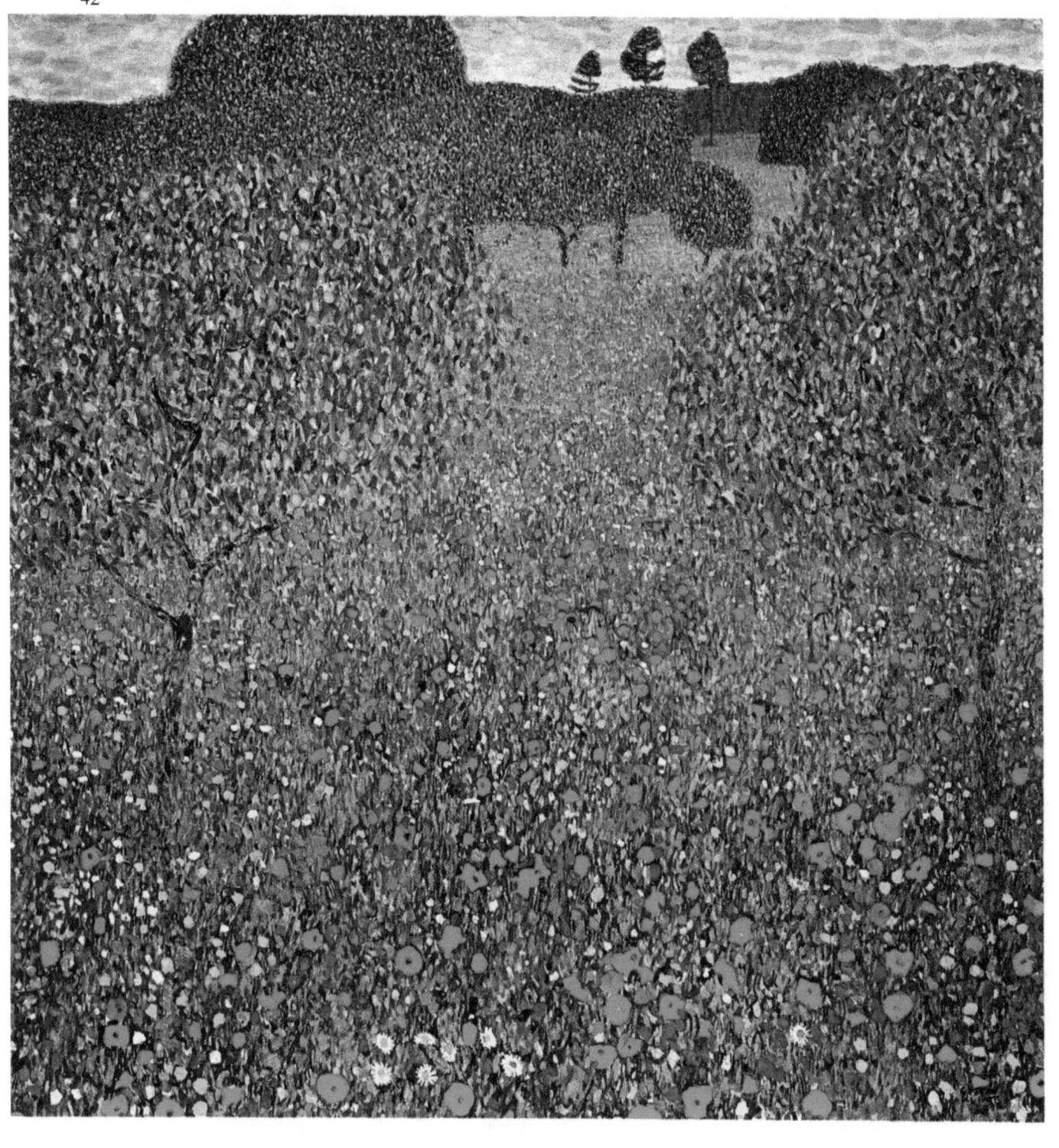

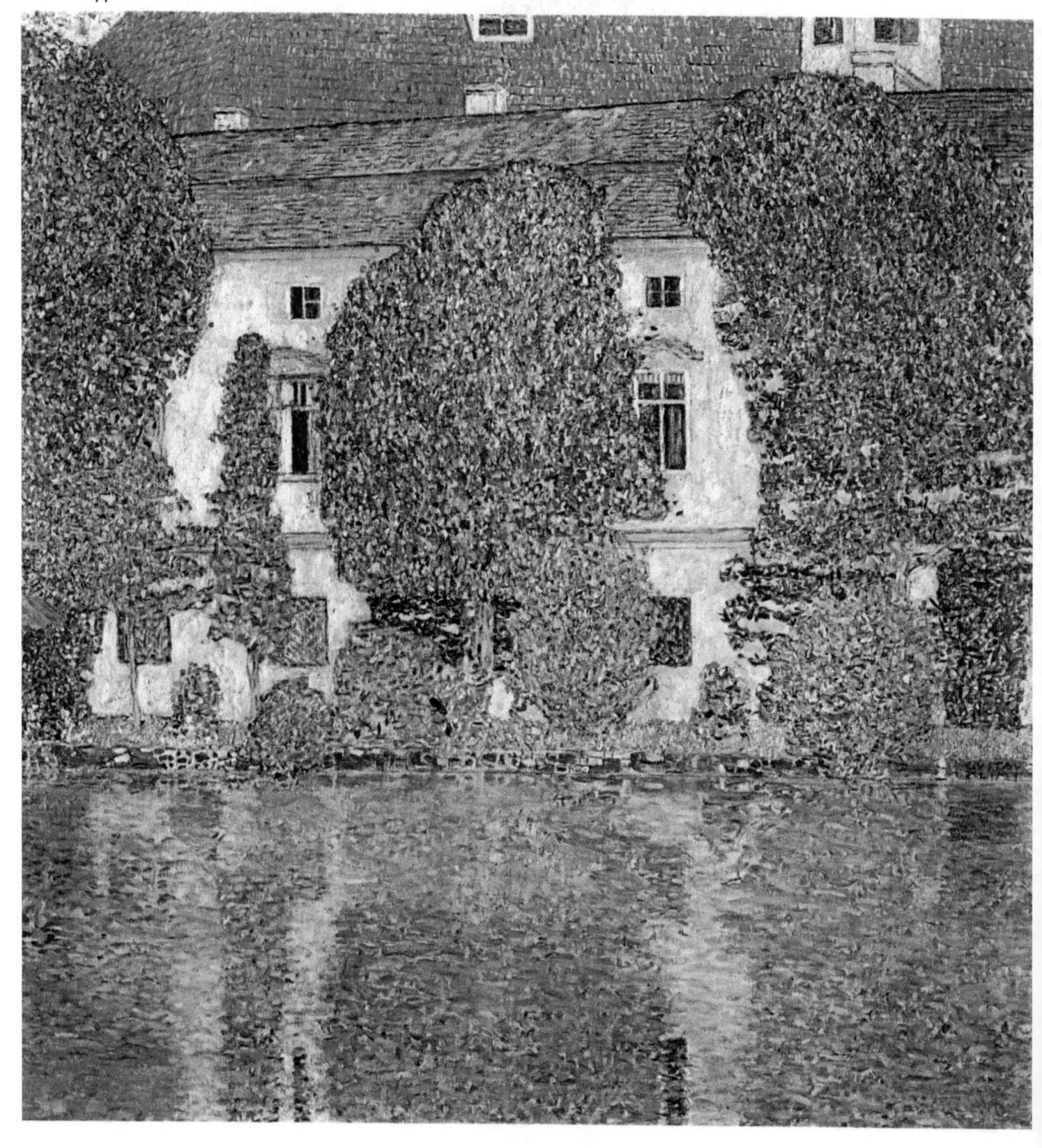

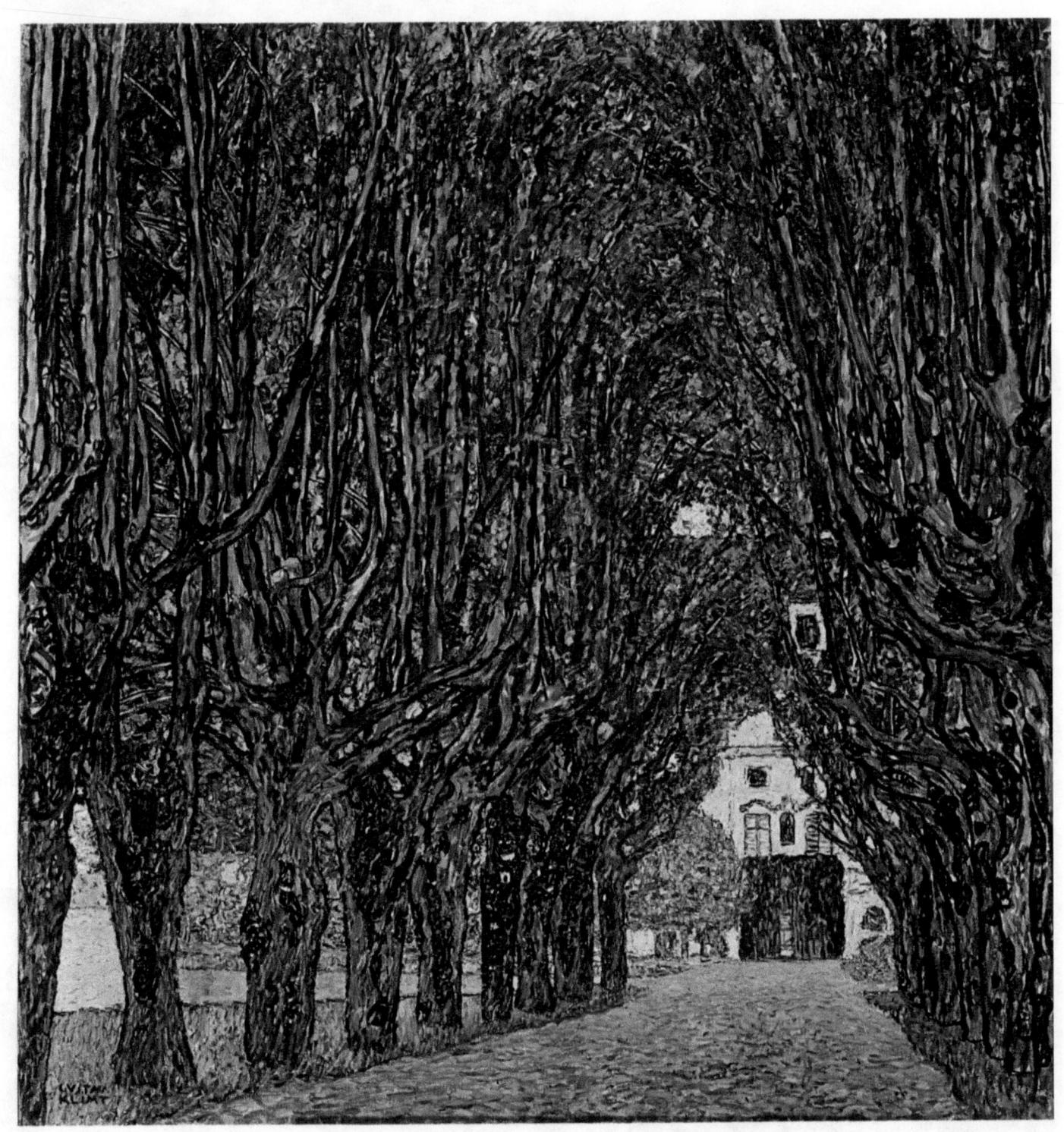

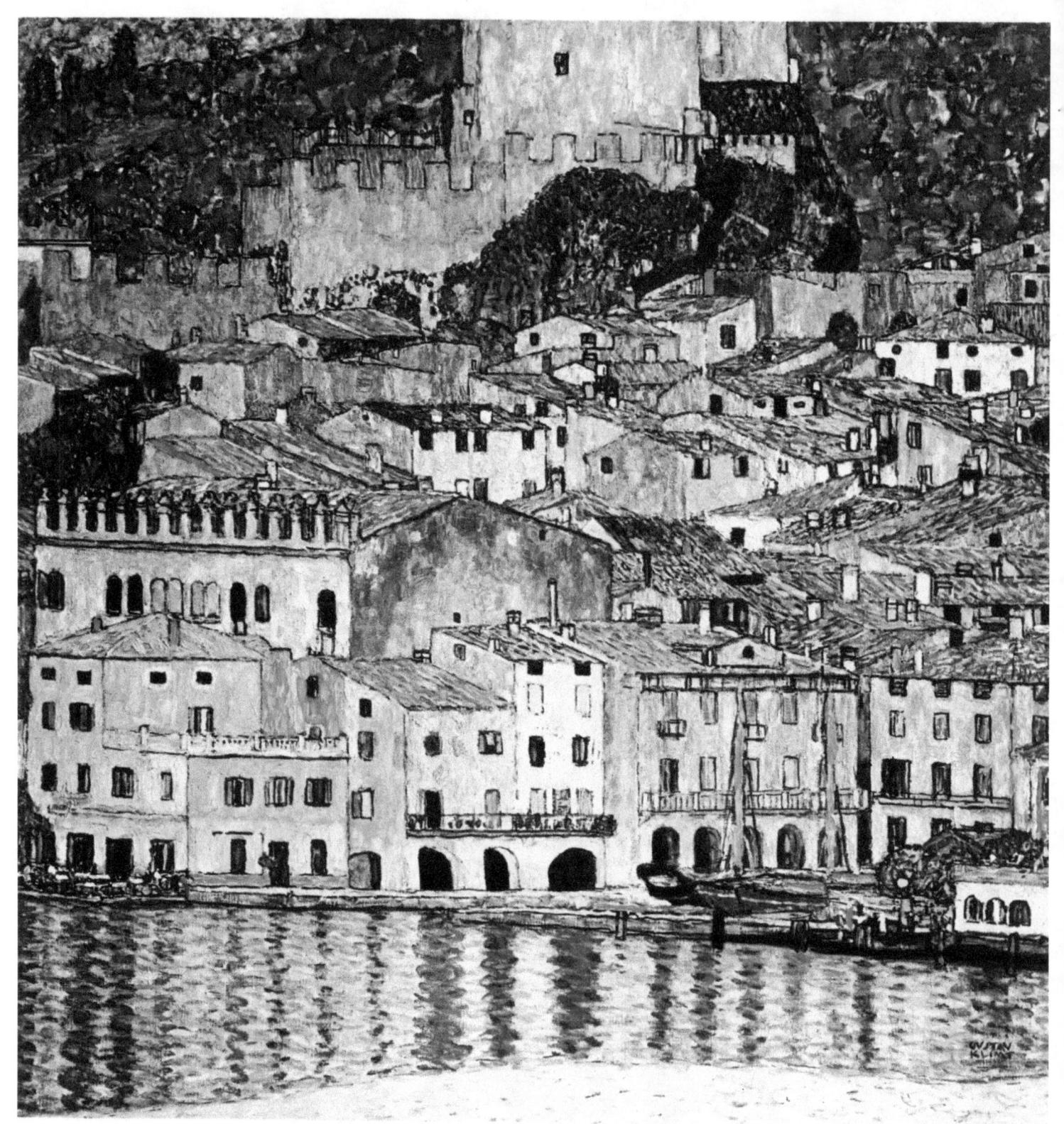

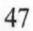

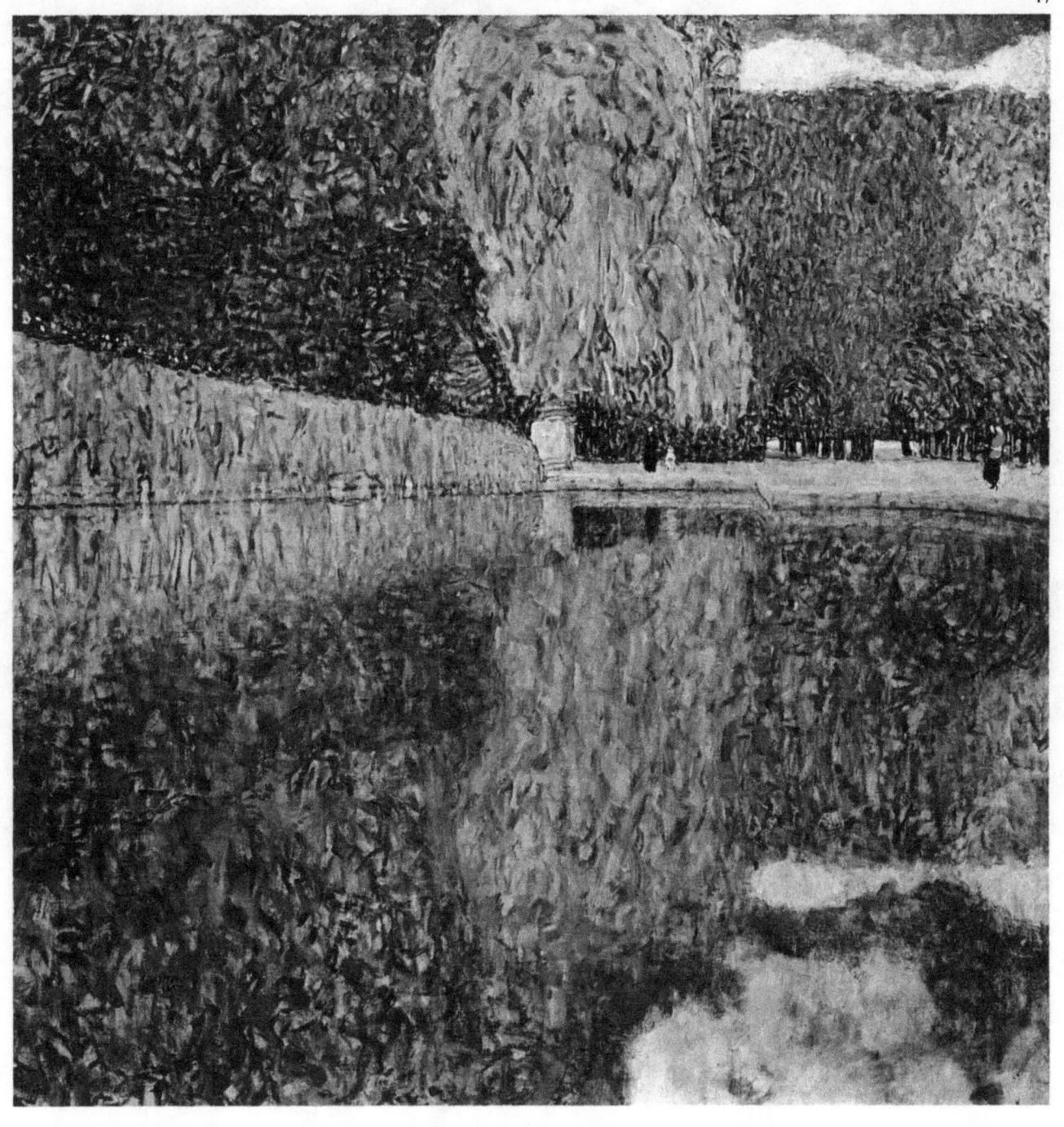

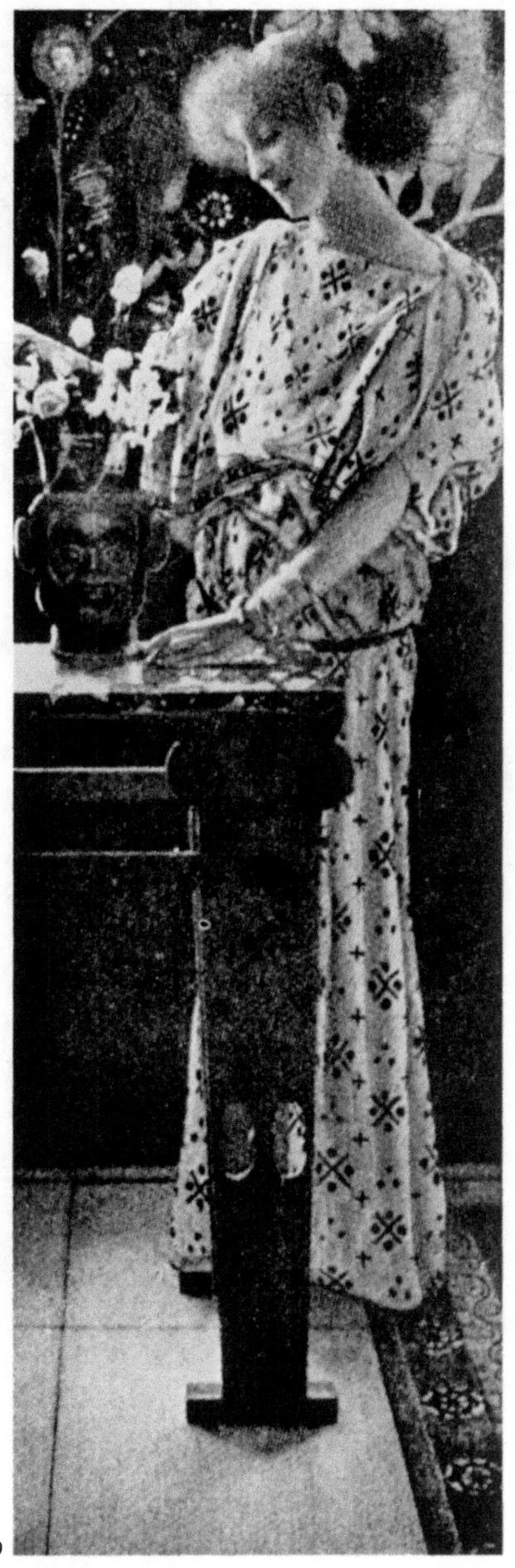

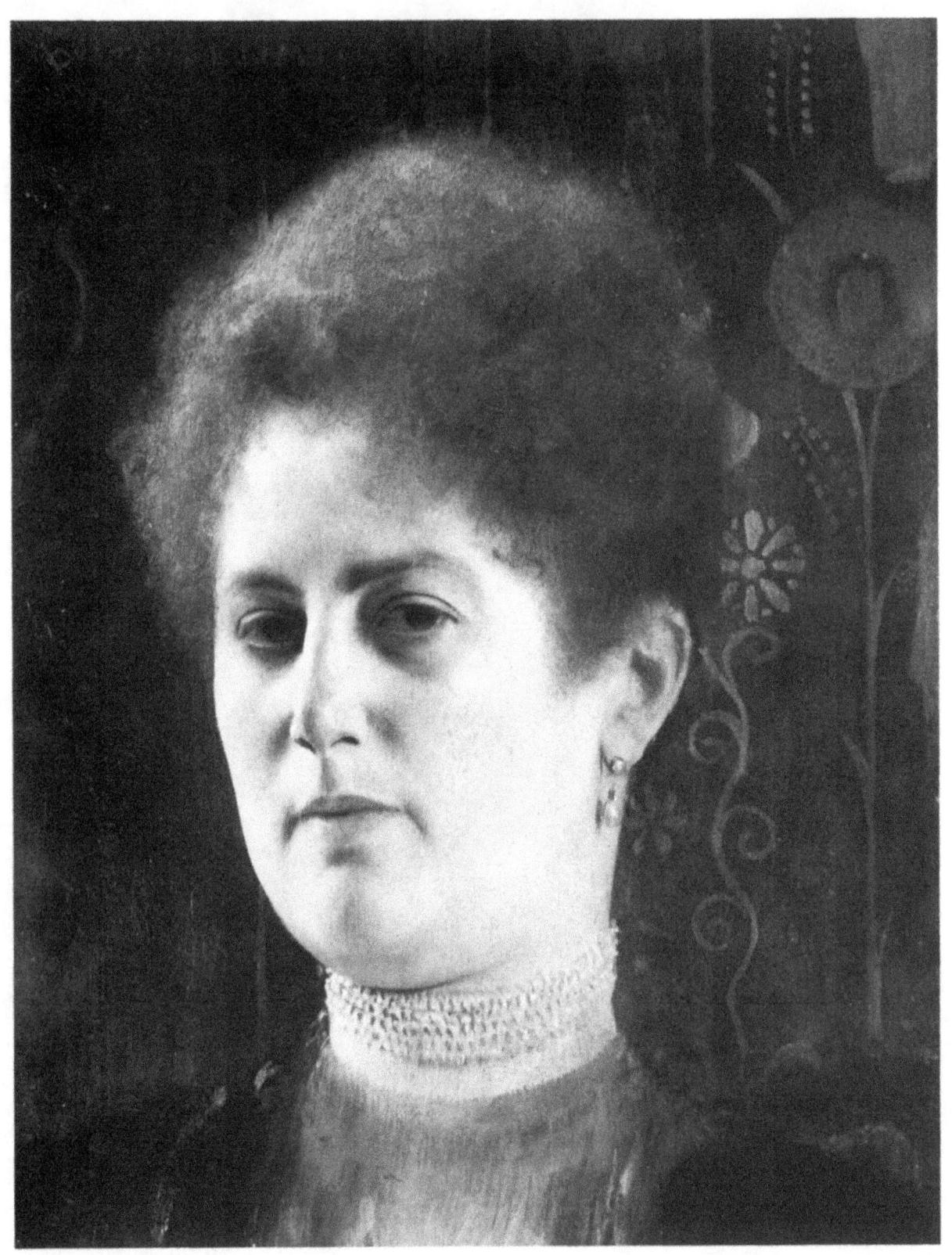

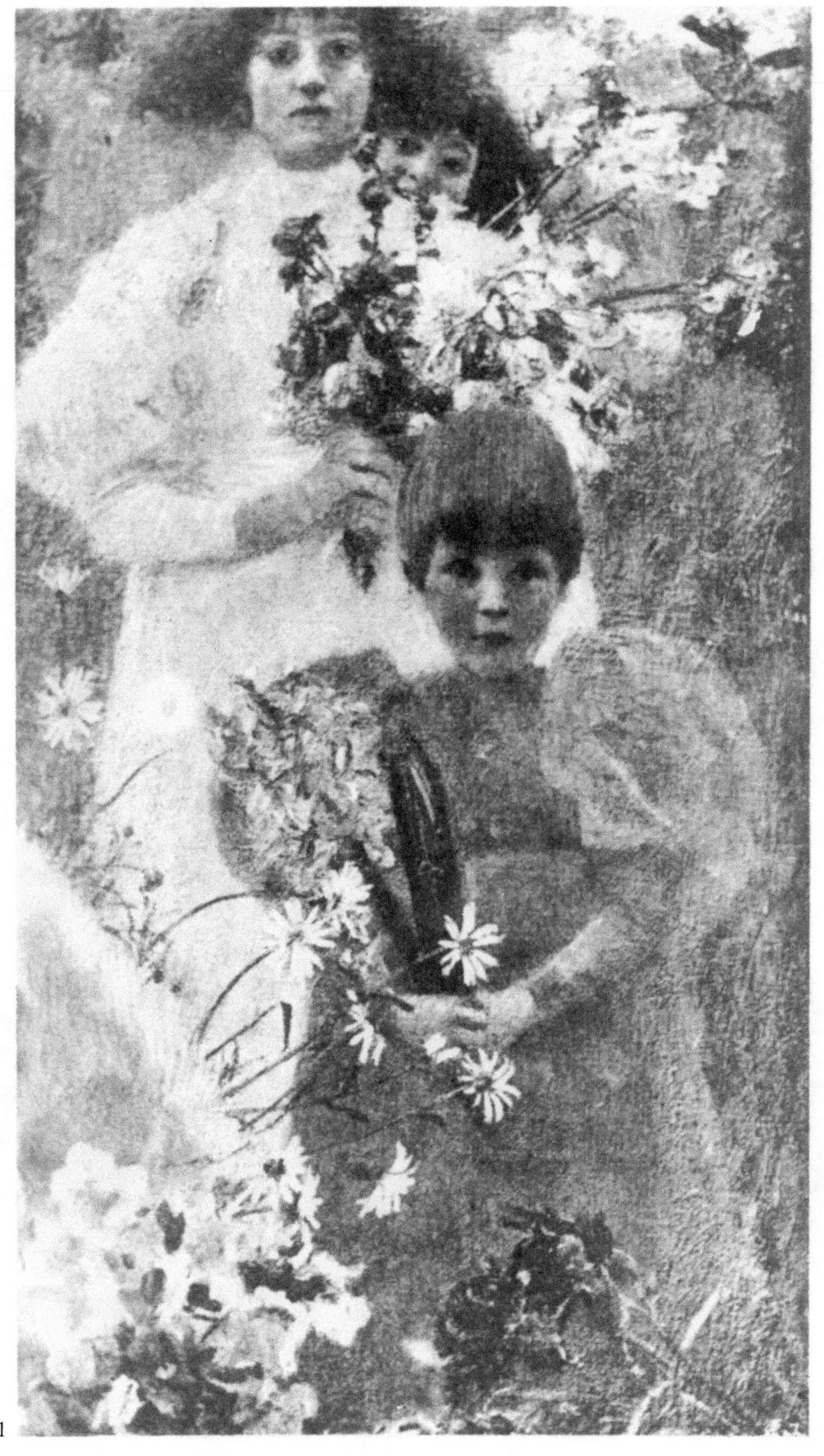

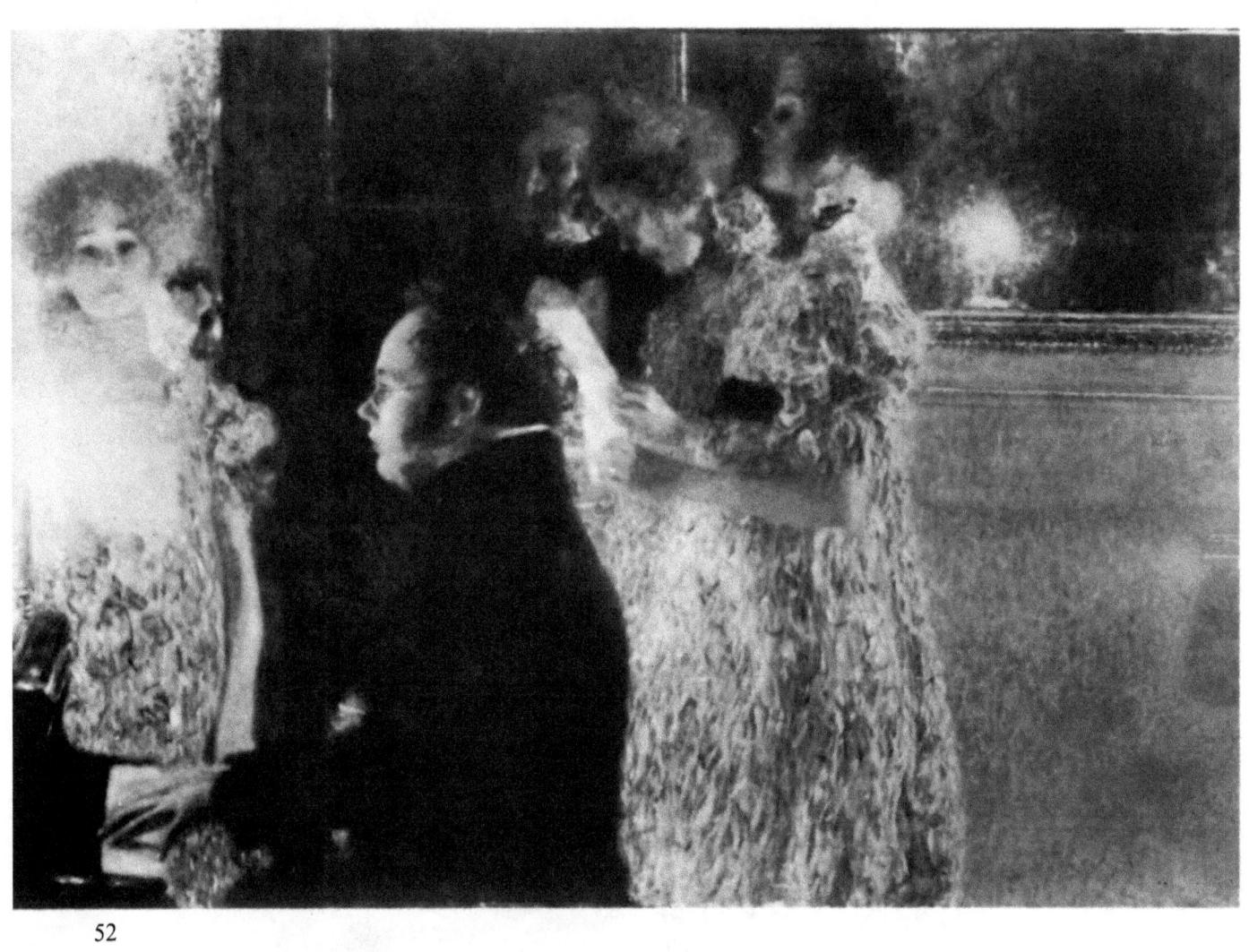

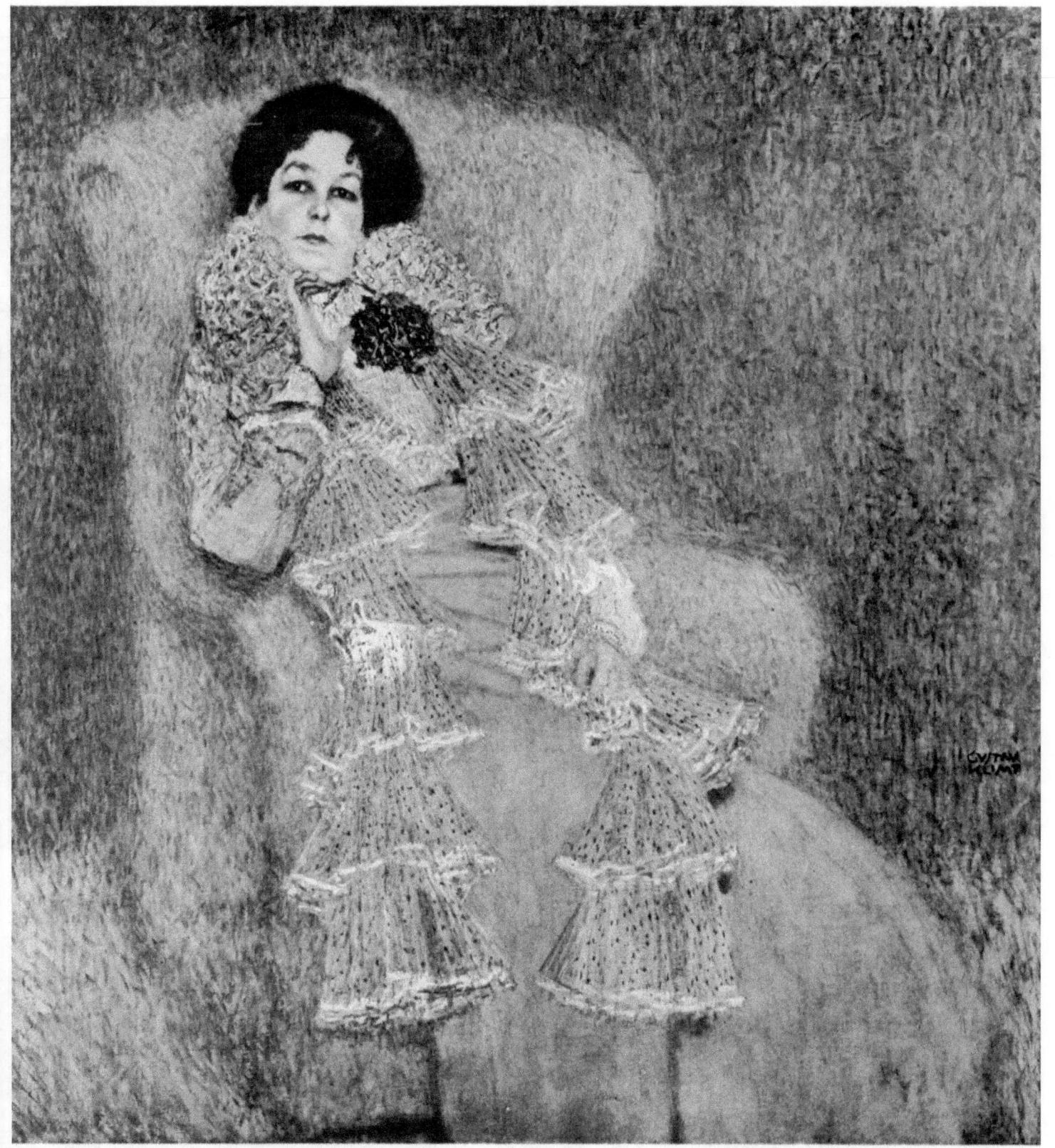

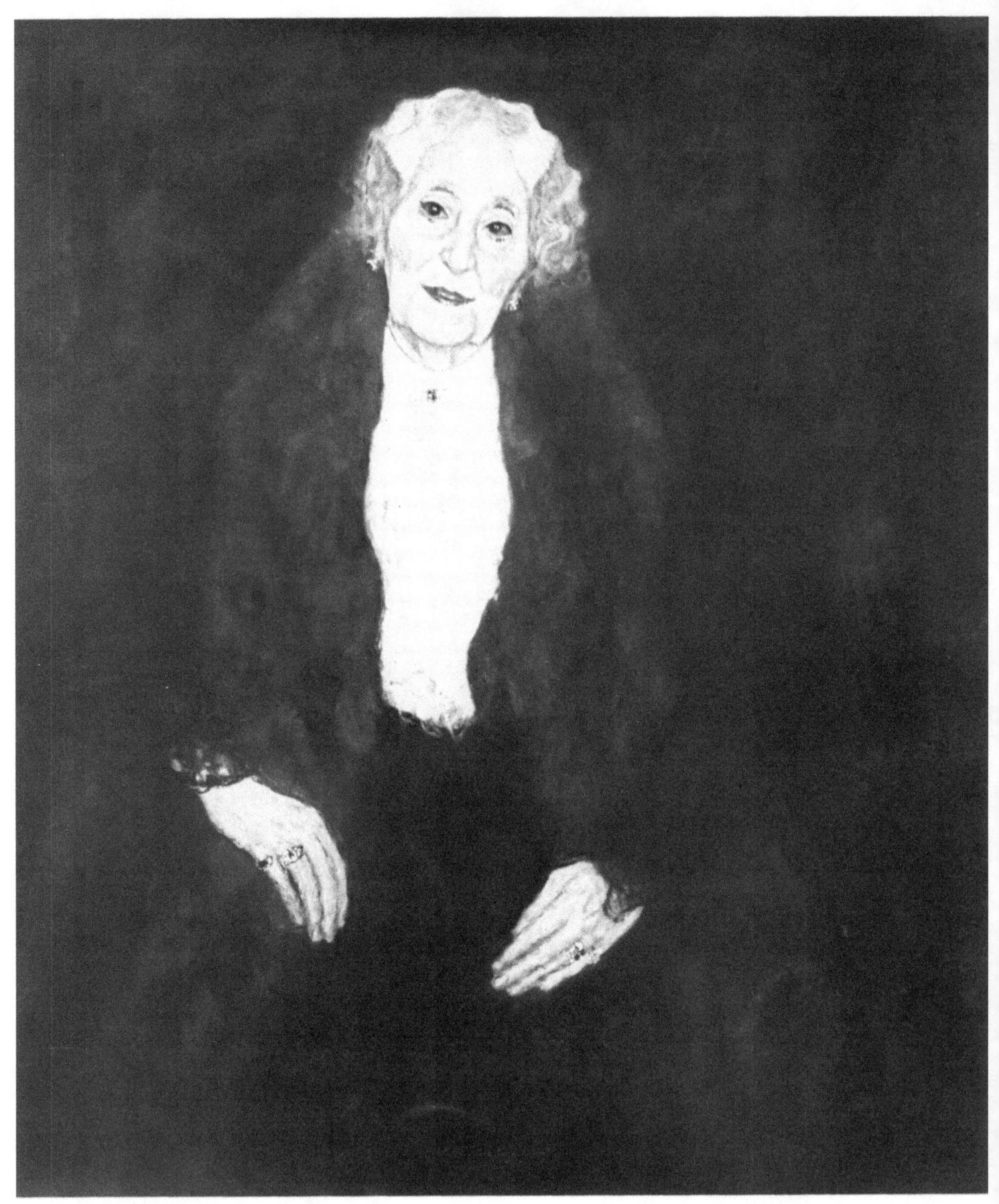

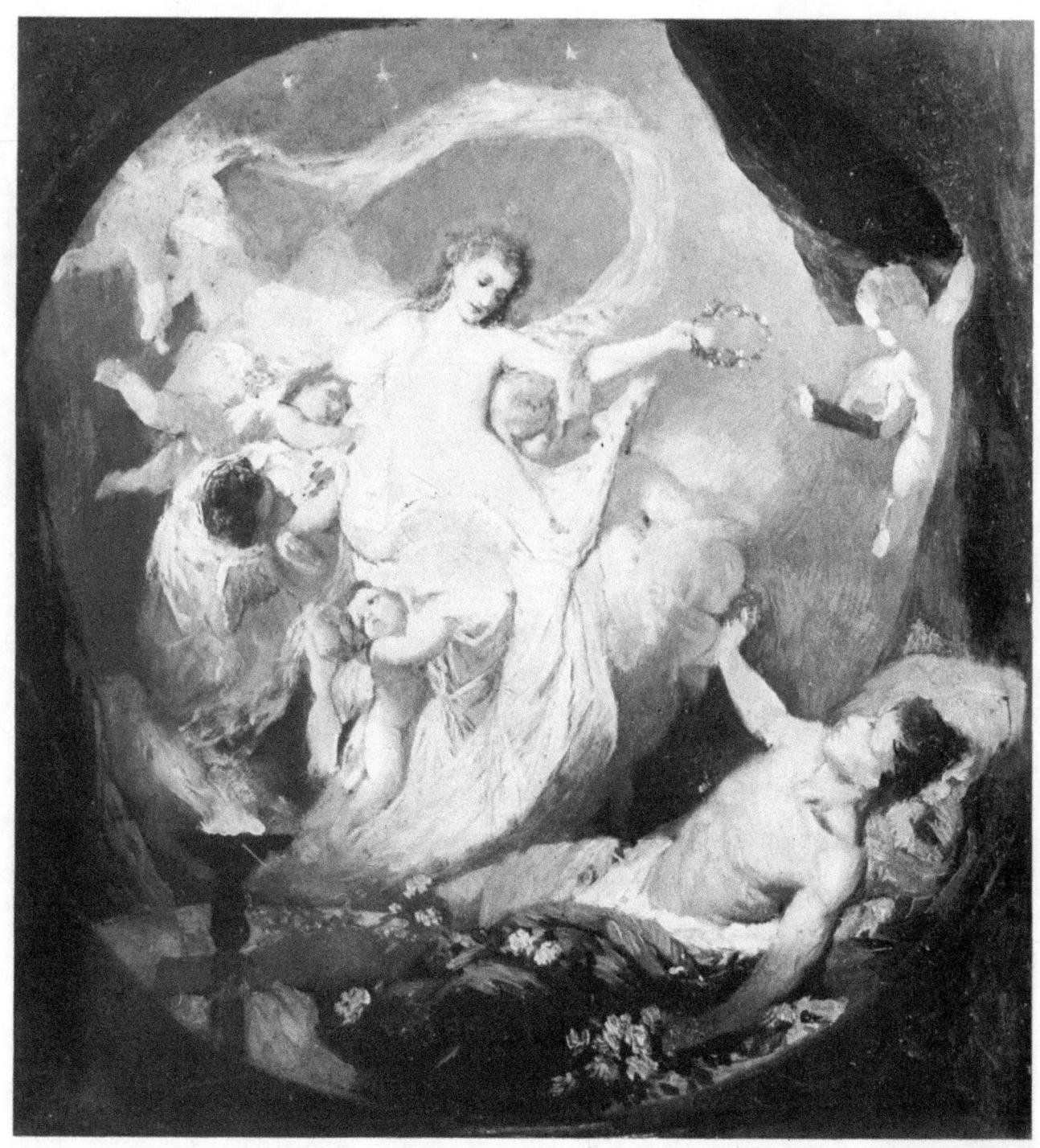

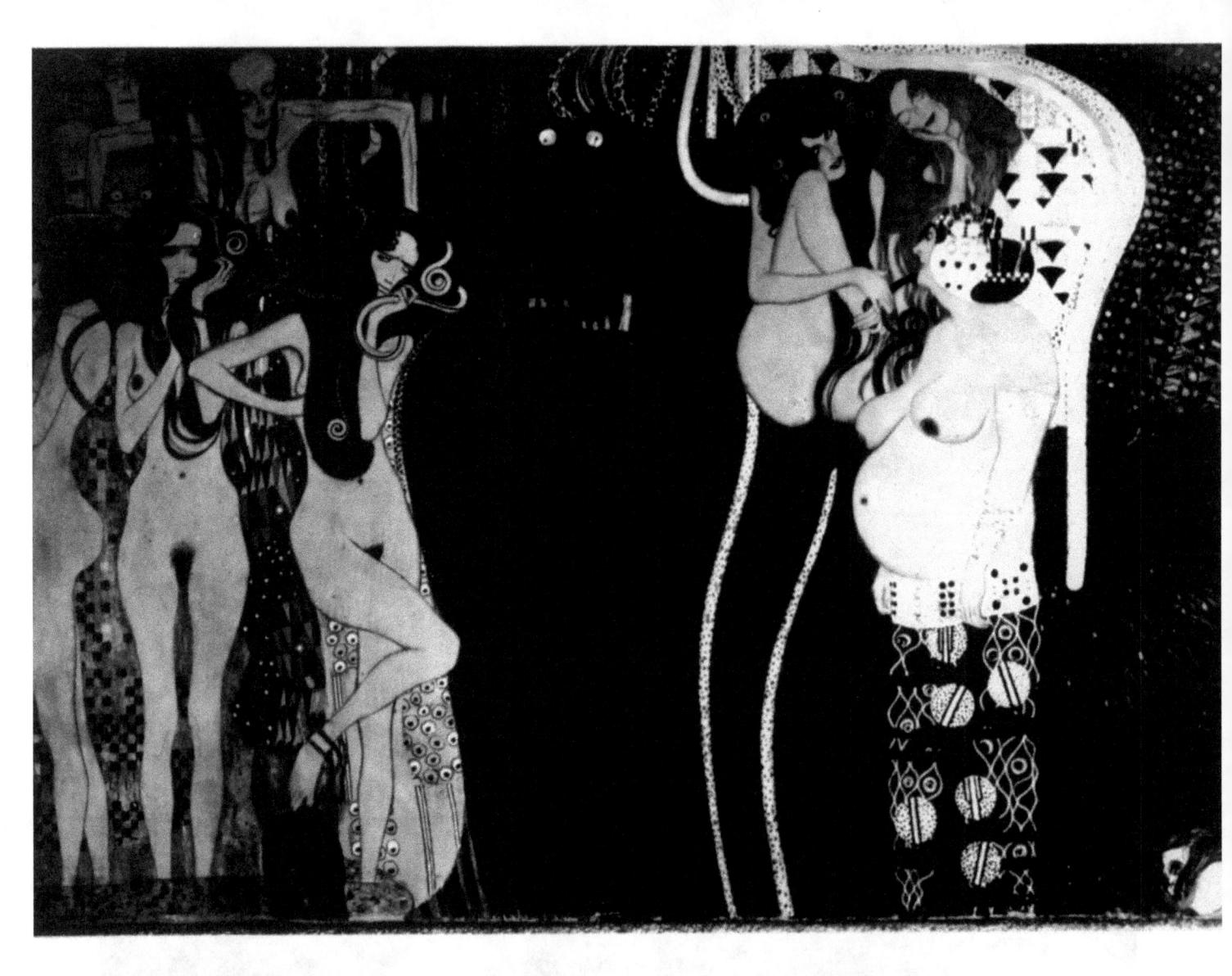

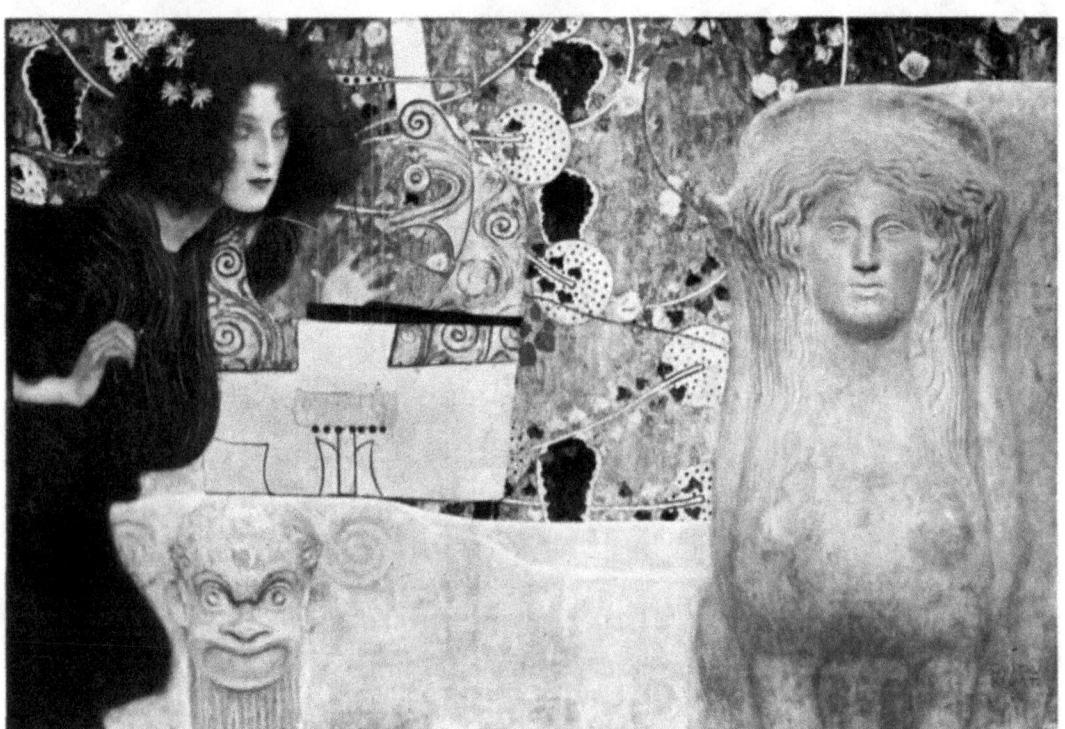

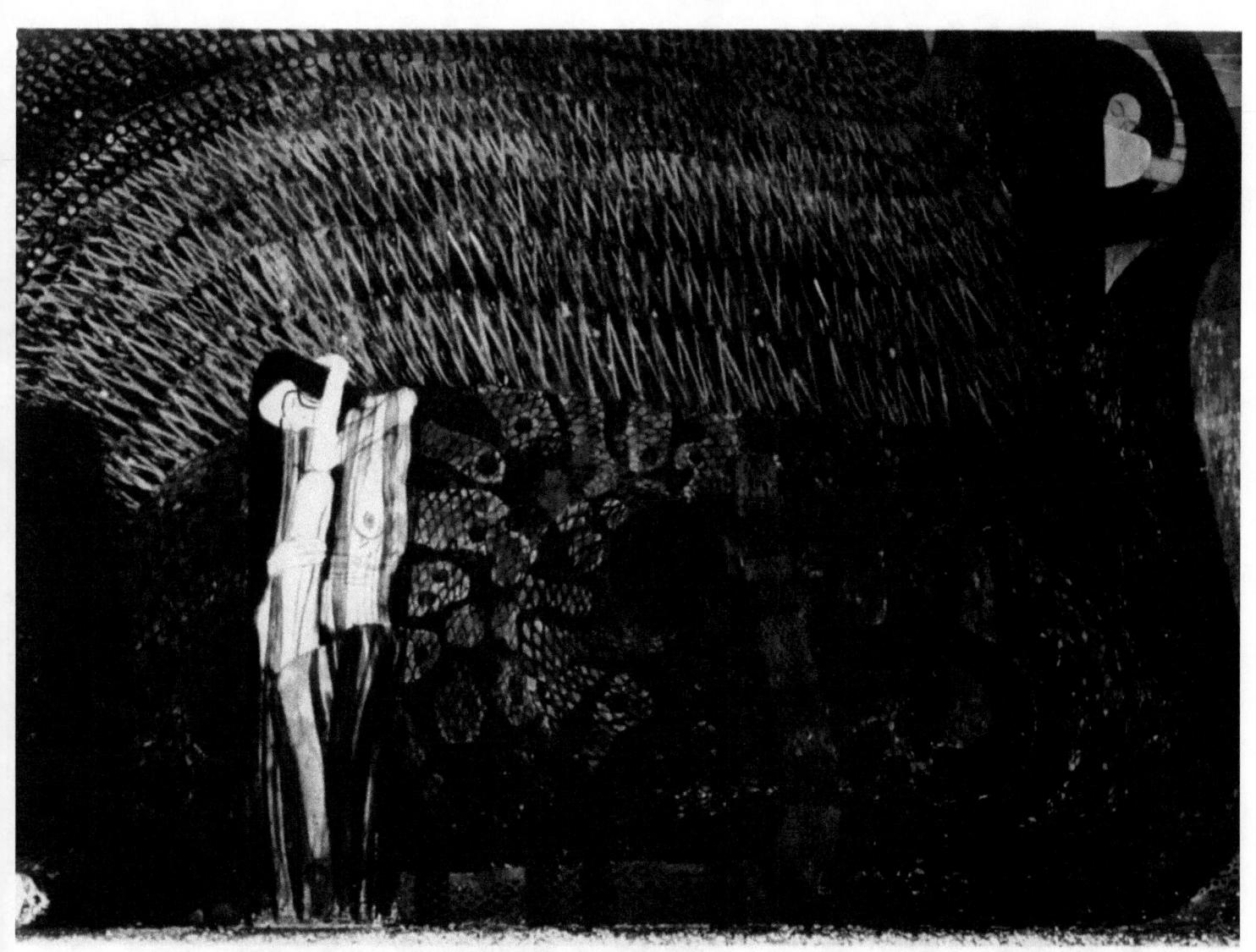

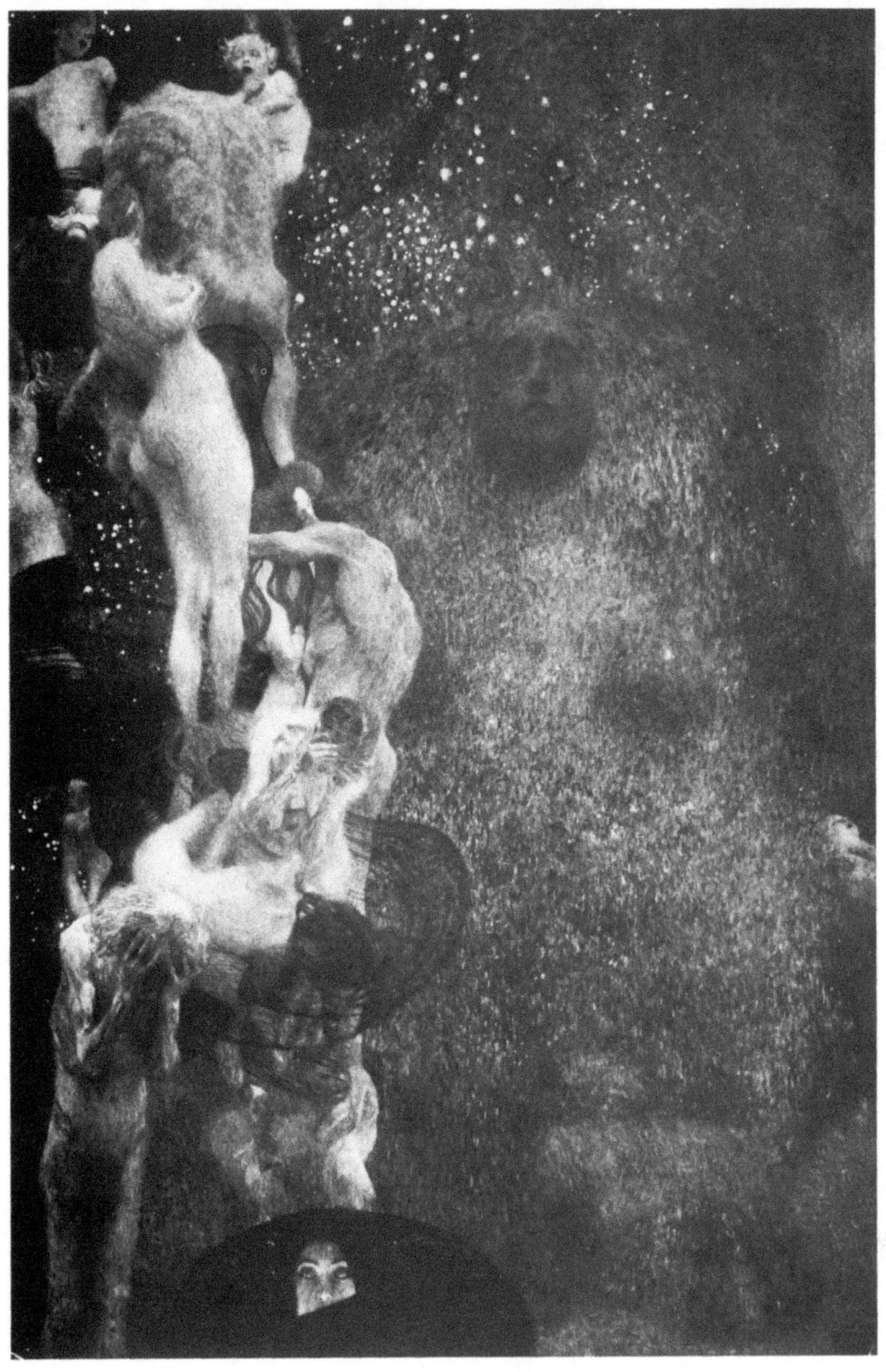
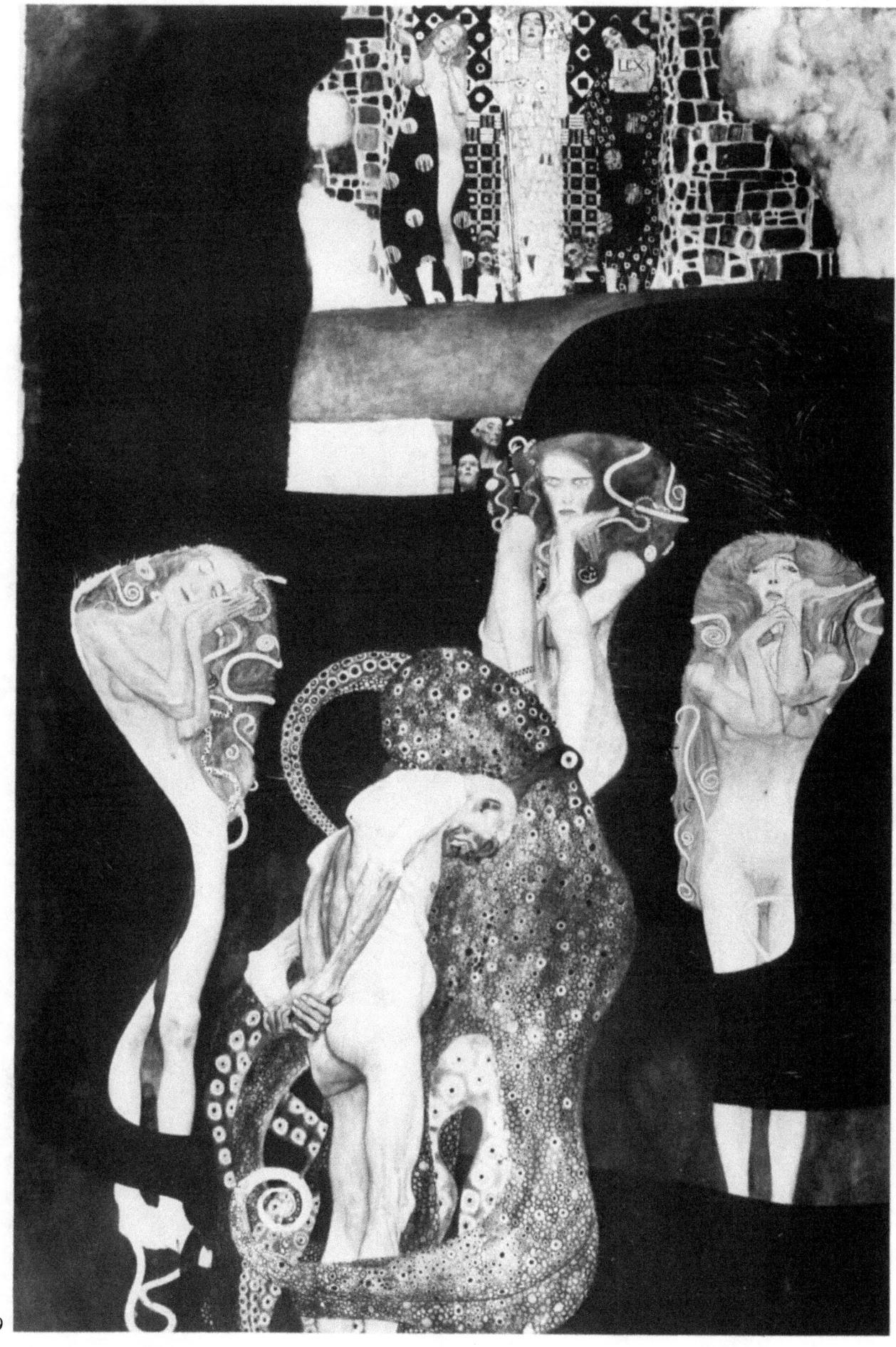

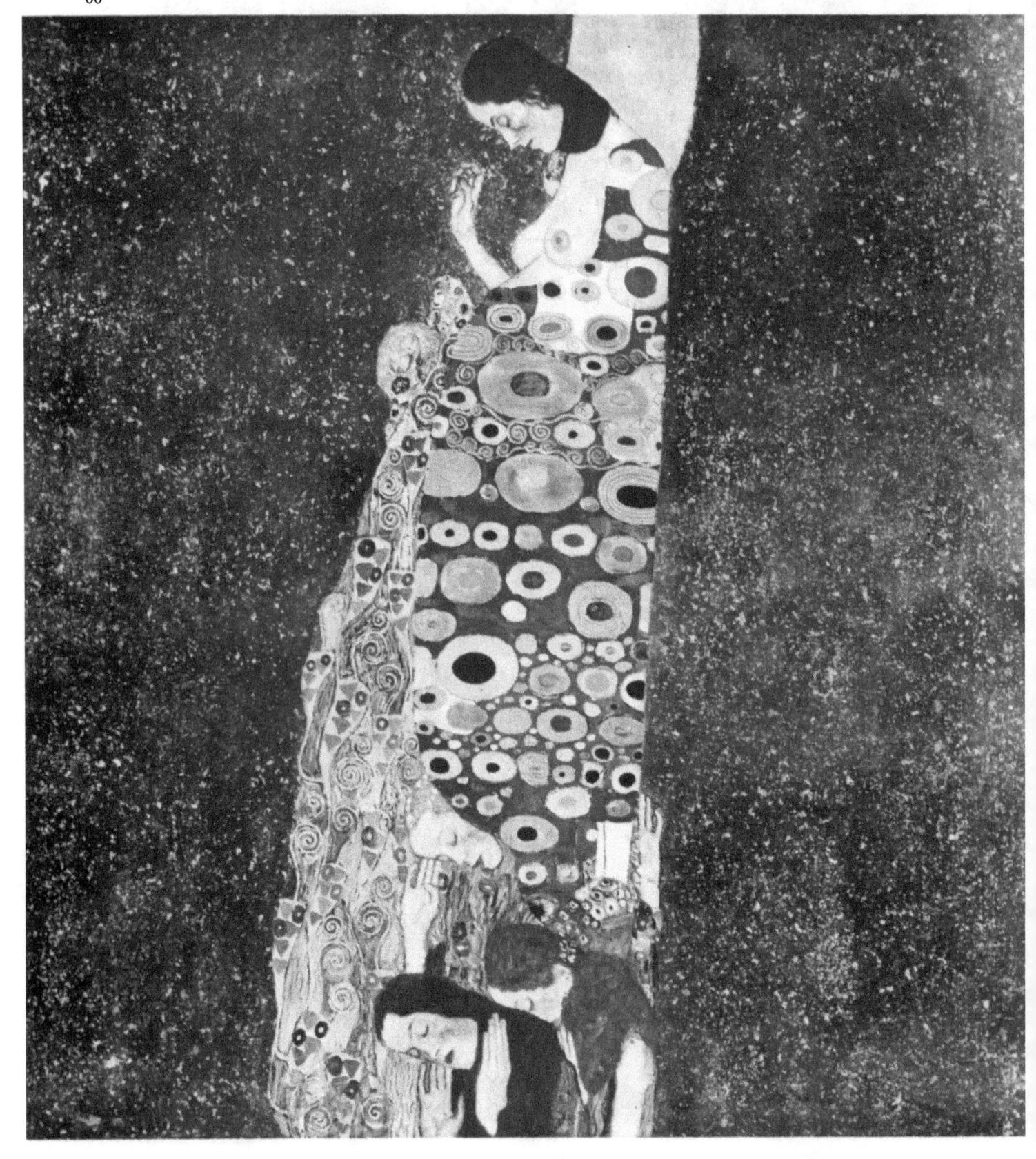

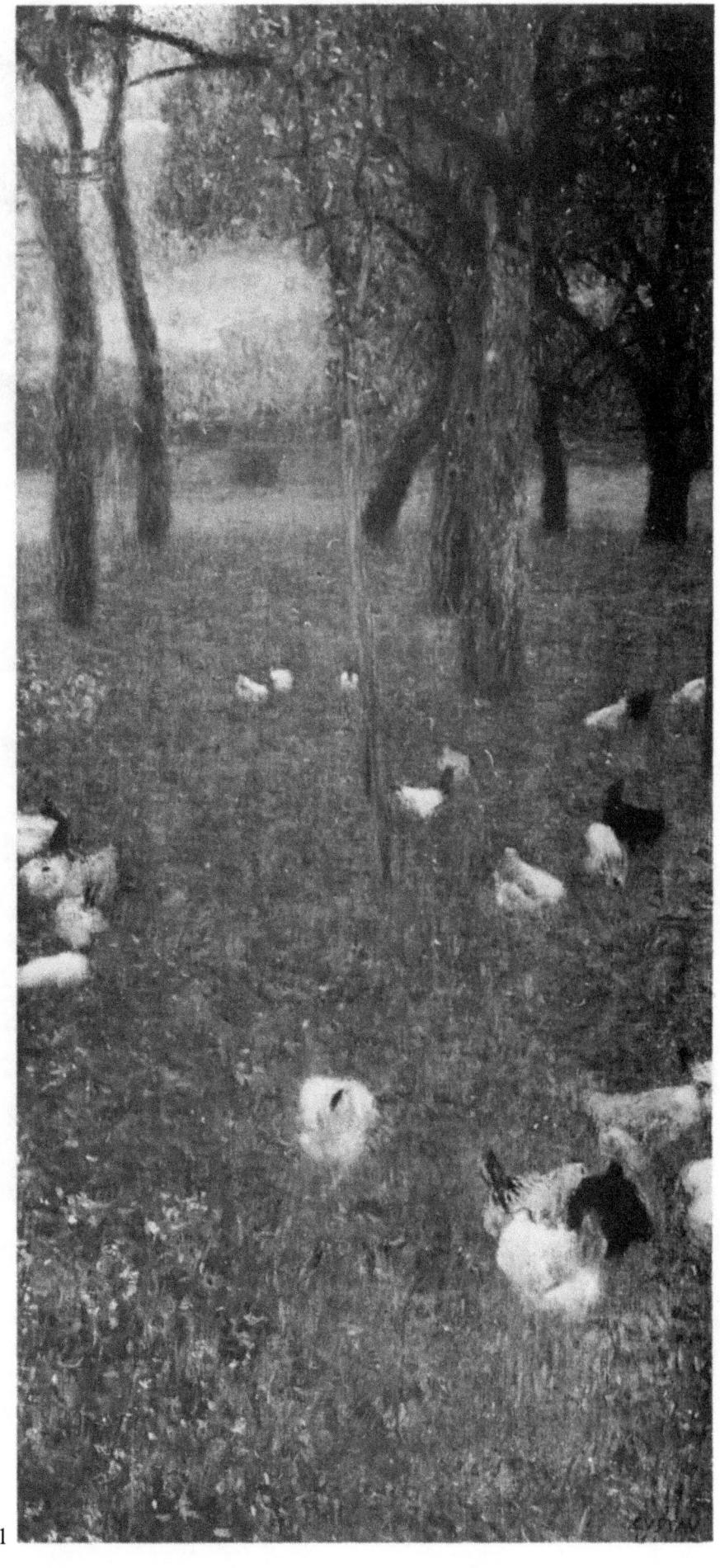

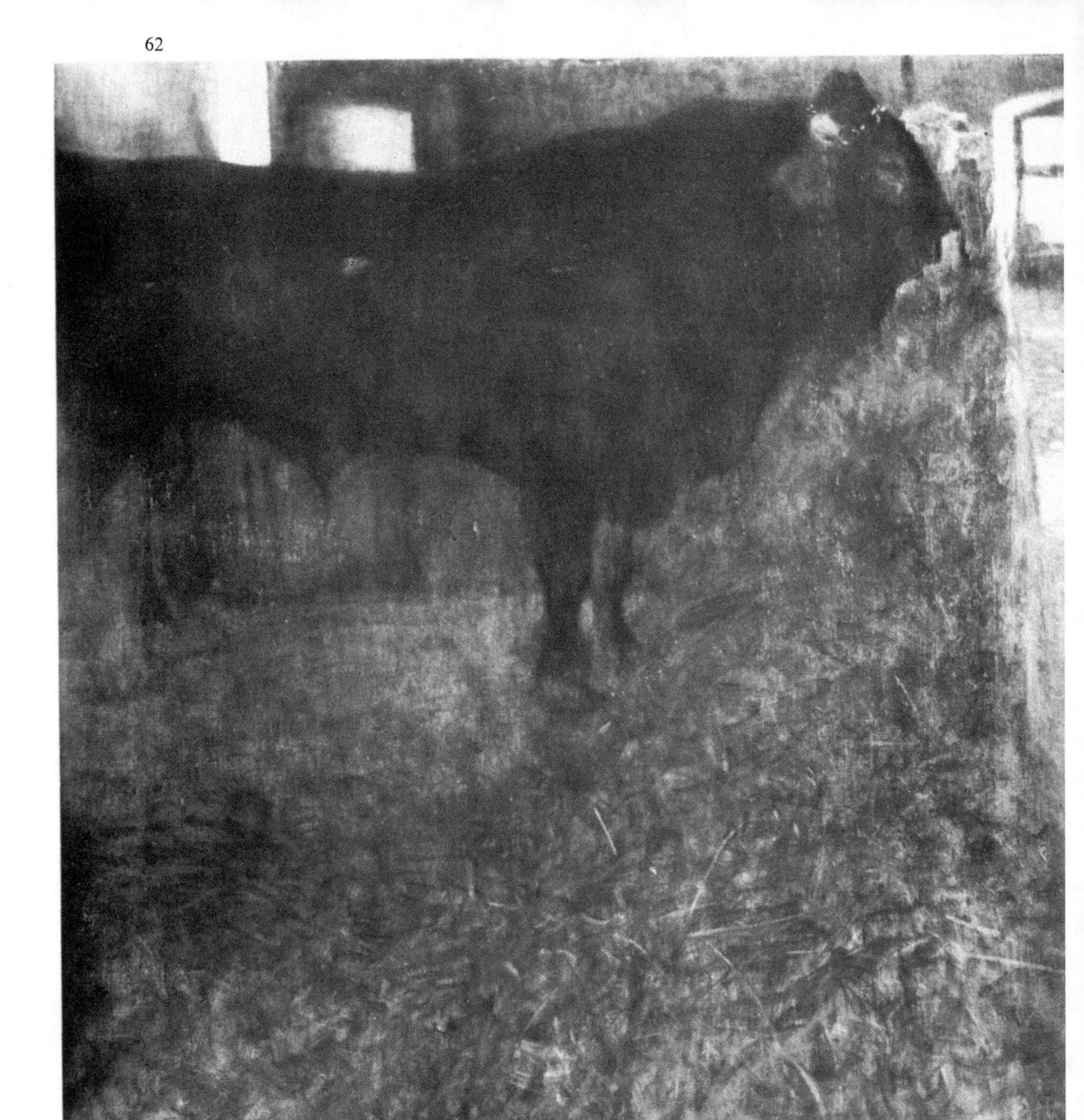

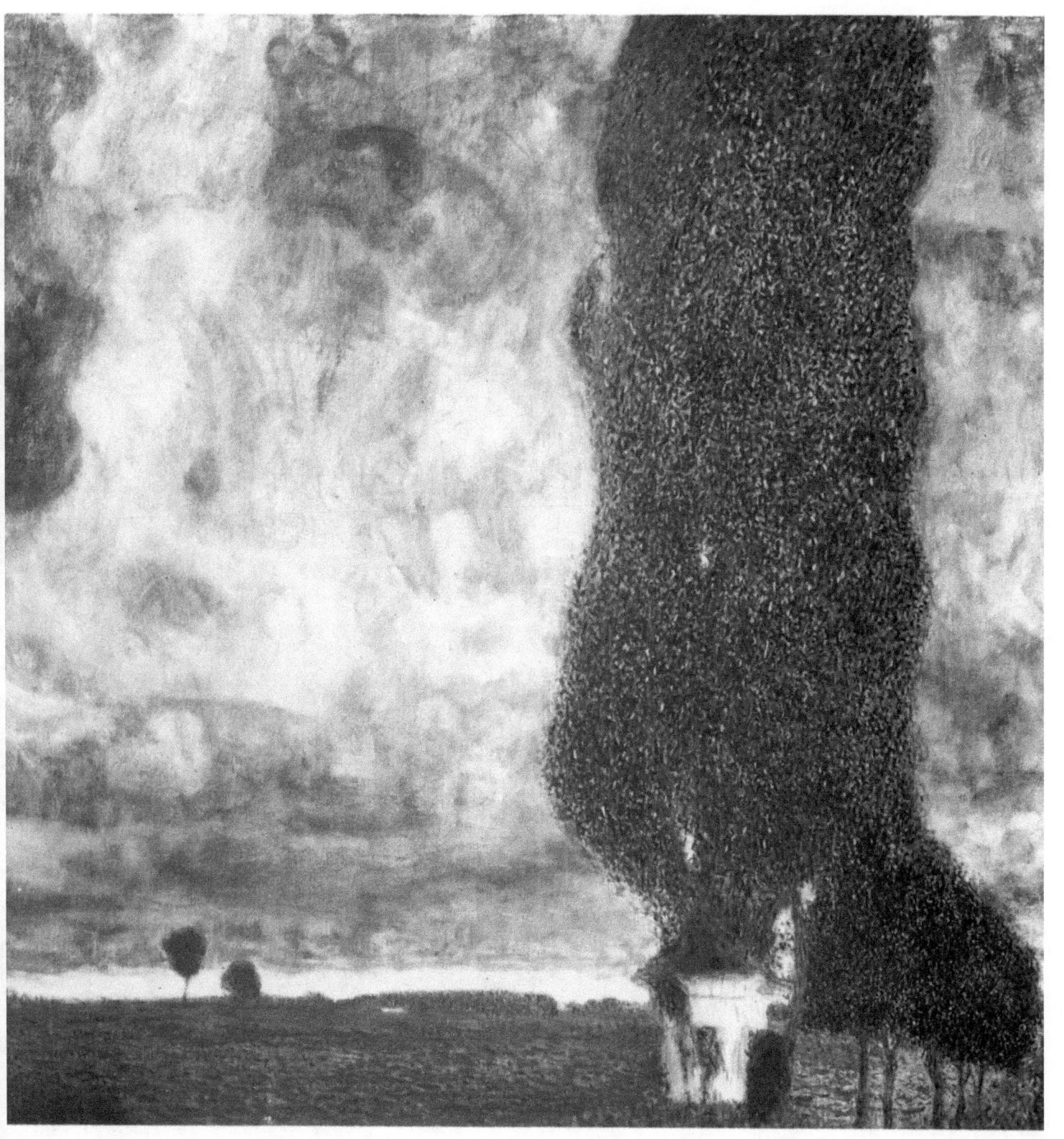

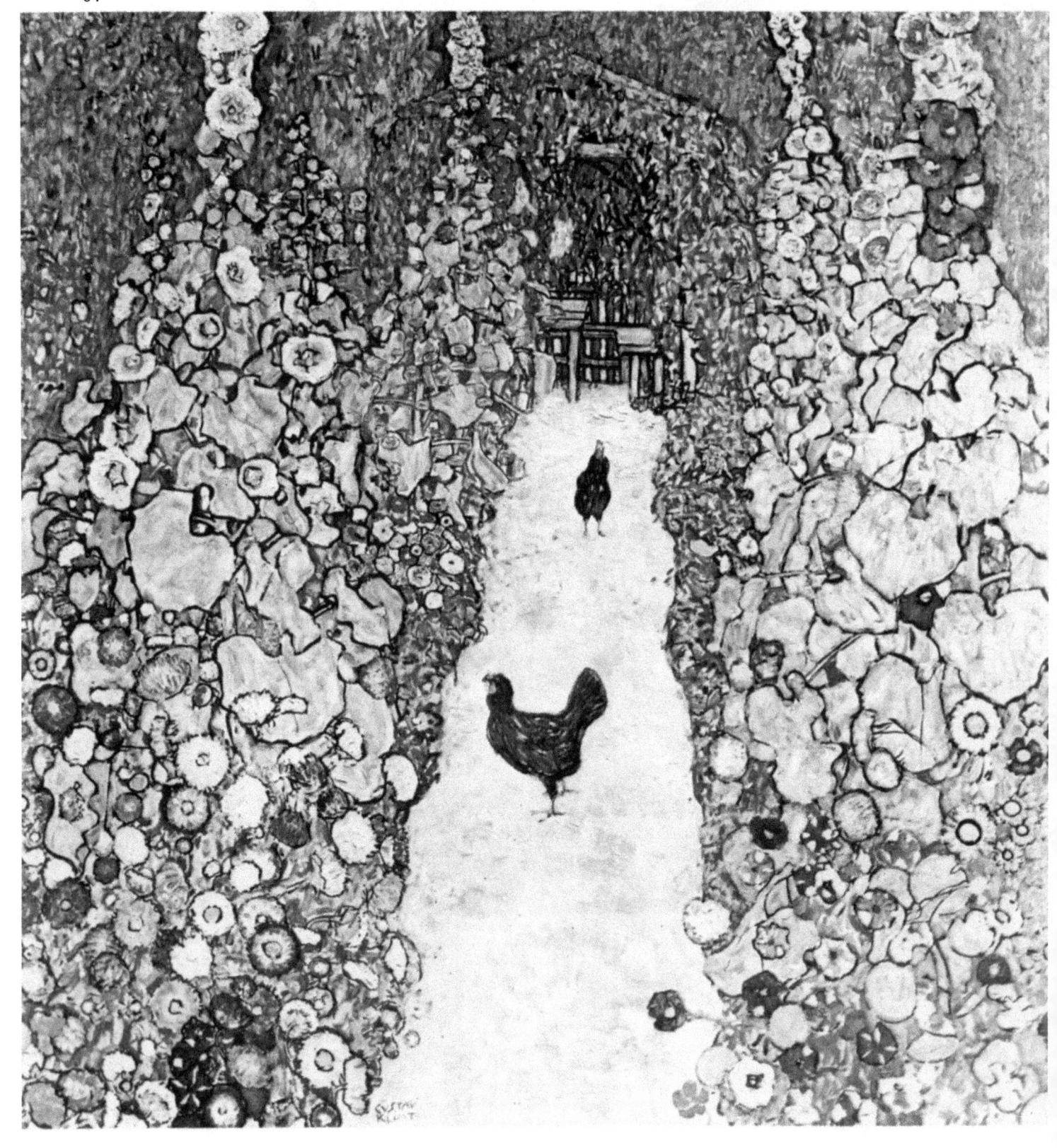

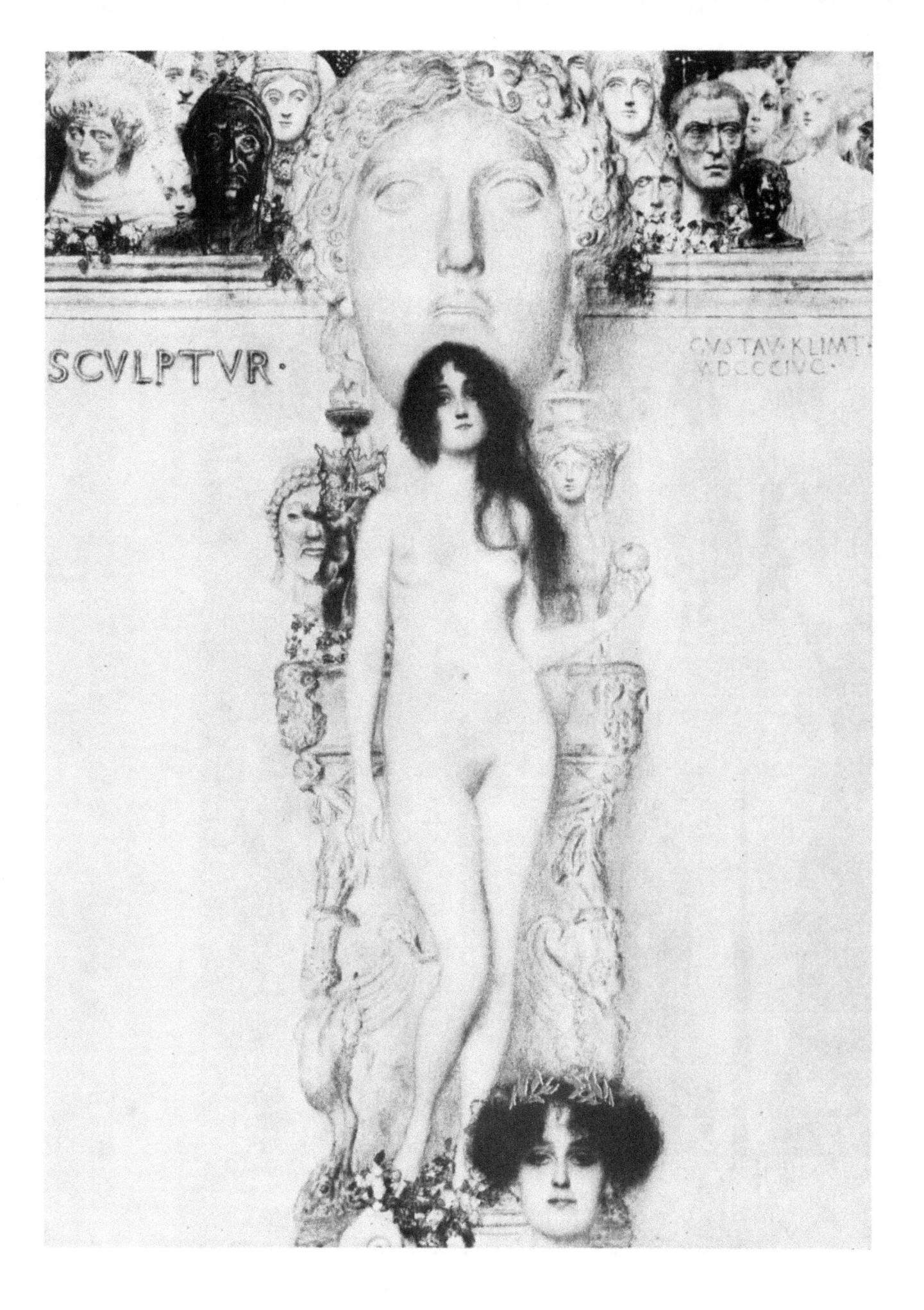

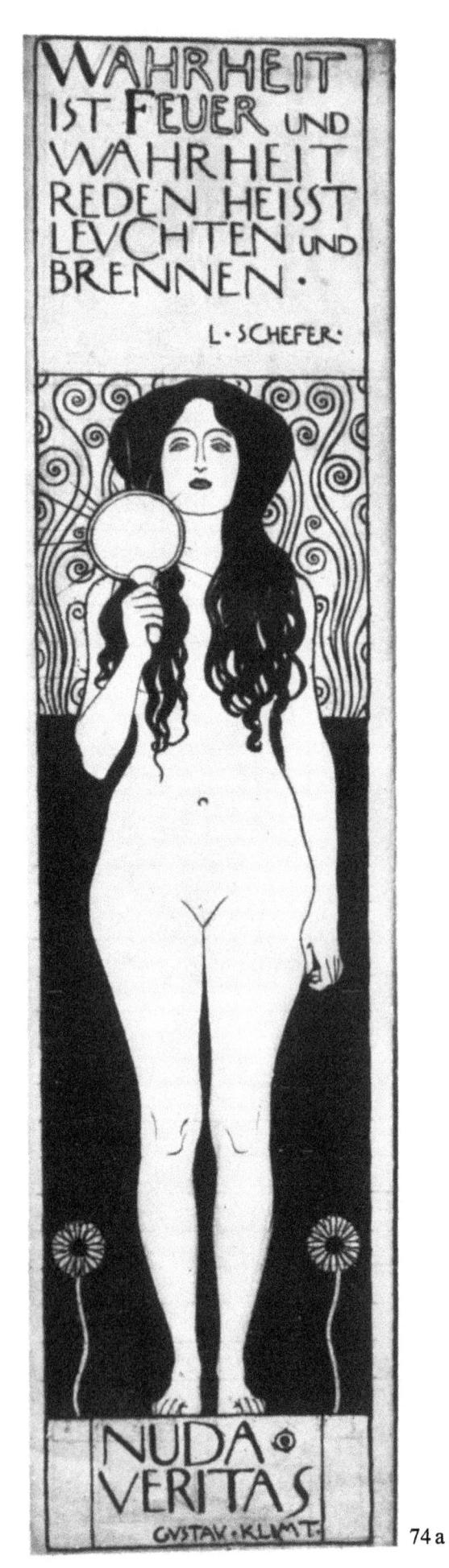

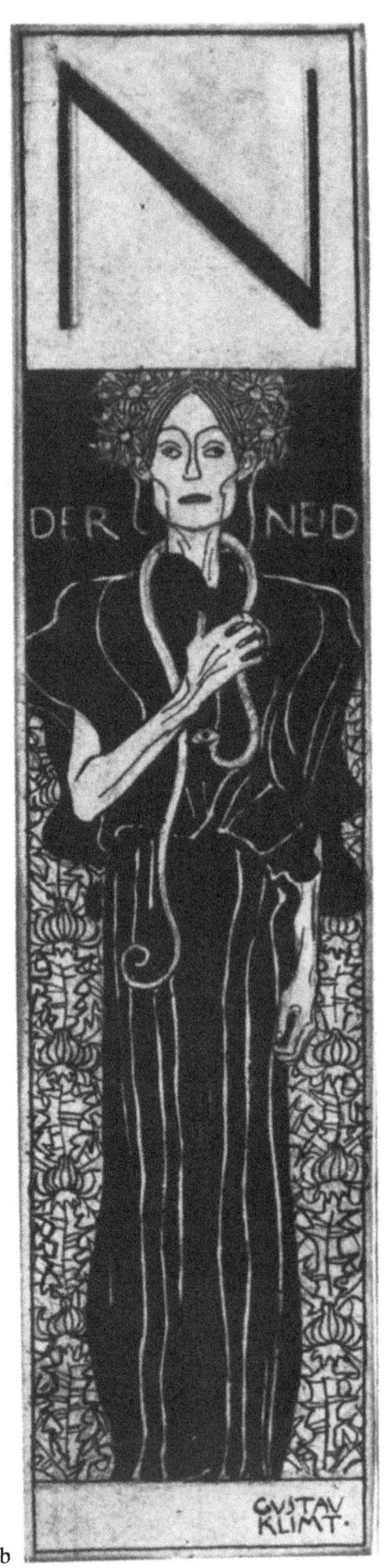

1a 74b

76 a

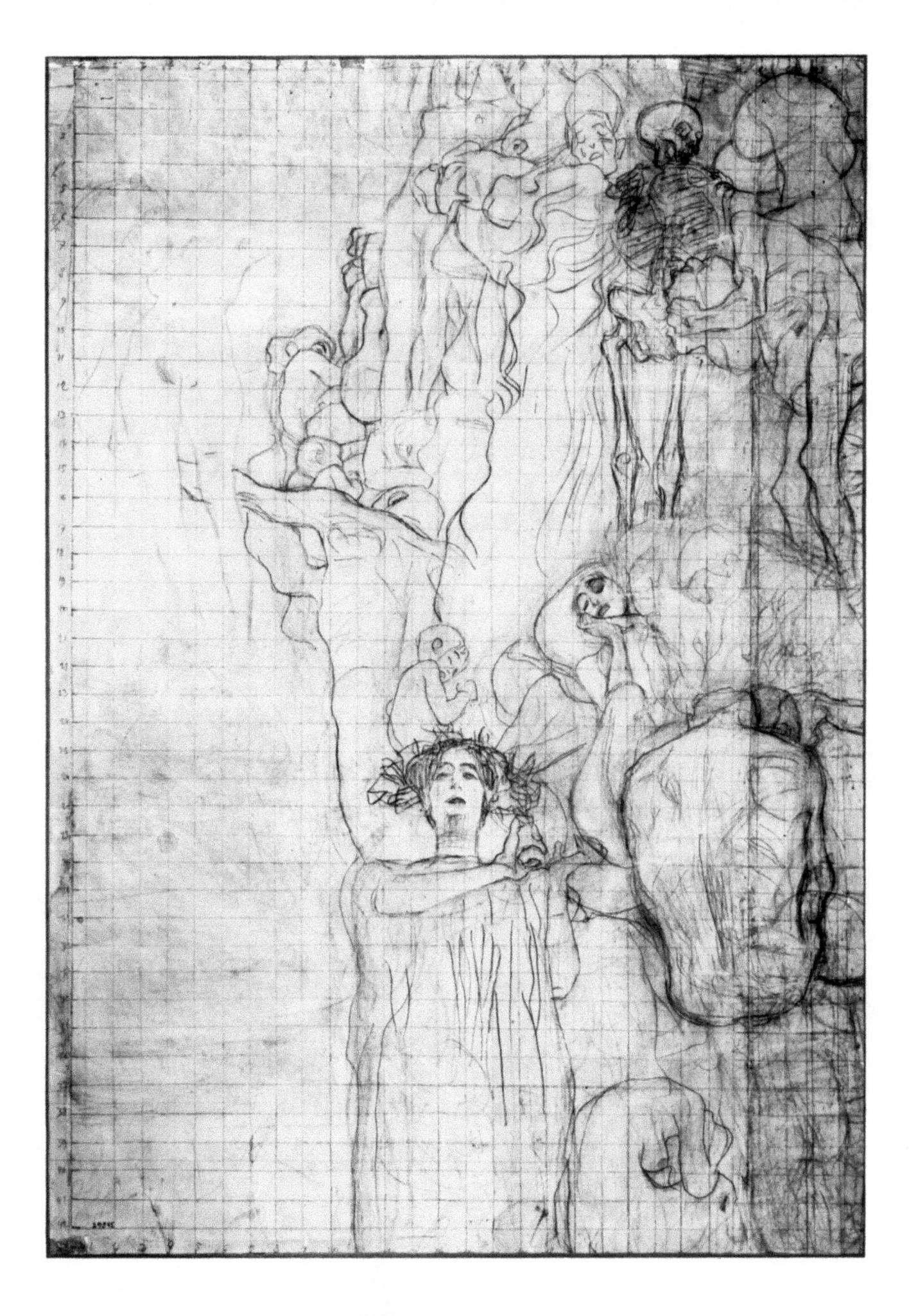